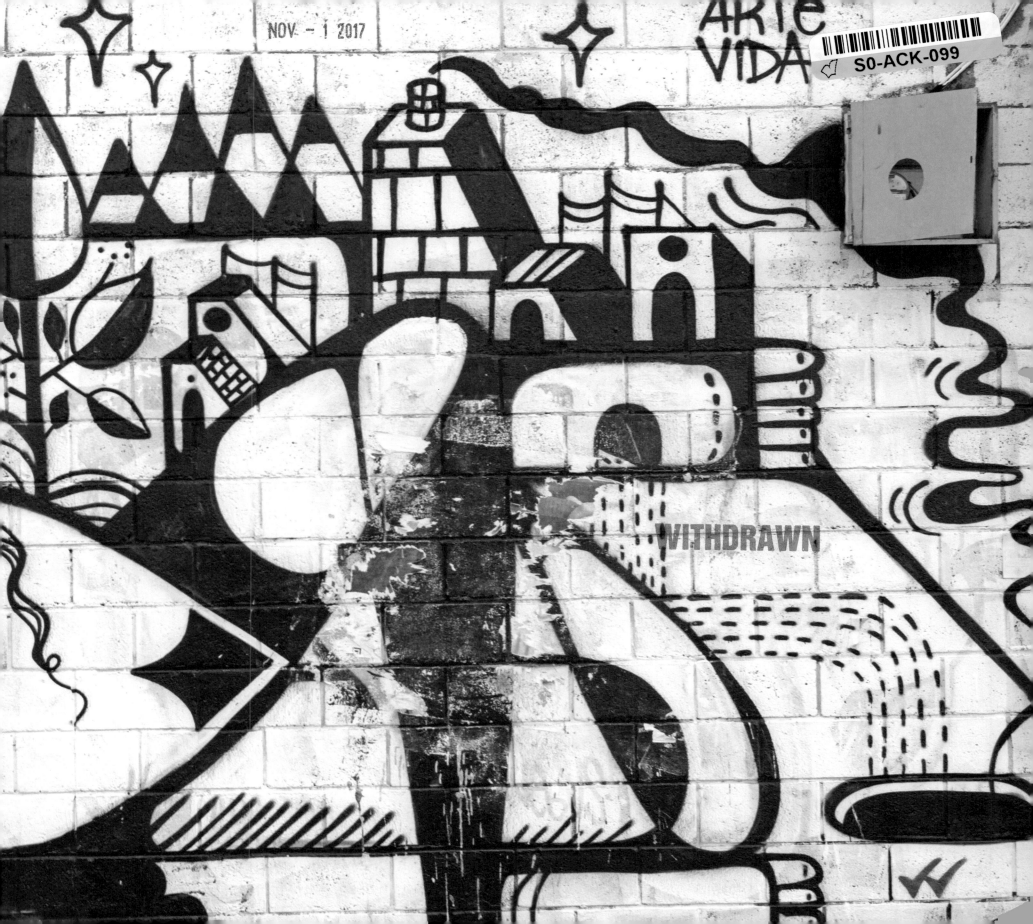

THE URBAN CANVAS

STREET ART AROUND THE WORLD

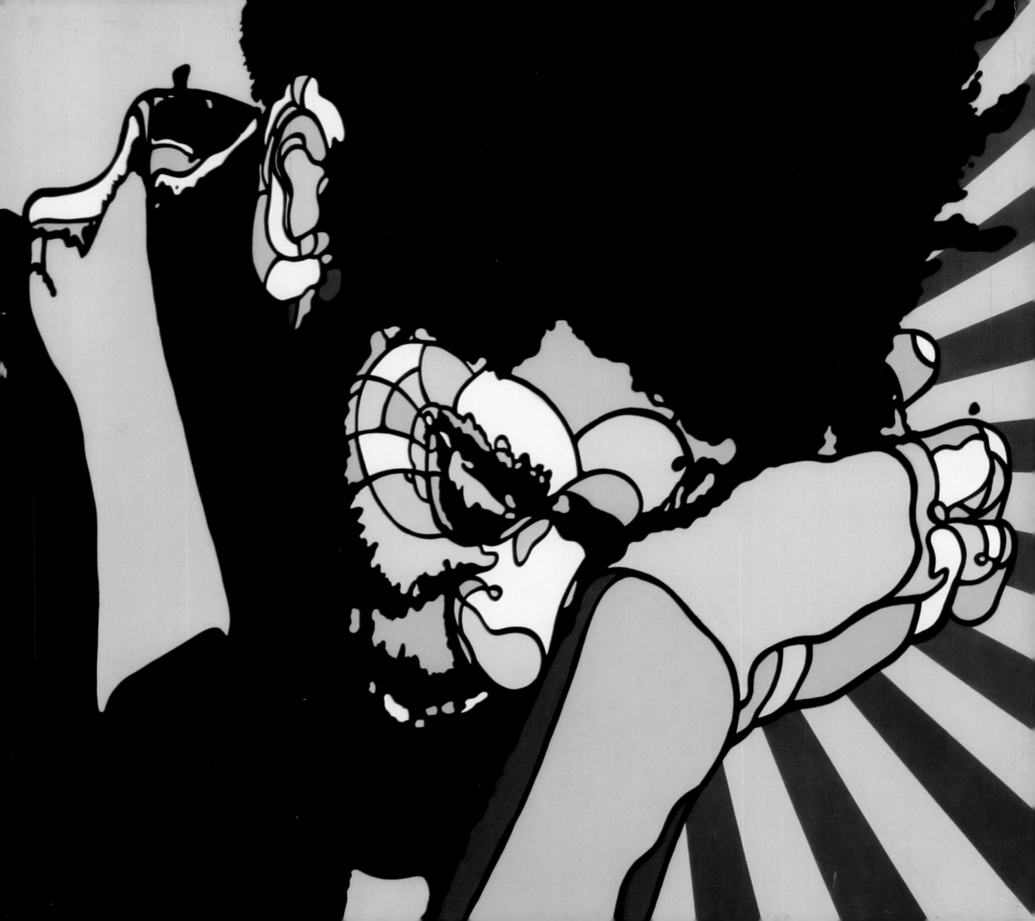

G. JAMES DAICHENDT

FOREWORD BY RON ENGLISH

THE URBAN CANVAS

STREET ART AROUND THE WORLD

weldon**owen**

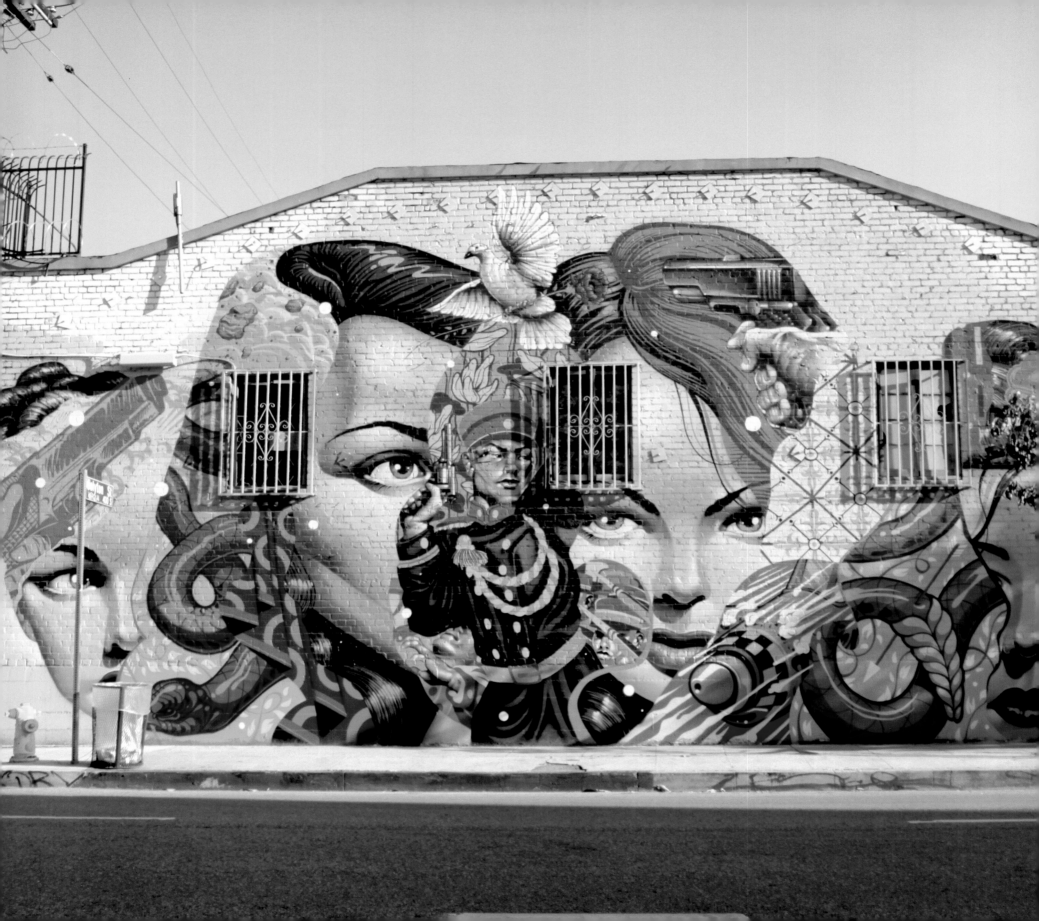

CONTENTS

Foreword by Ron English | 07

Introduction | 08

NORTH AMERICA | 37

SOUTH AMERICA | 81

AUSTRALASIA | 105

EUROPE | 133

ASIA | 177

AFRICA | 205

Visual Gallery | 224

Acknowledgments | 238

Colophon | 239

Tristan Eaton, Los Angeles, California

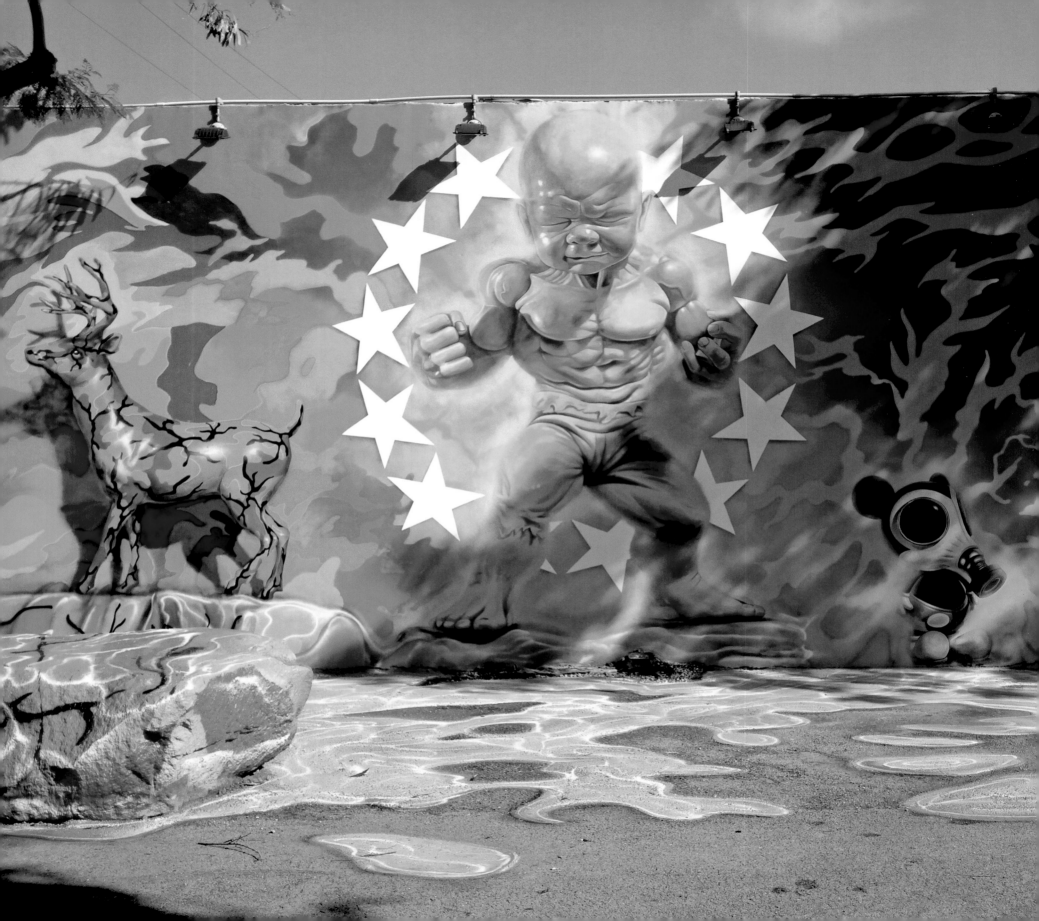

What good is art that no one sees? What good are ideas that no one shares? And what good does it serve a person to exist in a tape loop of agreeable, self-buttressing, often corporate-crafted concepts? If you were born to the coastal elite, you might have been directed into a prestigious university with a top-notch art program that also serves as a feeder to a gallery system that will market your creative endeavors to the power class, which participates in an ongoing intellectual narrative through the arts. If this was not your situation, then the possibility of a sustainable career fueled by your artistic talents might have seemed like a mirage; however, the desire to create and disseminate your creations was no less pressing or valid.

For me, a Midwestern son of factory workers, it was underground comics hand-published and distributed through local head shops that got me started before I progressed to the streets. Whether it was spray-painting fake shadows on walls and potholes on roads or creating a monument of used toilets on the town square, the results were satisfying. Watching someone looking around for the person casting the shadow painted on a wall gave me my first sense of generating a unique artistic moment.

Street art was accidental for me; there was no term for it in the late seventies. In fact, I called it vandal art. It was punk appropriation, hijacking public space not for self-promotion but for the chance to be part of the conversation. One night, standing behind the Mother Blues bar in Dallas, I looked up and saw a huge billboard with a ladder that came down to twelve feet above the ground. It occurred to me that if I had a twelve-foot ladder, that billboard could be my canvas.

I pirated billboards all over Texas, using house paint, spray paint, seamless paper, and wheat paste until I finally got busted in 1984. Charged with a second-degree felony, I rolled up my six remaining billboards, packed a backpack, and moved to New York City. I posted two of them in Soho that were soon tagged by someone named SAMO. Within a few weeks, I'd met Keith Haring. We traded stories about getting arrested, and he became one of the first friendly faces in my new home. One by one, I tracked down all the graffiti artists I'd admired from afar: Lady Pink, Phase 2, Crash, Daze. A few years later, I was hanging out with friends at Max Fish. A guy was pacing around by himself, so I asked him if he wanted to sit at our table. He finally came over and started telling us of his adventures the night before. He'd stayed up all night covering a billboard with photocopied paper sheets that puzzle-pieced into an enormous portrait of wrestling legend André the Giant.

By the late nineties, a new generation of artists was taking to the streets equipped with art degrees, business savvy, the tattered road map left by pioneers, and the thing that would prove more powerful for the movement than the invention of the spray can: the Internet.

Nobody can be a big fish in a small pond when the world is connected. To survive in the 1980s subway and street culture, you had to be slightly better than the next guy. Graffiti artists were scored not only on stylistic innovations but also on degree of risk involved with location, size of piece, and sheer effort in getting it up. The publication of Martha Cooper and Henry Chalfant's book *Subway Art* may have brought graffiti and its spirit of competition to the notice of some, but the Internet seeded the aesthetic throughout the world. Suddenly, the next wave of what are now called street artists (many traditional graff writers refer to them as "art students," and I count myself among them) exploded onto the global visual landscape with quick-witted stencils, trompe l'oeil mind-bends, and character-driven masterworks executed on the streets for eventual consumption through the Internet or on iPhones, driving the quality of street art into astonishing territory.

Distinctly different from the traditional art world, where technical skill seems not to apply, street art has always seemed more akin to sports. There is no such thing as an aesthetically pleasing gutter ball in bowling, and Michael Jordan was not Michael Jordan because his dad owned the team. Sports has the proven capacity to sustain itself through the participation of children whose love of and experience participating in a sport makes them lifelong fans. An incredible number of youths are engaged in the activity of street art, and you don't need a degree from Harvard, and your dad doesn't have to own an art gallery. You just need a wall and a can of paint (and an iPhone, of course) and that youthful interest will, hopefully, spawn a lifelong passion for art. —RON ENGLISH

Ron English coined the term *POPaganda* to describe his combination of high and low cultural references. The Baby Hulk, or "Temper Tot," combines high art painting techniques with references to childhood toys, alluding to misdirected anger and immaturity.

Street art has exploded as a worldwide phenomenon that has touched every aspect of culture. From the backs of street signs to corporate boardrooms, the influence of its practitioners and the visibility of their work show little sign of slowing down. Reality television, museum exhibitions, public tours, PR firms, and talent agencies have tapped into the art of the people. The popularity of street art and the exposure the artists enjoy have drawn many who would otherwise never associate with the art form to tackle mural projects and outdoor installations. Equally, little old ladies from Pasadena and hipsters drinking craft beers seem to find something to like about street art, making it a very popular way to view and appreciate art. This is evident from the massive crowds that gather for exhibitions featuring street artists and the draw of mural festivals around the world, events that often complement concerts and other popular forms of entertainment. In sum, there is an incredible enthusiasm for street art as it continues to evolve in the twenty-first century. From these experiences, it is without a doubt making an impact that cannot be ignored.

As a professor, critic, and historian interested in art forms that influence culture, I continue to be surprised by the relevance and depth of street art. For the majority of my career I have focused on writing about modern and contemporary art—art that the general public often views as elitist and unintelligible. The accessibility of street art initially provoked my attention, and the depth of many of its proponents kept me interested. I have since been encouraged by the growth of many artists associated with street art, and I believe that street art offers a new way of thinking about the art world and an alternative way to engage art. This exciting proposition is part of the reason that street art has mass appeal across the globe.

Chancing upon a work of art while walking down an unfamiliar street is an exciting encounter, a bit like finding a hidden gem. Likewise, hunting down a piece of street art makes an outing into an adventure. The interaction becomes both physical and emotional and, ideally, provokes a conversation about the artwork. This type of engagement happens in museums and galleries as well, but it often requires you to pay the cost of admission and cross into an atmosphere reserved for worship. Street art meets us where we live and doesn't require the cold white walls of an institution to tell us that it's important.

To broaden the understanding of street art, contributors from around the globe were invited to participate in this book. The result of these discussions was in some cases surprising and in others predictable. The need to be heard, the desire to preserve important concepts, and the urge to highlight achievements were constant motivations. Expressions of political unrest and personal narratives were unique to artists in a few locations.

Despite the many characteristics that proponents of street art maintain, the accessibility of the art form is its ultimate strength. This is evident in the popularity of social media platforms that capture the public's imagination through dynamic images. There are a number of art historical and cultural observations and analyses that I believe have something to offer the field. While art is often deemed to be a universal language, this has not been true in practice throughout art history, as art has been used by the wealthy and powerful to great effect and has been removed from the daily lives of the average person. Paul Gauguin is credited with saying, "The history of modern art is also the history of the progressive loss of art's audience. Art has increasingly become the concern of the artist and the bafflement of the public." This is a condition that street art is diametrically opposed to, as it has done just the opposite in last few decades.

To situate the reader, the text begins with an essay that is followed by short introductions about street art on each continent. There is no perfect way to divide the regions of the world, so the book errs on choosing the main bodies of land that make up the globe. Experts in the art world—a philosopher of art, a journalist, an art historian, and photographers who eat and breathe street art—introduce these sections of the book and offer the necessary perspective to think critically about this art form. The images in each section were selected to illustrate the powerful momentum that street art has generated across various cultures and to complement the analysis in the essay. The result is a powerful combination of rich visuals and analysis that is intended to engage you with art on a deep, meaningful level. While you may not agree with everything discussed, your participation in this dialogue is the goal.

Street art uses all the media available to the arts and is not limited to spray paint or stencils. This piece by CamoLords endeavors to blend into the aesthetic of the city streets by cleverly hiding in plain sight.

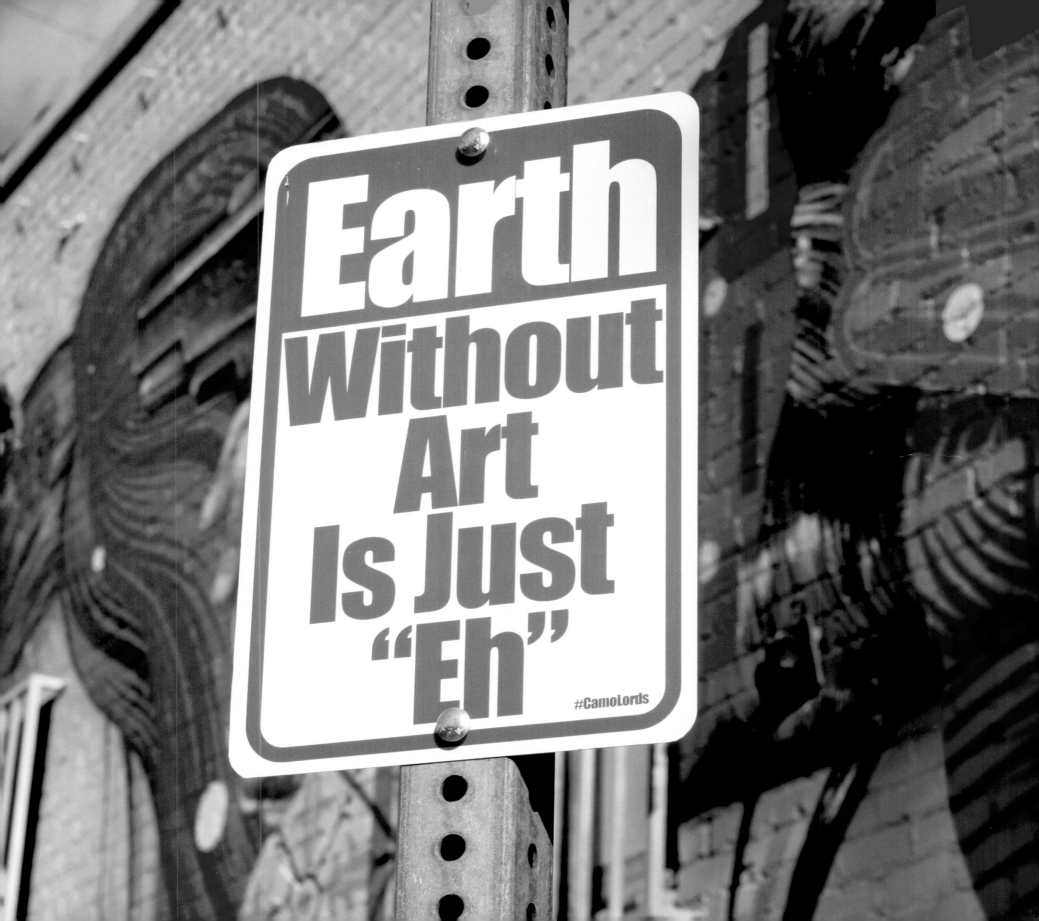

THE STREET ART PHENOMENON

Street art and the artists responsible for creating it have become media darlings in recent years. Major newspapers and commercial outlets around the world have highlighted Robbie Conal's political messages, Votan Henriquez's works empowering Native American communities, and the pop culture relevancy of KAWS, who has progressed from being a street artist to enjoying the status of an international brand. Street art has received the type of international attention that extends far beyond the point of creation, as it is seen through the screen of a phone, computer, or television.

For example, simplistic drawings of children situated on piles of rubble by Abu Malik al-Shami drew attention to the civil war in his native Syria and generated astute political commentaries on the hope for peace. For Shamsia Hassani, a professor of art at Kabul University in Afghanistan, the streets are a canvas for juxtaposing her stylized female figures in traditional garb. She is breaking gender roles within a context that makes producing street art very dangerous. Her hope is to beautify the city with color despite the darkness of war. The imagery by both artists, despite language barriers, utilizes common symbols and figurative depictions that are easily understood and heighten the amount of coverage they receive and how far it can be distributed. There are even multiple street art news sources that report on the latest street art tours in Dubai or the famed Chapel Road in Mumbai, India.

Banksy's provocative street art, with its humor and poignancy, has influenced a generation of artists. Lesser-known artists have been described in headlines as "the New Banksy" or "the Japanese Banksy" to signify that they have an aesthetic similar to Banksy's and are worth watching or are making waves in their particular culture and deserve the attention Banksy typically receives for his art. But the problem is that we want to draw a circle around those who paint outside and call them street artists. Or perhaps we want to call them graffiti or mural artists because we want to associate them with something dangerous (graffiti) as opposed to something safe and legal (murals).

The attention that Banksy has given to street art is admirable, but there is much more beyond street art's favorite son. The field is incredibly interesting once you pull back a few layers. The number of artists involved in street art has grown tremendously large, so much that it has become difficult to maintain a universal list. As I visit cities around the world, I am constantly adding names to my files, from a new international contact to the up-and-comer. Small rural towns always have a sticker artist who puts his or her creations on the backs of signs, while large metropolitan cities often feature hundreds of artists who paint, poster, and install their work in myriad locations. From small towns to the metropolitan cities, the size of the field has pushed proponents to new levels of creativity and technique.

The popular press is not much help in defining street art, often lumping everything into one bin. Therefore, it's helpful to review some basic history and concepts that will help us understand what makes street art special and why it receives such significant media attention. The accessibility of street art is easy to overlook and confuse with art pieces that have a similar aesthetic. Reviewing the difference between street art and graffiti does more than define terms—it helps us understand why we see and interpret visual images the way we do, before we can move to deeper levels of analysis and criticism.

Many commonalities in street art are noticeable through the imagery and can be identified by the reader. The use of limited tools creates some universality, and a lot of shared techniques have become standard tools of the trade. The world has become a smaller place because of the Internet and social platforms. Anything that is new and innovative is shared right away. The cross-fertilization that happens with international events and the continued influence of the digital world allow new knowledge in an area to spread quickly. Yeta the unique customs and culture in each location make for inspirational and telling differences—differences that make street art so powerful.

The conceptualization of the term *street art* in the 1980s has become confounded with other genres of art making in the twenty-first century that are distinct yet related. Both graffiti

TOP LEFT Robbie Conal has been using the streets as a medium for his satirical political messages since the 1980s. BOTTOM LEFT Shamsia Hassani of Afghanistan uses her art to help people forget the long history of war and suffering in her country. RIGHT These street works by Banksy ended up for sale in an art fair not long after they were taken from the streets in 2013.

and mural art are related to street art, but are intimately tied to its genesis and perhaps also to its end. Each continent, from South America across the ocean to Asia to parts of Europe and Africa, has its own cultural history that makes street art come alive and relevant to viewers in that part of the world. Yet the story of street art in theory starts with graffiti and eventually ends with public murals.

As the popularity of street art has soared, a number of issues have changed the way we view and understand it. These include modernity, globalization, and the uncomfortable relationship street art has with commercialization. While street art has been knocked around the block by these concepts, street art is not dead. Thousands of artists around the world will continue to practice street art for the foreseeable future, holding on to romantic ideals that make it an endearing and approachable art form, even if the movement has reached its logical zenith.

GRAFFITI—YOU KNOW IT WHEN YOU SEE IT

The graffiti duo called Mint and Serf capture the essence of graffiti writing when they state, "If it takes more than five minutes, it's not graffiti." The crux of what Mint and Serf mean is that graffiti is about

writing one's name or tag quickly and that anything that takes time becomes something else. The term *graffiti* has come to represent anything drawn or etched on a public surface that does not belong there. Although this is an oversimplification, this connotation of graffiti is universally recognized.

Graffiti is more properly understood as a signature—a personal and unique mark that refers to the writer's identity. A graffiti artist may write his or her name over and over, on as many surfaces as possible, and doing that effectively requires speed. Hence Mint and Serf's accurate definition. The responses to these marks vary, from viewing them as a crime to seeing them as bringing color and beauty to forgotten neighborhoods.

Writing graffiti on a public surface assumes ownership, states a presence, and/or preserves a memory. The act also has aspects of destruction, which are acknowledged by both the writers and the property owners. Graffiti is an important aspect of visual culture because it's so prevalent. Understanding what it is, who does it, and

BOTTOM LEFT The artist Retna utilizes the aesthetics of graffiti with his distinctive script derived from Gothic, hieroglyphics, Arabic, Hebrew, and calligraphy. BOTTOM RIGHT In comparison to graffiti, traditional street art is imaged based, and if text is present, it reinforces the imagery, demonstrated here by the artist Teacher in this commentary on Bill O'Reilly.

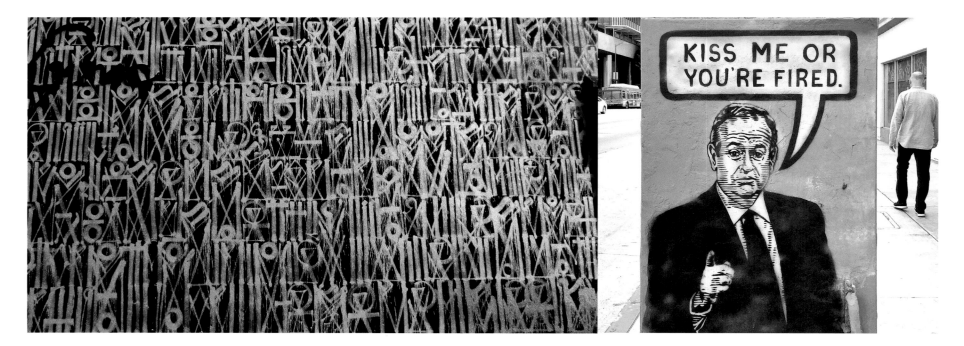

why they do it helps us better engage with it as appreciators or possibly helps those who hope to contain or prevent it.

As an art critic, I recognize there is a beauty to graffiti that is part of a dialogue between the people who inhabit our communities and the structures that make up where we live. These issues are not easily broken down but are part of the larger dialogue that goes beyond defining the differences between graffiti and street art. For example, hobo graffiti provides insight into the subculture of marked boxcars. As John F. Lennon points out, through these marks on what was otherwise invisible as the trains passed through communities, we can begin to understand an ignored subculture. Likewise, gang graffiti represents social groups and their relationships (some criminal, others cultural) with the larger community. Researchers like Rafael Schacter argue that graffiti serves as an ornament that slightly alters our physical environment, a way of reforming and reinventing how we negotiate the spaces where we live.

"You know it when you see it" is a phrase often used to explain graffiti. Given the scorn of city planners and law enforcement, graffiti often has many more negative than positive connotations. Yet the transition from graffiti to street art is important to note in order to move forward onto larger issues.

Many histories trace graffiti through time, through ancient civilizations and into the Middle Ages. Christians avoiding persecution carved symbols in the walls of the catacombs in the Middle Ages, and political activists scratched critiques onto public buildings during the Renaissance. Soldiers stationed around the world left behind symbols and marks (for example, "Kilroy was here" illustrations) that documented their presence.

Contemporary graffiti, typically created with spray paint, ranges from simple letters to incredibly complex designs, including abstract letterforms. In the United States, graffiti developed in city centers like Philadelphia, New York City, and Los Angeles in the 1960s and 1970s and could be seen as a reaction to the dehumanizing architecture of the modern era and a need to be heard. Graffiti soon spread around the world but is used in myriad ways in different cultures and communities depending upon local customs and each culture's relationship to the West.

The border between graffiti and street art is well established. Graffiti has a long history based in writing letters and essentially only requires a wall to write on. Street art, based in imagery, typically includes a multitude of media and emphasizes, through its execution, the uniqueness of context, which often heightens the interpretation of the piece.

The anti-mainstream aspect of graffiti is one of its most redeeming aspects and one of the reasons I am drawn to it as an academic.

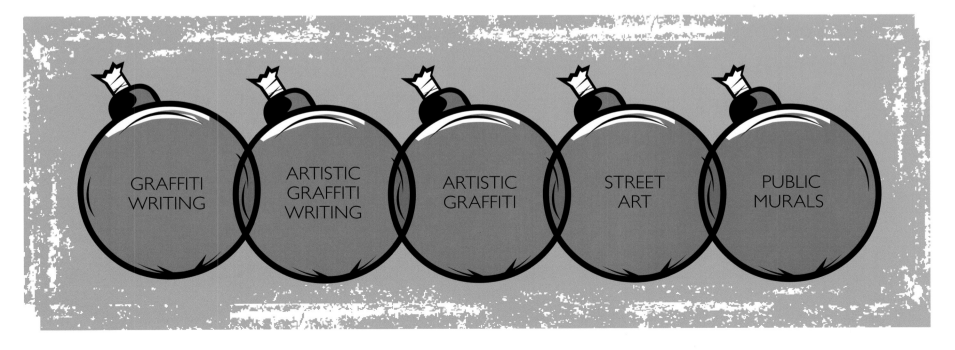

GRAFFITI WRITING — ARTISTIC GRAFFITI WRITING — ARTISTIC GRAFFITI — STREET ART — PUBLIC MURALS

The educational traditions, knowledge base, and learned skill sets that come with artistic training are tossed to the wind. Instead, the techniques can be learned without an institution, and the exhibition of the work takes place without permission. While street art may be aesthetically different, conceptually it has embraced many institutional structures. The closeness that street artists have with the mainstream artist industry has benefited both.

FROM GRAFFITI TO STREET ART TO PROPAGANDA

The acceptance of street art in popular culture is frustrating for many proponents of graffiti. The culture of graffiti has common rules and places importance on longevity invested in the field and hours dedicated to the craft of writing. Street art requires none of this, and the willingness of proponents to embrace aspects of the professional art world distances street art from the romantic ideals of graffiti practitioners.

As Suzi Gablik notes in *Has Modernism Failed?* graffiti is a well-studied subject and extends beyond traditional art history and criticism. According to Tracey Bowen's research, graffiti has been explored from sociological, urban planning, and anthropological points of view because of the territoriality and the socioeconomic status of graffiti and street artists.

Drawing on a number of interviews with graffiti and street artists, I developed a Venn diagram to outline the porous borders between graffiti and street art. As we explore the similarities and differences in each category, it becomes easy to see the shared characteristics and how street art is caught between the world of graffiti and public murals.

The first three categories of the Venn diagram are all forms of graffiti, which helps us visualize why it is so different from street art, yet is often associated with street art in particular circumstances. Public murals are situated on the far right with no direct connecting to graffiti. It's only through street art that this narrative has a beginning and end.

GRAFFITI WRITING

The foundation for the Venn diagram, the graffiti writing category, is about writing letters, often very quickly. The letters can be scratched,

painted, or drawn and typically involve aerosol paint, markers, paint pens, or scratching tools to make the marks. There are no images or elaborate uses of color. This is the most basic form of graffiti, usually in a solid color. In a philosophical argument, Nicholas Riggle calls this category "mere graffiti" because it essentially says, "Someone was here." Graffiti writing is not necessarily an art form, and these individuals see themselves as writers and clearly identify with this term. This is the oldest type of graffiti.

ARTISTIC GRAFFITI WRITING

This category, likewise based on writing letters, also involves elements and principles of design. The style of the letters is much more expressive than that of basic graffiti writing, and the colors, forms, and use of line are manipulated dramatically. There is a crossover between graffiti writing and artistic graffiti writing when formal elements appear but without the full-color imagery associated with genres of artistic writing like Wildstyle (a style that abstracts through blending and decorating elements) or Blockbuster (evenly spaced block letters). Graffiti writers call this type of writing a piece. (The word is short for masterpiece.) Much more planning and practice are involved with artistic graffiti writing, and the results are impressive visually.

The location of artistic graffiti writing is important for its visibility. The context may signal ownership or territorial concerns, but also may be just an ideal wall to paint. The name painted on the wall is important for the writer's or crew's identity, but artistic graffiti could potentially change contexts and the meaning would be the same. Artistic graffiti writing shares some characteristics with artistic graffiti when imagery complements the writing. However, when the letters are of primary importance and are a central focus, the graffiti in question fulfills the characteristics of artistic graffiti writing.

ARTISTIC GRAFFITI

The name of this category acknowledges that it is based on images rather than words. A commonality between the first two categories is the medium of spray paint, and this continues with artistic graffiti. Many

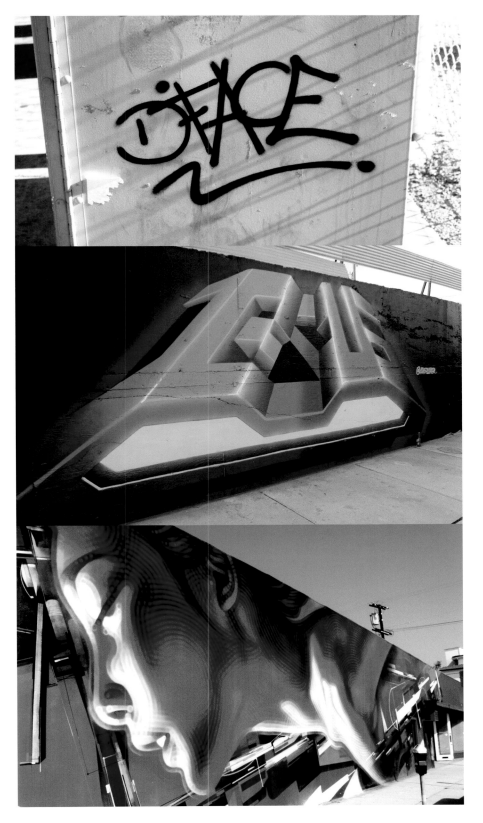

examples may overlap between this category and the previous one, depending upon the number of elements involved in the creation of the graffiti. Artistic graffiti may incorporate letters, but is not dependent upon them. Instead, it uses visual symbols and imagery to drive the composition. It's not uncommon for artistic graffiti to depict large visual images that borrow the techniques of shading typically used or developed in artistic graffiti writing but are put in the service of creating the human form, cartoon characters, or other images based in reality.

Based upon the history of letter writing, artistic graffiti utilizes graffiti-based techniques and materials to create imagery. Thus, many who practice this style identify with the tenets of graffiti, but their art verges on more sanctioned versions of street art and sometimes muralism. This category of graffiti is most often confused with street art and is a middle ground for artists around the world. Not all graffiti is street art, and street art is not graffiti. However, artistic graffiti is where the border between graffiti and street art becomes blurred. Artistic graffiti is not about territorial concerns or writing names; instead, these artists have personal motivations for creating works of art that extend beyond writing a name in the public square.

STREET ART

The transition to street art is based in both visuals and letters, but street art expands beyond the limited materials for creating graffiti. Not restricted to aerosol or spray paint, street art involves the use of wheat pastes, stencils, wood, yarn, and any number of traditional and untraditional art materials. The list of techniques and materials—stickers, posters, photographs, photocopies—seems to get longer as street artists innovate and incorporate found materials into their artwork.

In *The History of American Graffiti*, Roger Gastman and Caleb Neelon note that around the late 1980s and early 1990s, a few graffiti artists began to push beyond the typical materials when they started using sculptural materials, posters, and other media. This development laid the foundation for street art to become commonplace—and to distinguish it from graffiti.

TOP Example of graffiti writing. MIDDLE Example of artistic graffiti writing. BOTTOM Example of artistic graffiti.

As the media and techniques evolve and grow, the aesthetics of street art continue to change. The popularity of street art has made it desirable in certain communities as a marker for creativity and an aesthetic hipness. One could make the argument that street art is close to becoming another form of public art, especially when the term *mural* is used. However, the issues of permission and permanence keep street art in a category separate from murals and public art. The illegal aspect of street art is the most telling aspect that differentiates it from public art and murals.

MURALS

The final category, murals, incorporates the aesthetic of any of the previous categories but removes the illegality. A mural is an artwork painted on a wall, ceiling, or any stable public surface. It is a particular kind of public art that has been used for thousands of years. Whether made with tempera paint during the Renaissance or house paint in the twenty-first century, murals have long been an important part of human culture. Because they are facilitated or commissioned, they are not illegal and are often intended to be permanent or semipermanent. (Restoration efforts have advanced, allowing murals to be removed from their original surface and relocated.)

Permission is granted for painting murals on walls, and artists accept payment for their work. When a benefactor is involved, his or her voice becomes important to the process. The artist's individual expression is not necessarily compromised, but the process has the potential to become more complicated. The great success of street artists has witnessed them undergoing a transition from illegal to legal work. This distinction is important to note as artists make this transition.

GOING FORWARD

Street art shares many characteristics with other forms of public art, but the temporality of street art and its illegality (another parallel to graffiti) have caused critics to call it out as a negative force in communities. During the run of the 2011 *Art in the Streets* exhibition at the Museum of Contemporary Art in Los Angeles, surrounding neighborhoods witnessed a dramatic rise in graffiti and street art.

Heather Mac Donald, in "Radical Graffiti Chic" in the spring 2011 *City Journal*, was one the most passionate critics who felt the show was simply glorifying the crime of vandalism, and that the real victims were the residents of Los Angeles and even the vandals themselves. This harsh condemnation lumped together everything in the show to represent the bane of cities. Though street art is not legal, it generally does not attract the same scrutiny as graffiti.

Jeffrey Ian Ross, in *The Routledge Handbook on Graffiti and Street Art*, discusses issues related to graffiti and street art based on two urban factors: growth of urban surveillance/policing regimes and consumption-driven urban development. The former factor is about public safety and preventative policing in order to reduce reactive policing (social control). The aim of installing cameras and surveillance measures into environmental design is to reduce crime and allow urban areas to flourish. The latter factor entails the repurposing of abandoned factories and warehouses as privatized spaces with high-end zones for residences and consumerism in the form of restaurants and trendy shops. The residents' improved quality of life is the marker for success. Ross uses these two urban developments to see graffiti and street art as either an urban threat or an artistic contribution to or opportunity for communities. This complexity explains the varied responses that graffiti and street artists receive, ranging from prison sentences to museum retrospectives, a contradiction experienced by many artists who have reached the highest levels.

The seriousness of street art crimes is lessened when street art becomes a way to improve city centers. The artists, who no longer need to be anonymous, give interviews and make television appearances without fear of punishment. However, street artists are not always angels sent to better society with their wit and wisdom. While some works of street art are protected, cherished, and sometimes even stolen, many more are unwanted, and their creators fined or arrested.

Although street art borrows many characteristics from graffiti, it is not held to any common foundation, and the diverse backgrounds of

TOP LEFT Jef Aerosol created a giant stencil in the Beaubourg district of Paris in 2011. A technique typically used by street artists, it juxtaposes the art that resides inside the Centre Pompidou across the street. TOP RIGHT Based in the United Kingdom, Sweet Toof's work falls within the artistic graffiti category. The artist focuses on distorted imagery of teeth as a reminder of our own mortality. BOTTOM The French artist JR provides a good example of street art with the project "The Wrinkles of the City," which uses wheat paste techniques.

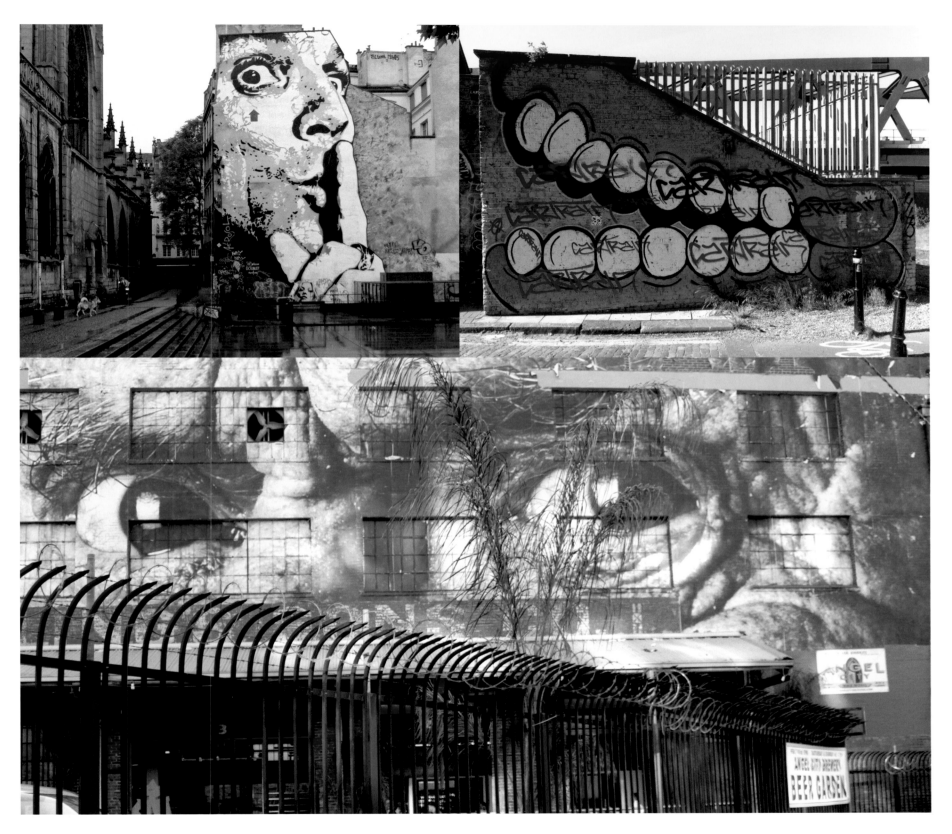

street artists have made them desirable for potential partnerships with corporations and the media. Street artists do not need to hide from police enforcement, but they have commandeered monikers associated with graffiti, which give them an element of danger or mystery that provokes appeal without the risk.

Street art, despite being born from graffiti, is something new and different. While street art may, to the professional art world, seem dangerously close to graffiti in particular situations, its distinct features are the location outside gallery/museum walls, the accessibility of the visual material, and the use of imagery as opposed to letters.

The creation of public murals by street artists provides some of the most exciting developments in the genre but could also be a sign of the end of street art as a movement, as it sheds its skin and public image. Improving the social, cultural, and economic viability of the city, murals signify a commitment to the arts and beauty, so one must wonder if the introduction of a new term like *street art* in the 1980s was a way to eradicate the issues of illegality and the close relationship of graffiti to this new way of making art outside. In *Street Art*, Johannes Stahl comments on the rare appearance of terms like *urban folk art*, *spray can art*, and *post-graffiti* and asks if they were a method to cleanse street art from the past and make it more approachable, friendly, and serious to the public and the larger art world. Public murals may just be the next evolution as street art matures and further distances itself from graffiti.

PROFESSIONALIZING THE FIELD: FROM STREET ART TO PUBLIC ART

Allan Schwartzman's 1985 *Street Art* introduced the term *street art* to the art world. The term seemed to adequately capture the confluence of artists and writers practicing a different type of graffiti that went beyond writing one's name on a public surface. While street art maintained aspects of graffiti and was influenced by graffiti culture, artists working within the more formalized art world often practiced it. Proponents of early forms of street art include Keith Haring, Kenny

Shepard Fairey has bridged the gap between street art and the professional art world through his legitimate platforms of distribution of his artwork. This transition has provided access to installations in locations that would otherwise be impossible.

Scharf, and Jean-Michel Basquiat. Two of the three (Scharf and Haring) were enrolled in art school when they began to draw and paint in the subway platforms and on the sides of structures. They were influenced by many different forms of low-brow art and were enamored of making art more accessible, which graffiti writers were not always drawn to accomplishing.

Street art could also be described as post-graffiti. As Lynley Farris points out, this term bridges the gap between the subculture of graffiti and the newer, more accessible forms of street art. Farris claims that post-graffiti challenges the art establishment and allows the public to define what art is by recognizing street art as art in the absence of the museum. This scenario overlooks the illegality of street art because the work is understandable and the public values its creativity or aesthetic. As the public audience grows for street artists, art world institutions come around to offer support for these artists or to showcase their work.

As street art moves away from the raw aspects of graffiti, it becomes more professionalized until eventually, there is nothing to differentiate it from other forms of art making. This balance between the graffiti subculture and the professional art world is required for street art to maintain its legitimacy, but is tipping toward the professional art world.

In recent years, a number of developments have challenged the characteristics of street art. The term *curator* refers to a skilled professional in the visual arts who is responsible for the research, organization, education, and documentation of artworks. Now there are street art curators, who organize neighborhood walls much as museum and gallery curators organize indoor exhibitions. The line of work once reserved for museums, galleries, and institutions of higher learning has been co-opted by this subculture. Granted, the term *curator* has lost much of its appeal lately, now that everything from your Netflix account to the cheese board at your local restaurant is "curated" based on expertise in a particular area.

The development of neighborhood walls being curated much like an indoor exhibition helps to legitimize street art and distance it from its roots of illegality. Working with local residents and city governments, these curators follow the proper procedures required for installing public art and maintaining the work so it has a longer and healthier life span. This is a positive development, though it turns works of street art into murals.

Festivals like POW! WOW! hold weeklong events in Hawaii, California, Taiwan, Israel, Germany, New Zealand, and Guam that feature local and international artists who create large murals in particular parts of their respective cities. The results are impressive—yet are not street art. It's interesting to take the analysis one step further and call these outdoor installations propaganda. The intent of large-scale murals is important and crucial for how they are received in communities.

Curators of street art secure walls for street artists to paint—but do not serve the same role as museum curators, where education, preservation, and scholarship are essential goals. These aims are replaced by promotion and hype through social media, time-lapse videos, and slick photography. The number of these curators—or, more accurately, promoters—is on the upswing because they make it easier and more profitable for street artists to create their work. These efforts are a great aid to artists, but they also potentially hurt them in their efforts to create meaningful work. Murals can be and are often used as promotional posters for gallery shows, merchandise related to the imagery, or in some cases an advertisement for a product. The exposure of street art and public murals is a resource that corporations like McDonald's regard as being great value and are quick to utilize for their own purposes.

The enthusiasm for commercial ventures and the professional success of street artists are commendable achievements for artists who work in these areas. However, the state of street art in the twenty-first century could not be more distinct from the approach of artists like Robert Smithson in the 1960s, who sought to reject the gallery and the commercialization of art by moving his art far from the commercial system so that no one could mistakenly confuse the intention of the work. Instead, street artists and muralists are embracing these practicalities on a more consistent basis, which has made the distinction increasingly blurry at best.

EAST VERSUS WEST

Since contemporary graffiti originated in the United States, it's not surprising that the majority of texts on street art and graffiti focus on the Western Hemisphere. However, Asia holds half of the world's largest cities based upon population and has five of the top ten fastest-growing cities globally. This is an important issue and trend when the aim of this book is to consider street art from an international perspective.

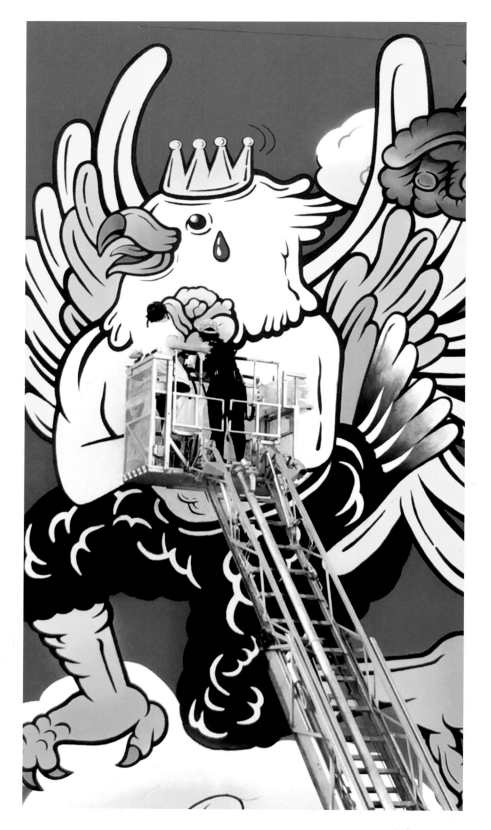

The influence of the West is apparent through imagery and stylistic decisions on the international scene, but it's not necessarily a simple read. Military conflicts between the East and the West have imposed certain cultural influences on some Eastern countries, while other Eastern countries have defiantly resisted these influences through their art. The relationship between East and West is complicated, resulting in some interesting street art in places such as Hong Kong and India.

The origins of modern graffiti are rooted in the United States as a creative outlet for the voiceless in major metropolitan cities. American films on graffiti in the 1980s and magazines featuring graffiti helped to spread the aesthetic trends within the American subculture. Graffiti was linked to hip-hop and punk subcultures, which disseminated ideas and concepts at a much faster rate throughout the 1970s and 1980s.

In the ensuing decades, graffiti became a global phenomenon rooted in particular cultures. The Eastern education system emphasizes rote learning and is often criticized for not nurturing creative expression. Graffiti in East Asia, according to Lu Pan in *Aestheticizing Public Space*, is more about challenging a hierarchical structure and the competition structure that is part of the social ethos. Proficiency in calligraphy or ideograms is a major aspect of becoming cultured in contemporary China and has a long history that is prized over other art forms. When graffiti was first introduced to China from the West, it was subsequently imitated, not out of lack of creativity but because of the deep way of studying signifiers and liberating them from their basic functions.

American pop culture has been exported around the world. Certain Asian countries integrated this culture seamlessly, while others resisted. For example, South Koreans resisted these cultural waves because their feelings toward the West were highly influenced by military presence. In comparison, the defeated country of Japan internalized American pop culture and, as Pan writes, "The American lifestyle . . . became the utopian image of modernity, democracy, and happiness."

The popularity of public art in creative centers and cultural hubs has also influenced the creation of street art and murals, to the ultimate benefit of these centers. Legal walls such as Japan's Legal

LEFT The Thai-Japanese artist Yuree Kensaku, based in Bangkok, is highly influenced by her surroundings, and there is a mix of Western and Eastern in her imagery. OPPOSITE Cranio comments on the importance of camera phones and social media in contemporary culture. In fact, most viewers see street art long after it's created (and sometimes destroyed) through a screen.

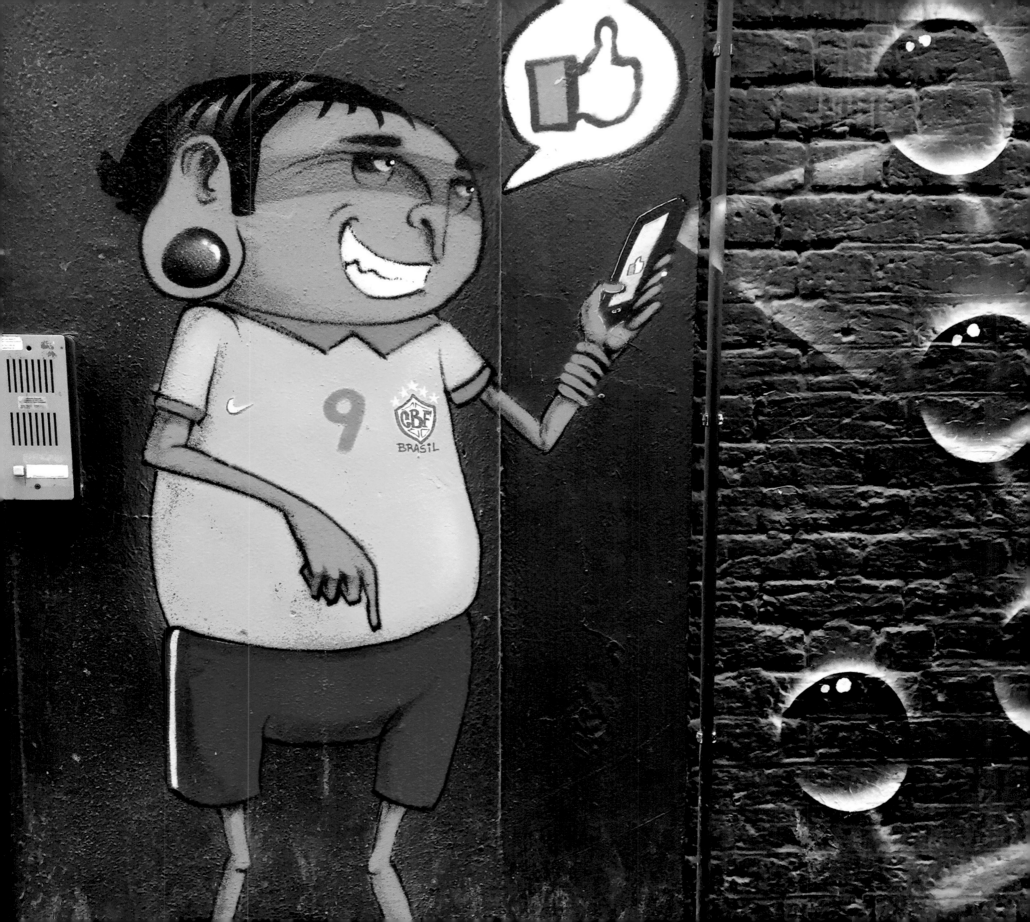

Wall Project and mural festivals, along with street art–friendly areas like the Roppongi Tunnel in Tokyo, have been created to energize and attract professionals in Asian cities. These developments are not much different from the mural programs held in cities like Washington, DC, where a commercial real estate firm, JBG Companies, facilitated the installation of murals to improve the marketing and sales of the company's developments. Street art in the East is distinct from that of the West, but the trend toward legal walls remains a consistent theme as street art moves closer to public art.

THE COMMODIFICATION OF STREET ART

The legitimization of street art seems to be the direction that many are suggesting for those working within the subculture—a transformation that is important but not always necessary when looking at the bigger picture. Press releases for new murals have become quite common. Sometimes the release is sent by the artist. In other cases, the company or store whose walls host the art send it to their customers and neighbors. In one discussion I had about street art, a woman became angry with me over the term *street art* and how this work should really be categorized as murals. The comment speaks to the "epidemic of muralism," in the words of street art artist Shark Toof, which has taken over much of the art world. Traditional artists have seen the exposure street artists and graffiti writers enjoy by having their work outside, and many have joined the ranks. Whether coming from the street art world or a more established art background, murals now meet between the subculture of street art and the larger professional art world.

From the illegal work installed in the public square to the murals facilitated by corporations, the romantic and pragmatic aspects of the street art world are well known. The popularity of the art form has birthed an entirely new set of galleries, print houses, art fairs, and brokerage firms that sell and profit from the work of street artists. These developments have been to the dismay of some, while simultaneously being celebrated by others. Historically, Keith Haring and Kenny Scharf embraced the practicality of making their work accessible in both price and form, much to the dismay of the art world. Yet the average person is much more likely to purchase a bad piece of clothing or a mug featuring the work of an artist than an original picture. This is partially because of the expense of originals but also because of practical reasons. These dilemmas raise issues of selling out and the idealistic views of many who enter the field of street art and why they become frustrated with their peers who maintain different views.

Street artists range from the romantic to the pragmatic, and this scale is helpful for understanding why some push toward legitimacy while other shy away from it.

ROMANTIC ————————————————— PRAGMATIC

The monetization of street art leaves many shaking their heads at what happened to this pure art form that needs public access in order to be properly understood. On one extreme sits the romantic artists, who do not believe in selling their work or in having any type of representation—or that profit is good for the cause. These artists create for the sake of creating. From their position on the romantic end of the scale, these artists believe that street art must be illegal. They hold an idealistic view of the world and do not envision the need for their work to be associated with institutional or monetary success. They do it for the love of it, which may mean that a particular political message, environmental concern, aesthetic, or social issue drives the creation and distribution. For these artists, the characteristic of their work being illegal is a core attribute, and their art must have a guerrilla aspect for it to survive and be defined in this manner. At the other end of the scale, artists who hold a pragmatic view of street art aim to make the work legal and protected. They seek avenues for their work to be recognized by the art world, albeit by using the public square as a place to view it. These artists may enter into partnerships with galleries and corporations to further their art, and they don't see these ideas conflicting with their role as street artist.

This spectrum creates tension within the street art community and brings up accusations of selling out, but it also gives (or grants) staying power to the term *street art* because of its malleability its and relevance to the issues within the movement and the genre of art making. The close association street artists maintain with the professional art world infuses street art with possibilities, yet also distinguishes it

Kenny Scharf, acknowledged by many as one of the grandfathers of street art, has long embraced the practicality of commercializing his creations.

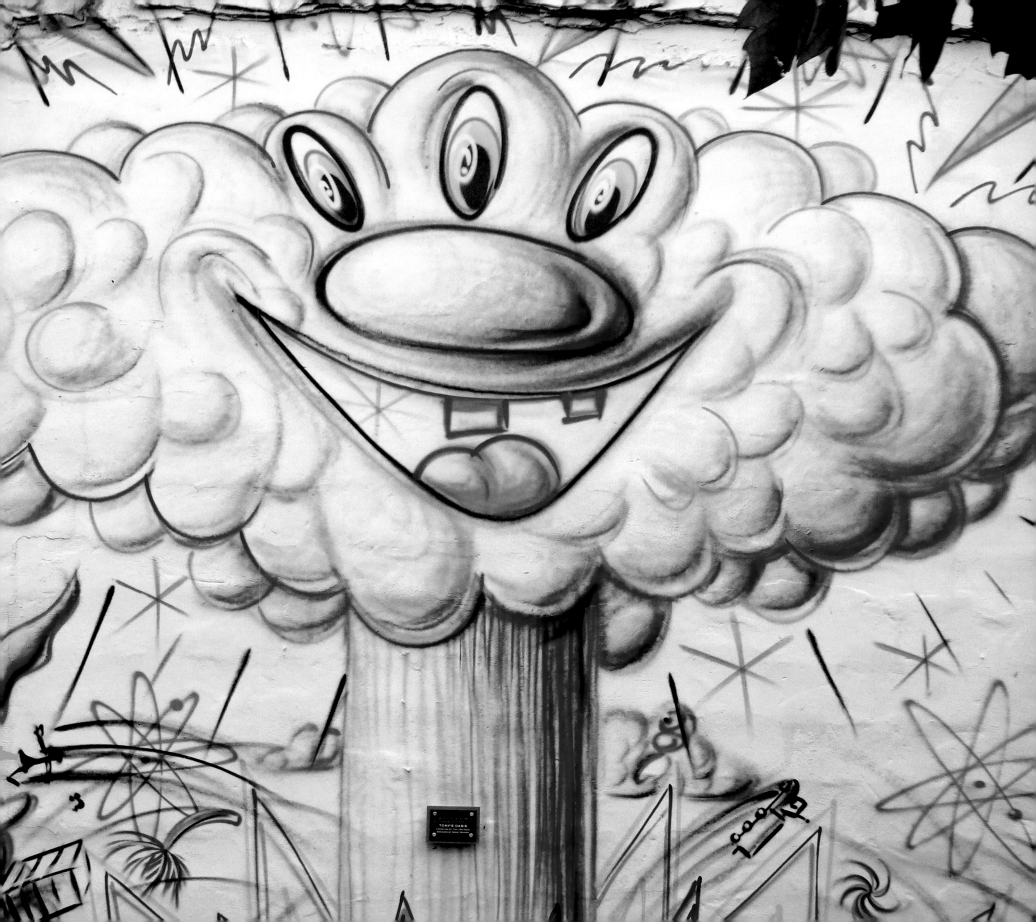

from graffiti. Many street artists are trained in the fine arts or a related discipline, which makes their explorations appear strategic in nature.

THE DIGITAL PUSH

One of the most impressive and telling indicators of street art's influence on pop culture is the Google Street Art Project. A number of influential and well-informed blogs and websites focusing on street art and celebrating individual accomplishments have emerged since the early 2000s. They have begun to establish a platform that allows for a serious contemplation and study of art in the streets. The Google initiative seeks to archive street art and to make images, tours, and collections of street art from around the world available via the web. This level of care and respect is typically shown for museum works. The digital preservation of works that are not expected to last sends a signal that street art is indeed an important and significant movement worth preserving and engaging in beyond the street level.

Furthermore, the role of social media has been incredibly important for the rise in popularity of these art forms, bringing them to the attention of an audience that is far larger than the physical location of the work would ever enjoy. Despite the importance of photo-sharing sites like Instagram and Facebook and the many important blogs, the power of Google to document without having a particular agenda and the ability to archive images on a large scale are significant achievements for increasing the accessibility of street art. Although it may be too early to determine the usefulness of Google Street Art toward these ends, the program has altered the recent history of street art.

The audience for street art and the accessibility of the art form are due in part to its location in the streets—in shared public spaces. In some cases, hundreds of thousands come across street art because of strategic placement. Yet social media, blogs, and other online platforms for sharing artwork have far exceeded the very best physical location and have opened up artwork to the information superhighway, where these works can exist far beyond their temporary life.

Plastic Jesus (top) and Banksy (bottom) actively use new types of media to share their work and capitalize on influential networks.

The Internet is, to a population obsessed with celebrity and the need to be famous, key to taking you anywhere. These are important characteristics and not unfair to apply to many in the graffiti and street art world, since their acts are rooted often in a selfish desire to become well known.

Methods for making artwork go viral are in abundance. This has nothing to do with the quality of the work. These methods are just ways for artists to get their work seen and published in as many formats as possible. Plastic Jesus, a street artist based in Los Angeles, has mastered the formula. His timely and provocative installations are conceived to correspond with popular culture events and stories that are already in the media forefront. His sculptures mocking drug use alongside the Academy Awards and his jab at useless technology were instant viral hits.

Plastic Jesus says, "Social media has been a huge influence on the reach of my work. A traditional piece of street art may get viewed by a few hundred or maybe even a few thousand people on a daily basis as they pass by. However, with the correct use of social media, I've been able to bring my work in front of millions of people. A piece on the street will be noticed and connect only with those who have an interest in street art. By using a hashtag on a social media post, I've been able to target an audience that generally would not see my work. For example, one piece about credit and debt I would hashtag 'bank,' 'debt,' 'money,' 'credit card,' and so on. A piece about drugs I hashtag 'drugs,' 'rehab,' cocaine,' 'addict,' and by doing so I have been able to target a very untraditional audience for my art. Once a piece starts connecting with a specific audience, I have found they are very likely to repost it, as some kind of 'badge of honor' for being the first person to find the post."

In 2013, Banksy announced that he would be taking an artist residency in New York City during October, a hilarious circumstance. An artist residency is an award that often involves a change of location and the creation of a new body of work. Banksy called the series he made during his residency Better Out Than In, and used social media to promote and guide viewers to his new artworks every day for an entire month.

Ironically, Banksy began planning for the residency much earlier, making it more akin to an art show, since each work was created in advance. He even developed an audio guide that viewers could call to hear funny interpretations of his works on the street. The initial response was overwhelming. Once the locations of the works were discovered, throngs of fans arrived at the various locations to take pictures, pose with the work, and share their photos online. The process was similar to a scavenger hunt, with players calling themselves Banksy hunters. The domino effect was glorious, as the media attention, number of followers, and energy around the residency built with each subsequent day.

Living in Los Angeles, I was removed from the events, but the online coverage and messages from friends hooked me and made me feel involved. I could imagine fighting the crowds to get a shot of the truck with a waterfall installation inside. I grew angry when taggers felt the need to go over a fresh work as fans lined up to see it. I was frustrated with the men in Brooklyn charging $20 to see a work in their neighborhood. And my heart broke when thousands of people missed an opportunity to purchase an original Banksy work from a stand outside Central Park. Even by viewing the entire series online, I became emotionally involved and engaged with the works and the surrounding energy.

Nothing compared to discovering a new piece each and every day. It was often the first thing I did after waking up. Banksy would post a photo, and a few minutes afterward someone would find the location. By mid-afternoon, there was likely a story or drama associated with it. All too often, that involved someone trying to destroy the work or use it for profit.

The Banksy residency was interesting and fun, and the role of social media was illustrative of how experiencing art has changed. But nothing beats seeing the work in person, as evidenced by fans who rushed to the locations. Nevertheless, the online experience was satisfying, and part of that involved the payoff for the time invested. Little was sacrificed, and I was able to tap into the emotions and aesthetics without a large investment of money or time.

On the other hand, New Yorkers experienced something different. They invested time and enjoyed the fellowship of like-minded fans of art, as well as the chase that fueled their experience. This set of circumstances required a lot of time and dedication, which transferred into their experience. The online viewing experience is shallow and relies on the experiences of others to fully engage the viewer. Understanding a work of street art is more than looking at a picture of the work. The engagement with the work is what needs to be communicated for it to transfer well.

At this point in the history of street art, some work is only available online. The work of Insa is perhaps the best example. The artist calls

his work Gif-iti, and he uses an optical art aesthetic (à la Bridget Riley from the 1960s) that involves lots of black-and-white lines and shapes. The artist paints the entire side of a building, utilizing these twists and turns to create a somewhat benign image. He then repaints the entire wall, slightly shifting the colors and forms. After each thorough paint job, a digital image captures the progress. The result is two or three images that are edited together to create a small piece of animation. The black-and-white lines move when the work is viewed on the Internet and become a fun visual trick, mainly because of the novelty. Otherwise, when not viewed online, the work is a still, decorative image.

The digital push represents an extension of the work of street artists that goes beyond the physical object. The videos, photos, and cutting-edge strategies that reach out into the virtual world simulate engagement with the art that is tailor-made for our consumption of visuals through social media and the Internet.

POSTMODERN CONDITIONS FOR STREET ART

A number of significant shifts in the art world over the past century have brought enormous change in how art is made and experienced. These shifts have facilitated and broadened the consumption and appreciation of street art, from art as paint and sculpture to art being a concept and breaking free of physical description.

The concept of what art is plays an important role in the way we understand street art. Art developed from being a craft discipline in ancient civilizations to today's highly specialized areas of the visual arts. The skill of painting or sculpture was not valued any higher than a learned trade in ancient civilizations like Egypt, Greece, and Rome. Then, in the sixteenth century, during the Renaissance, the modern idea of the artist as someone who has a special talent that is different from a learned trade was born. This was quickly followed by the establishment of art schools and academies designed to house and teach this specific knowledge.

The period from the mid-nineteenth to the mid-twentieth century is typically referred to as modern. Anything from the mid-twentieth to the present is contemporary. As we look at a time line of art history, the modern era was a break from the realism propagated by academies of art around the world. This is where we see artists challenging conceptions of how art should be made and what the final product should look like. They began to abstract the human form and explore alternative ways of representing reality. Ideas like abstraction and expressionism were developed and found support.

Modernism ran its course through many movements, including impressionism, cubism, and abstract expressionism, until halfway through the twentieth century. Each successive movement built upon or reacted to something that preceded it. The result was a series of isms that drove art making and what we consider art far beyond a basic definition of drawing and painting in a realistic style to media like light, performance, and conceptual art, among many other forms.

Postmodernism, the era that follows modernism, and those who work within this philosophy challenge the chronological and orderly aspects of modernism. This era, which begins in the second half of the twentieth century, sees the art world as broken. Therefore, artists do not want to chain themselves to the past and instead refer to art history through appropriating and sampling images that may have no historical connection or context. The decentralization of the art world from major city centers has been a positive development for postmodern artists. The importance of locations like Paris in the nineteenth century and New York City in the mid-twentieth century has lessened with postmodernism, and there are artistic centers in small cities and countries that were overlooked in modernism. Artists no longer need urban areas to sustain their careers and do not subscribe to the romantic ideals of many mid-century artists who toiled away in their studios as solitary geniuses. However, cities have been significant places for the development of graffiti and street artists. The context of the urban area has been central to the development of street art. The emphasis on location changes the way the art is interpreted, since the work is site specific and does not exist in a white gallery that is interchangeable.

The concept of post-museum art, developed by Nicholas Alden Riggle, rings true because street art brings together art and life and meets us where we live our everyday lives. We recognize it as art without the context of the gallery. This is a particularly important point for determining what constitutes street art. We know it's street art at the gut level and can recognize it without the gallery context. The history of modern and contemporary art has taught us the importance of the gallery space, and we use this as a marker to determine when a Brillo box is a work of art and when it is something you buy at the grocery store.

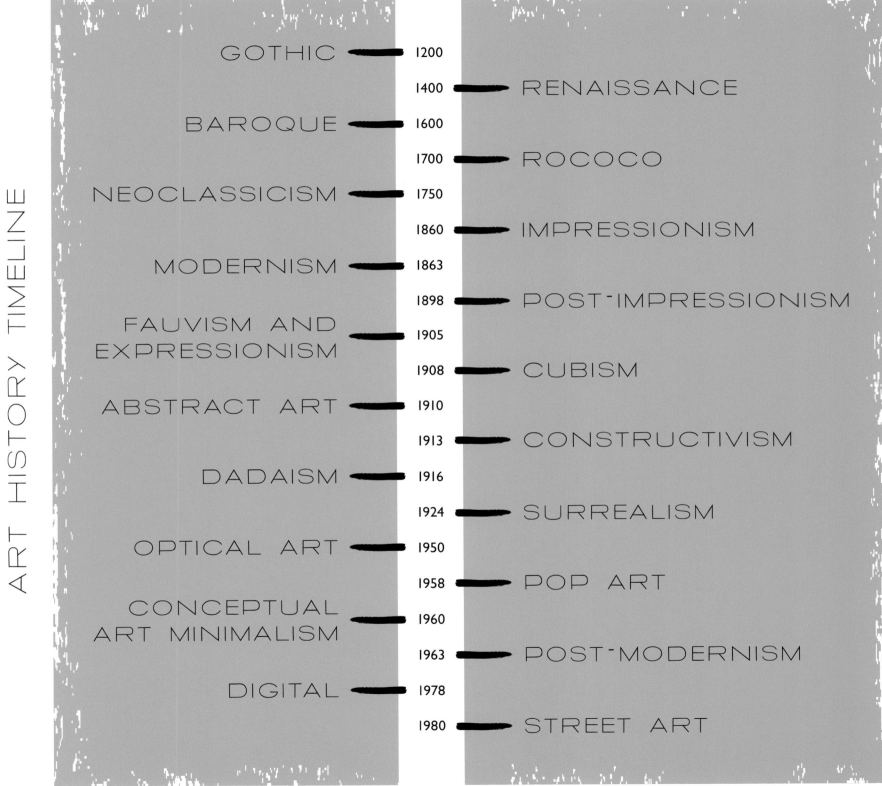

ART HISTORY TIMELINE

GOTHIC — 1200

1400 — RENAISSANCE

BAROQUE — 1600

1700 — ROCOCO

NEOCLASSICISM — 1750

1860 — IMPRESSIONISM

MODERNISM — 1863

1898 — POST-IMPRESSIONISM

FAUVISM AND EXPRESSIONISM — 1905

1908 — CUBISM

ABSTRACT ART — 1910

1913 — CONSTRUCTIVISM

DADAISM — 1916

1924 — SURREALISM

OPTICAL ART — 1950

1958 — POP ART

CONCEPTUAL ART MINIMALISM — 1960

1963 — POST-MODERNISM

DIGITAL — 1978

1980 — STREET ART

POST-STUDIO ART

The term *post-studio* is a particularly interesting one for graffiti and street artists and fits within the postmodern era. The concept of post-studio art can be traced to a number of individuals who practiced a type of art that devalued the role of the single stand-alone studio as central to art making. Andy Warhol's Factory; John Baldessari and his forward-thinking curriculum at CalArts; Carl Andre, who called himself a post-studio artist; Nancy Holt's earthworks; and even Robert Smithson, who claimed the studio confined his work—all were important contributors to the demise of the traditional studio practice and how street artists operate around the world.

In the twenty-first century, artists rarely make work in one single location. Since the mid-century era, the academic notion and modern practice of the artist retreating to his or her loft have slowly receded. Wouter Davidts and Kim Paice, in *The Fall of the Studio Artist at Work*, address the conventionality of the studio and its loss of relevance since artists began to question many of the assumptions in modern art production and distribution. Artists in 1960s who were the leaders of this movement saw the studio as a type of bondage that hampered creativity. An example might be the limitation of a door frame and how something so simple can restrict the size of art produced. This bondage or limitation may include traditional materials of art making. Sculpture and painting have been the anchors of art production throughout history. During the mid-century's explosion of new media, many types of materials were added to the artist's arsenal, including use of the landscape as a medium.

For street artists, the physical location of the studio is outdated because of the specific context of their work. Working on walls, they adapt and change their processes depending on the environment. There are a few exceptions, where street artists devise, plan, and

BELOW LEFT Drew Merritt portrays Andy Warhol, who was significant in moving modern art into the postmodern era. Below RIGHT The concept of post-studio art fits the characteristics of street artists who adjust their process and product based on the context in which they make art. OPPOSITE Street art festivals in cities like Bristol in the United Kingdom attract street artists to paint in sanctioned and unsanctioned parts of the city and the surrounding areas.

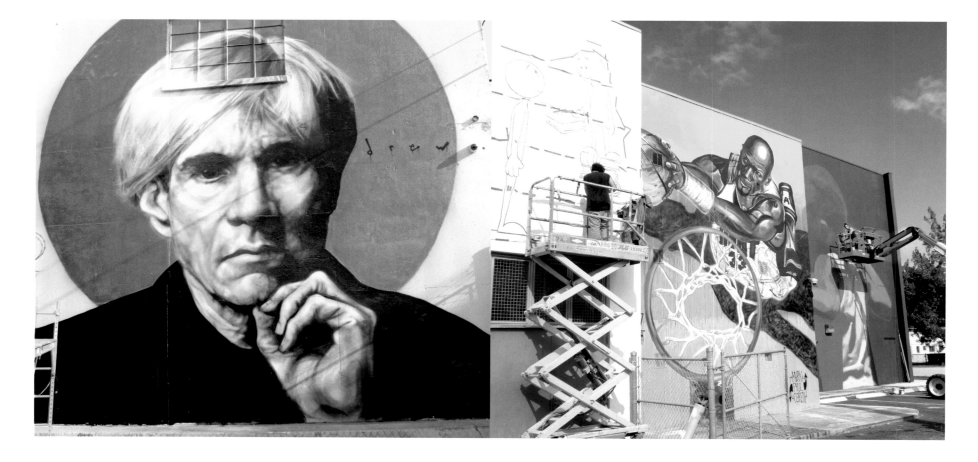

produce the work in a studio and then apply the design, like wallpaper, to a wall, analogous to an installation. However, the majority of artists featured in this book must create and execute their work on-site. This does not mean a lack of planning beforehand—only that the specific concept and location allow the artist to produce work that would be unimaginable in another era.

LOW TO HIGH

The idea that forms of art are deemed low or high seems ridiculous in the twenty-first century, especially given the postmodern perspective. These artificial barriers do exist in some circumstances because high art has become part of the vocabulary of the cultural elite, by and large the wealthy and educated. In more academic and historic terms, it's the art of aristocrats and the intelligentsia, a subset of society defined by social class and economic status. This is the art we see in museums and galleries and the art taught within the university context.

Low art, in contrast, typically refers to products of pop culture and entertainment. The term is used in a derogatory fashion because of the mass appeal these products have with the general public. The accessibility means they are understandable and typically in great supply. People who are swayed by these objects are deemed anti-intellectual, and the term *philistine* is used to describe their limited and uneducated perspective. Graffiti and street art are thrown into the low art category more often than not when discussing these art forms.

However, the resurgence of interest from galleries and museums in graffiti and street art around the world has made this low/high art debate much more interesting. Historically, graffiti and street art have not enjoyed the distinction of being deemed high art because they're accessible, use familiar imagery, and take place outside learned institutions.

Historian Martin Irvine, in "Work on the Street: Street Art and Visual Culture," writes: "Art world institutions prefer their avant-garde arguments and institutional critiques to be conducted intramurally within established disciplinary practices. Even though no art student today experiences art and visual culture without a knowledge of street

art, most art school programs continue an academic platform invested in playing out some remaining possibilities in a postmodern remix of Performance Art, Conceptual Art, Appropriation Art, Institutional Critique, and conceptual directions in photography, film, and digital media. Critics, curators, and academic theorists now routinely discuss art forms that are 'post-medium,' 'post-studio,' and 'post-institutional,' precisely the starting point of street art."

While we can agree that low and high art are different and that the connotations of each seem unlikely to change, it can be argued that the low art label is no longer a quality judgment. Rather, it's a cultural perspective that does not signify good or bad. High art is not necessarily more important than low. With street art and graffiti, there may not be any formal or productive difference between low and high. The difference is an artificial divide created by folks within the arts (curators, academics, collectors, and gallery professionals) and the institutions they represent. From the low art perspective, graffiti and street art challenge the status quo of the art world, including its institutions. The distinction between the two allows for further conversation about whether these borders are still relevant, especially since lowbrow artists are invited inside these institutions to curate, exhibit, and showcase what makes their work relevant and exciting. The public has responded to these presentations in force by expressing their approval with record-breaking attendance.

STREET ART FESTIVALS, FAIRS, AND MUSEUMS

Street art festivals and fairs have become more popular around the world. This is partially due to trends in art world economics that have challenged traditional methods for exhibiting and selling art. From blue chip fairs like Art Basel to lesser-known varieties, an increasing number of art sales, according to *Forbes*, are happening at fairs. A report validated by the *Art Market Monitor* shows sales increasing from $8.3 to $13.3 billion between 2010 and 2016. This turn of events is great for the art market, but can have a negative effect on brick-and-mortar galleries.

In 2015, Street Art Fair International hosted its first event in Los Angeles. The rented building featured hundreds of artists, dozens of galleries, and a number of events and performances—in the only fair dedicated to the movement. The establishment of such an idea seems logical, based on the success of international art fairs. Art Basel, Frieze,

Artissima, NADA, VOLTA, Untitled, Scope, and LISTE, among others, have provided an alternative to the context and experience of the traditional gallery for art to be seen and purchased. Utilizing a similar platform, the street art fair demonstrates that there is a distinct audience for this work. However, though the fair platform is successful, it does not exude the essence of street art as something that exists outside.

The street art festival, unlike the street art fair, appears to capture the ethos of street art in a way that's closer to the intent of its practitioners. Street art fairs feature work inside, and the art is limited to traditional canvas, sculpture, and gallery-oriented work. In contrast, the festival format encourages artists to work outdoors and create pieces that cannot be bought or collected. These works exist in the public square and maintain some of the tenets of what connotes street art.

These festivals are international in scope: Open Walls in Baltimore—the Nuart Festival in Stavanger, Norway; the Mural-ist Festival in Istanbul; the Urban Forms Festival in Lodz, Poland; and Latido Americano in Lima, Peru. They give artists many opportunities to bring their work to international audiences and demonstrate the wide appeal of increasingly universal imagery.

Similarly, music and art events—such as the Life Is Beautiful Festival in Las Vegas; the Bloop Festival, held on the Mediterranean island of Ibiza; and the Meeting of Styles in Copenhagen—feature a mix of music and public art installations and attract large audiences. In a similar vein, the Coachella Valley Music and Arts Festival in California draws thousands of people to the desert each year for concerts and large public art installations. The music and the festival experience are the major appeal. The art installations and even art sales are part of the contagious and invigorating excitement, though this enthusiasm can cause the low quality of the work to be overlooked.

The large number of people in confined spaces at these music and art events perfectly suits artists who desire exposure. Work that depicts a recognizable icon or refers to music becomes instantly nostalgic and pulls on the heartstrings of the dedicated music fan or new art collector. The experience and the art do not necessarily equate, but they are hard to separate. In other words, the art becomes a background for selfies and soundtracks.

The few efforts to establish street art museums include sites in St. Petersburg; Berlin; and Amsterdam. The Street Art Museum Amsterdam, located just outside the city center, has no walls. Nor is it accredited by an

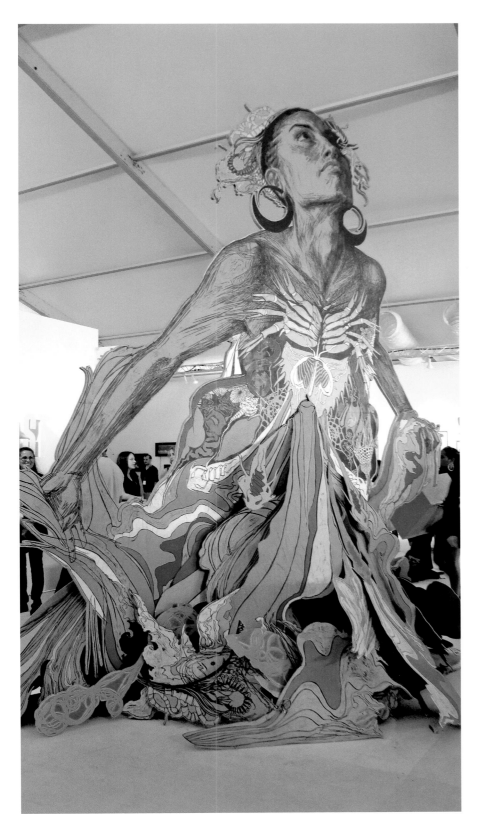

association. Founder Anna Stolyarova is an excitable middle-aged woman without a degree in art history or any museum training. Originally from the Ukraine, she has built something significant based upon her passion for street art. A former office worker, she decided to give up her humdrum life and follow her passion to create something new.

The museum is carefully curated and organized on the greens of the Geuzenveld-Slotermeer. Dozens of murals and installations have been facilitated by the nonprofit. The purpose of these works is twofold. First, the museum has a conceptual agenda—to highlight and engage the history of muralism and connect it with contemporary practices in graffiti and street art. Second, it uses these public artworks to highlight the history of the city and engage residents and visitors. The museum fulfills both civic and educational purposes. Many artists trave l far to take residence in Amsterdam, and many local volunteers run tours and help support large projects.

The street art museum is a bold concept that may be a difficult model to maintain, due to the limitations of the natural environment, the pressures from private developers, and the expense of maintaining work on the exterior of buildings that are always in a state of decomposing. Yet these sites also attract many visitors and encourage neighborhoods to reinvest in their communities. The fairs and festivals have positive aspects to offer the field of street art, but the professionalism involved in these ventures helps push the movement farther away from the romantic ideals needed to qualify it as street art.

ART BASEL: WHERE AN ART MOVEMENT COMES TO DIE

Comedian Lenny Bruce said that Miami is the city where neon goes to die. Hardly a cultural capital, Miami is known for a lot of things, but art is not one of them. Boasting beautiful beaches, warm weather, and a reputation for nightclubs, it is a popular tourist and vacation spot, especially for folks fighting the frigid temperatures in other parts of the world. Yet this seemingly fun beach city now experiences an unusual amount of attention from the art world over the course of a concentrated week of exhibits,

The street artist Swoon created a large installation inside SCOPE Miami Beach in 2014.

fairs, parties, sales, and glitz. How Miami became a hotbed for street art was a dynamic process involving a number of institutions, forward-thinking individuals, and community support, all of which have positioned the city as the largest outdoor public art space in the world.

Art Basel is the behemoth that started the art buzz in Miami. The company, which bears the same name, is an independent organization that stages art fairs around the world, in Basel, Switzerland; Miami Beach; and Hong Kong. The organization was founded in 1970, and the first decade of fairs took place in Basel. The Miami Beach edition, introduced in 2002, has grown in influence with each subsequent year. The world's very top galleries, catering to a clientele with extremely deep pockets, are represented at the fair.

Private planes descend upon the Miami airport by the dozens in anticipation of VIP previews, private parties, and corporate events. Celebrity sightings abound as the week progresses and the glamour of the event amps up. The 250 art galleries from around the world, representing the top tier of exhibition spaces, draw close to 70,000 visitors over the week at the main fair. While Art Basel may be the

center of this activity, dozens of satellite fairs have followed all around Miami, extending the art fair vibe.

The week of Art Basel has become much more than one fair. There are more than twenty major fairs independent of Art Basel, and they will increase in number as long as the economy continues to improve. Some fairs are traditional, while others are edgy. The combined effort makes for a wonderful spectrum of the international art scene. Galleries don't bring crap to art fairs. Instead, they present their very best, which is the reason to visit Miami in December. This is a chance to see some of most outstanding art being made right now.

A few miles from the epicenter of Art Basel sits the depressed neighborhood of Wynwood, Florida. Located just outside the center of the city, it's an area of Miami with humble origins and typically is known as a working-class community. In the 1970s and 1980s, the neighborhood experienced significant decline as unemployment and crime were on

How and Nosm painted a large piece inside Wynwood Walls, a quasi-open-air gallery that complements the late Tony Goldman's goal to transform the warehouse district of Wynwood in Miami.

the rise. The gentrification of Wynwood started in the 2000s, and Tony Goldman of Goldman Properties played a big role in this development.

The Goldman family purchased several buildings over the years and fulfilled their dream of facilitating an open-air art gallery of murals. A host of new businesses and monthly art walks complement the visuals. The energy is heightened each year before and after Art Basel in December. The current property features an art gallery, several restaurants, and gallerylike installations. The biggest names in the graffiti and street art world have painted various sections of the property.

From the commissioned walls in the center of the Wynwood area to renegade graffiti and street art on the outskirts of the community, the influence of the Goldman family's original idea has spread like a virus. Every December, the very best graffiti writers, street artists, and muralists from around the world descend on the city for art shows and events—and to create outside. In 2015 you could spot popular artists like Shepard Fairey and D*Face painting around the block from Fin Dac and Herakut. The confluence of so many artists working at the same time sent the smell of spray paint wafting through the streets and attracted gawkers by the thousands. The activity was contagious and felt like a street fair on acid. The buzz started on the walls, extended into the gallery spaces and restaurants, and held up traffic for miles in every direction. The amazing display of creativity was nothing short of inspirational and awe-inspiring.

Despite the economic boom that Art Basel provides residents and businesses of Miami, the city still wrestles with a divide between the economic classes. Local writer Andrea Torres noted in 2014: "Never is the wide gap between the rich and poor more obvious in Miami than during Art Basel week." The glamorous parties hosted by wealthy collectors and celebrity guests even rival the art, so that one wonders what the week is all about anyway—something writer Felix Salmon calls an "orgy of luxurious excess." The divide between the outrageousness of Art Basel and the plight of the average citizen highlights the appeal of the Wynwood Walls. The accessibility of the art and its availability on the streets make it, in philosophy, an exciting project unlike any other around the world.

LET'S THINK TOGETHER ABOUT STREET ART

As an art critic and writer, I acknowledge that art criticism and writing on art have changed dramatically in the late twentieth and early twenty-first centuries. The insight, judgment, and interpretation by critics and writers contributed significantly to the reception of and public engagement with works of art. The influence of their words can be debated, but they became part of an evolving understanding of artwork and artists. James Elkins writes in *What Happened to Art Criticism?*—"Art criticism is in worldwide crisis. Its voice has become very weak, and it is dissolving into the background clutter of ephemeral cultural criticism."

This worry for what art criticism has become is redeemed for me through street art. While critics now function as quasi promoters, public relations specialists, bloggers, curators, and gallerists, the idea of someone contributing intelligent and thoughtful dialogue has been pushed to the side for a fast-paced lifestyle that embraces the attention span of a social media post. Street art, much like most of the art world, has blurred many boundaries, including art becoming closely associated with entertainment. The abundance of relational aesthetics, which invite the viewer to participate in works of art, signals the importance of engaging an audience with art rather than seeing them taking pictures in front of it.

Art typically involves substance and prolonged engagement, whereas entertainment, while holding the attention of an audience, provides pleasure. The great thing about street art is that it both captures viewers' attention and offers pleasure—and, when done well, can provoke intense engagement and prompt insightful reflections. This depends upon the viewers. They can be led to the art, but that does not mean they can be forced to think about it.

The enthusiasm for street art is contagious. Lines are packed outside exhibits featuring well-known street artists, and festivals are booming in popularity. Articles and social media provide exposure for work of both high and low quality, and social media platforms, magazines, and galleries help fuel the hype. This excitement appears to be equally matched by a lack of critical discourse and judgment.

The work is described as strong and impressive by a fan base that has little experience in the arts. This is coupled with art criticism that has moved further from judgment. The combination leaves little room for dialogue that has potential for deep thinking. At this time, the advice from the late Paul Arden, author and creative director for Saatchi and Saatchi, should be heard: "Do not seek praise. Seek criticism."

Part of the joy of street art is that everyone has a voice and the best and worst can exist side by side. I appreciate that anyone can fly to Miami and be part of the excitement of Art Basel. One does

not need a VIP pass (although there are inner circles where one is required) to paint on the walls of the city. This is an issue raised by critic Dave Hickey when he said that there is a "democracy of the streets." Essentially, this means that the very best works survive in the public square. Higher-quality works tend to last longer than pieces of poor quality because the best are protected by and respected in the community. Street artists are less likely to cover up a strong painting, and a neighborhood may embrace certain works because of their relevance. This is true for both legal works (murals) and illegal works (street art). The abundance of self-referential public works—works that only draw attention back to the artist—is troubling, absent of any knowledge or interest by the surrounding community. Regardless, the field moves forward despite the lowest common denominator, and the strongest can and often do survive.

What we can learn from criticism is that good description leads to better understanding of artworks, rather than pointing back to the critic. Individuals do not see the same thing when viewing artworks, and the purpose of critical dialogue furthers an understanding of the artworks being viewed. While a viewer may be wowed by a work of street art, the lasting impact is whether the work is worth revisiting and whether there is more to engage with each subsequent visit, something that can be done through personal interaction but also through photographs and print reproductions.

Critical discourse is essential in the arts. Meaning is derived from conversations between individuals about works of art, and new perspectives are explored and discovered through this process of dialogue. The influential mid-century journalist William Knowlton Zinsser wrote, "Whenever I listen to an artist or an art historian, I'm struck by how much they see and how much they know—and how much I don't. Good art writing should therefore do two things. It should teach us how to look: at art, architecture, sculpture, photography and all the other visual components of our daily landscape. And it should give us information we need to understand what we're looking at."

The mass appeal of street art globally is a positive direction both for the art and for art audiences. I am hopeful that the accessibility of the work and the enthusiasm within the field will bring about deeper and more prolonged looking. Going forward, let's agree to talk about the work. Let's debate its quality and challenge each other to look closer at the exciting developments in the arts. Street art is more than a movement or era—it's a way to engage the world.

This smart stencil by an unknown artist captures the reflective stance one must maintain to engage the visual world in an intelligent manner.

REFERENCES

Bowen, Tracey. "Graffiti Art: A Contemporary Study of Toronto Artists." *Studies in Art Education* 41, no. 1 (1999): pp. 22–29.

Davidts, Wouter, and Kim Paice. *The Fall of the Studio Artists at Work.* London: Antennae, 2009.

Farris, Lynley. "Challenging Conceptions: The Fine Art of Graffiti." MA thesis, Missouri State University, 2005.

Gablik, Suzi. *Has Modernism Failed?* New York: Thames and Hudson, 1984.

Gastman, Roger, and Caleb Neelon. *The History of American Graffiti.* New York: Harper Collins, 2010.

Irvine, Martin. "Work on the Street: Street Art and Visual Culture." *In The Handbook of Visual Culture*, edited by Barry Sandywell, 235–278. London: Berg, 2012.

Lennon, John F. "Trains, Railroad Workers, and Illegal Riders: The Subcultural World of Hobo Graffiti." In The Routledge Handbook of Graffiti and Street Art, *edited by Jeffrey Ian Ross, 48–60.* New York: Routledge, 2016.

Mac Donald, Heather. "Radical Graffiti Chic." *City Journal,* no. 21 (spring 2011): Retrieved from https://www.city-journal.org/html/radical-graffiti-chic-13369.html.

Pan, Lu. *Aestheticizing Public Space: Street Visual Politics in East Asian Cities.* Bristol, UK: Intellect, 2015.

Phillips, Susan A. "Deconstructing Gang Graffiti." In *The Routledge Handbook of Graffiti and Street Art*, edited by Jeffrey Ian Ross, 27–35. New York: Routledge, 2016.

Riggle, N. "Street Art: The Transfiguration of the Commonplace." *The Journal of Aesthetics and Art Criticism* 3, no. 68 (2010): pp. 187–191.

Ross, Jeffrey Ian. "How Major Urban Centers in the United States Respond to Graffiti/Street Art." *In The Routledge Handbook of Graffiti and Street Art*, edited by Jeffrey Ian Ross, 393–403. New York: Routledge, 2016.

Schacter, Rafael. "Graffiti and Street Art as Ornament." *In The Routledge Handbook of Graffiti and Street Art*, edited by Jeffrey Ian Ross, 141–157. New York: Routledge, 2016.

Schwartzman, A. *Street Art.* New York: Doubleday, 1985

Stahl, Johannes. *Street Art.* Nyack, NY: Ullmann, 2009.

99% OF PEOPLE WILL NOT NOTICE THIS

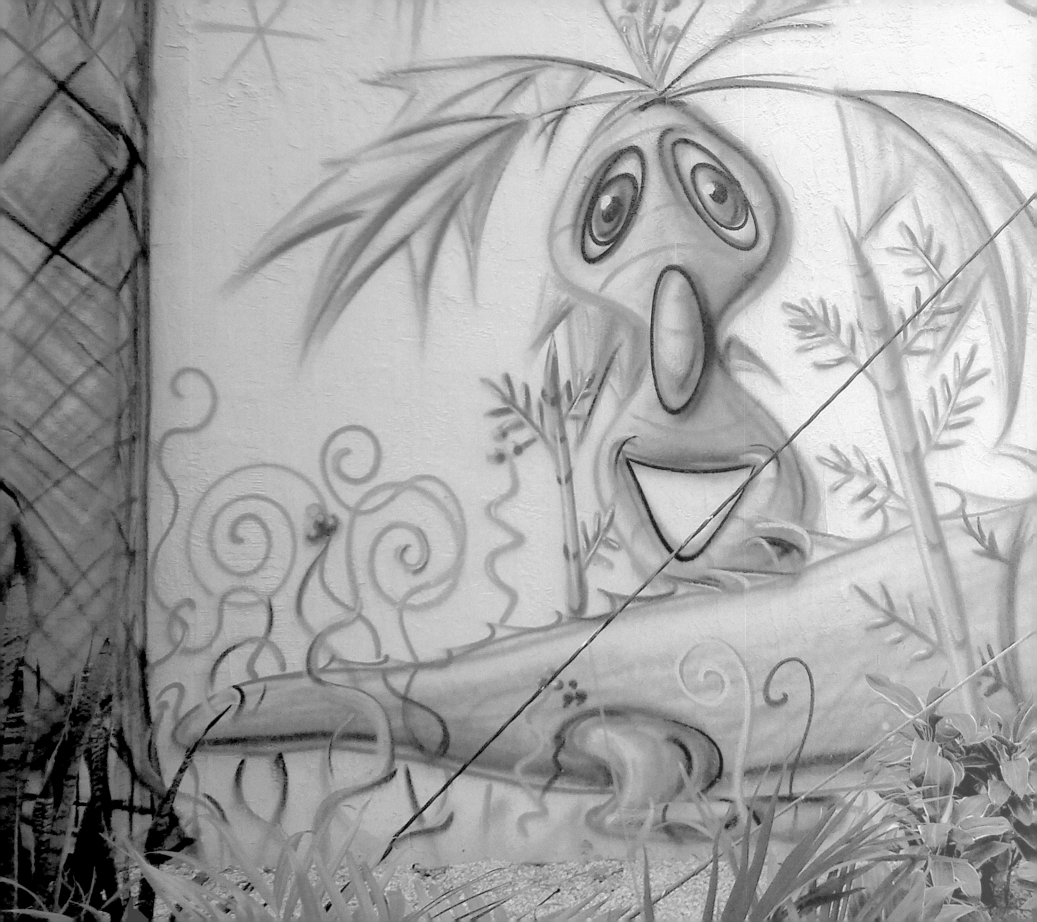

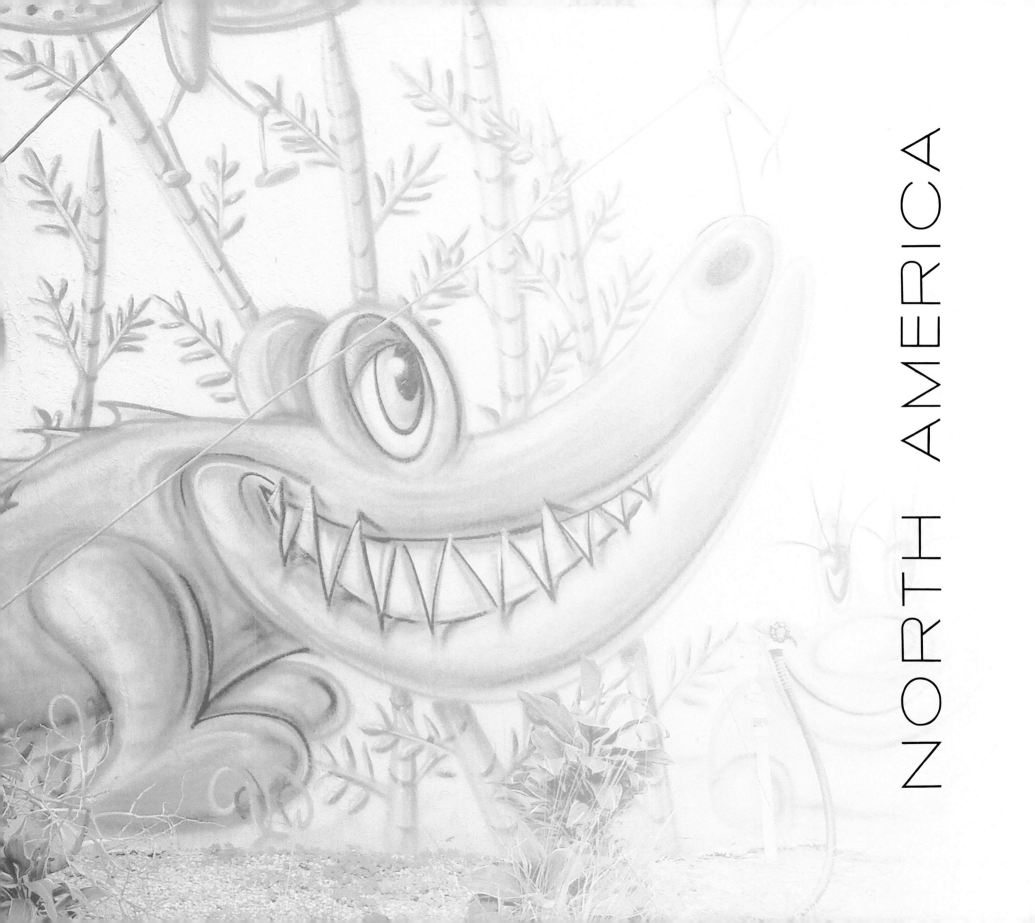

NORTH AMERICA

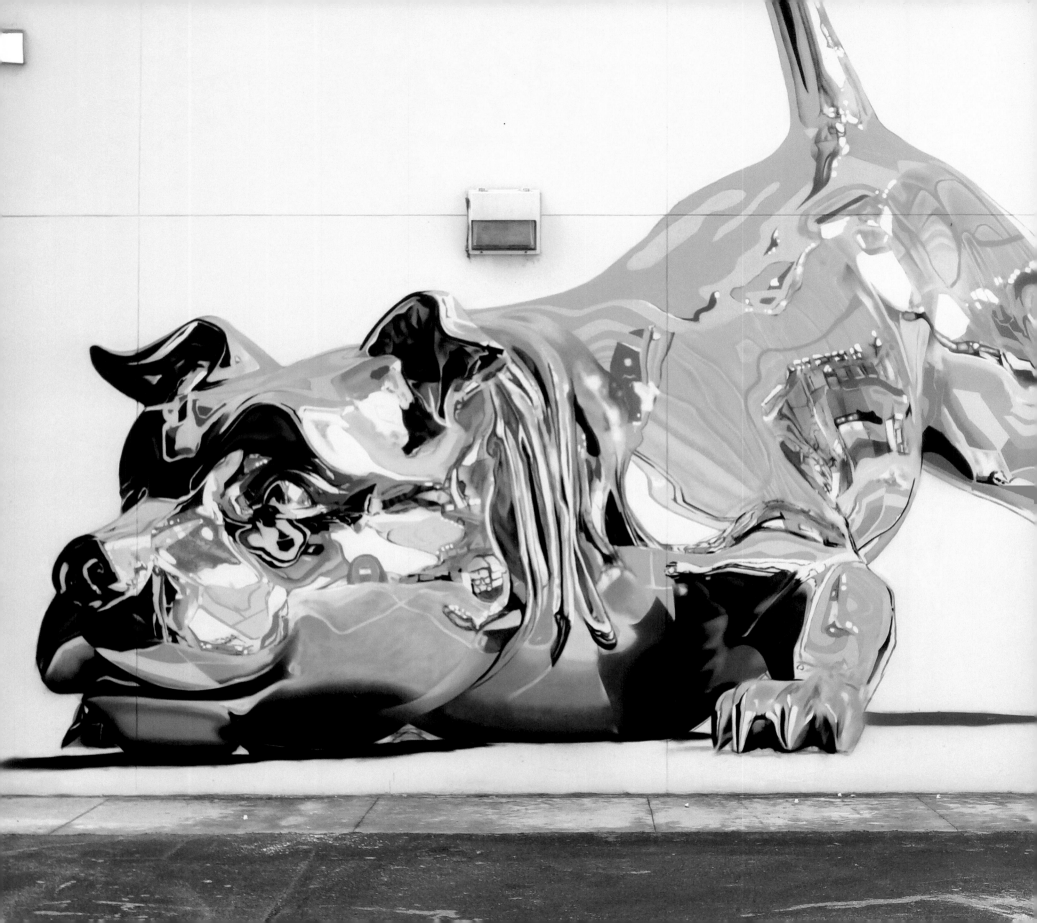

NORTH AMERICA

Fielding the North America section in this collection, you should expect some visual bullet points on the dichotomy of street art and graffiti, the politics of public space, and transgression and subversion. We could address the commodification, the galleries, the hype market, superstars, branding, ephemera, and a widened definition of the term *street art*.

In an academic approach, we could discuss how snugly street art fits into post-structuralist concepts or how a semiotics tool set would benefit the investigation and appreciation of the genre. It deserves scrutiny as much as praise, but in the fervor to fill in the street art diagram, we begin to obscure the unassailable core merit of street art. The one quality that the writers, the painters, the printers, the pasters, the stencil cutters, the knitters, and the tinkerers have in common. The secret sauce that makes this arguably the most relevant contemporary art form. Moxie—the audacity of street art. The punk it takes to get up, go out, see it through, and put a dent in your city.

From the visual one-liners to the massive mural, from the humble tag to the elaborate installation, street art has widened the definition of art along with its accessibility and audience through sheer abandon and fearless impudence. Street art injected the unadulterated fix of an alley pick-up game into an otherwise members-only club sport. Street art has changed how art is experienced; it changed the demographics of art, changed the relationship with the spectator and, to some extent, the role of art itself. Nobody had told you that it is okay to break the rules until street art came along and just did it.

It's because of street art that art as such is no longer an abstract concept. That the very idea of art is not sequestered in hallowed halls and curated collections, but is a tangible part of the cityscape and everyday life, breathing, cocky, and impertinent. Above all, it's about people who engage with the street and fill it with meaning, and the collective surrender before the might of the vandals.

Since you're reading this book, you are already well through the looking glass, and I salute you for it. You chose art in your life. You made that fickle beast your companion. You chose to look to art for guidance and inquiry. You chose to poke, provoke, and leave your mark. You were brazen enough to ask the hard questions, nail-biters such as "How shall one live?" and "What can go wrong?"

Street art is at its best when it's the rowdy friend under your academy dorm window, asking you to come out and play—you know you should study and follow the syllabus, but the allure of this hoodlum is a call to action, adventure . . . and a life less dull.

So, does street art really need an introduction? Not if you've been paying attention. *All that's left to do is just that —go out and play, and create monuments for the moment.*

—Lord Jim, Los Angeles–based photographer, collector of the interesting, and advocate for street art and the artists dedicated to it.

Bik Ismo, Miami, Florida

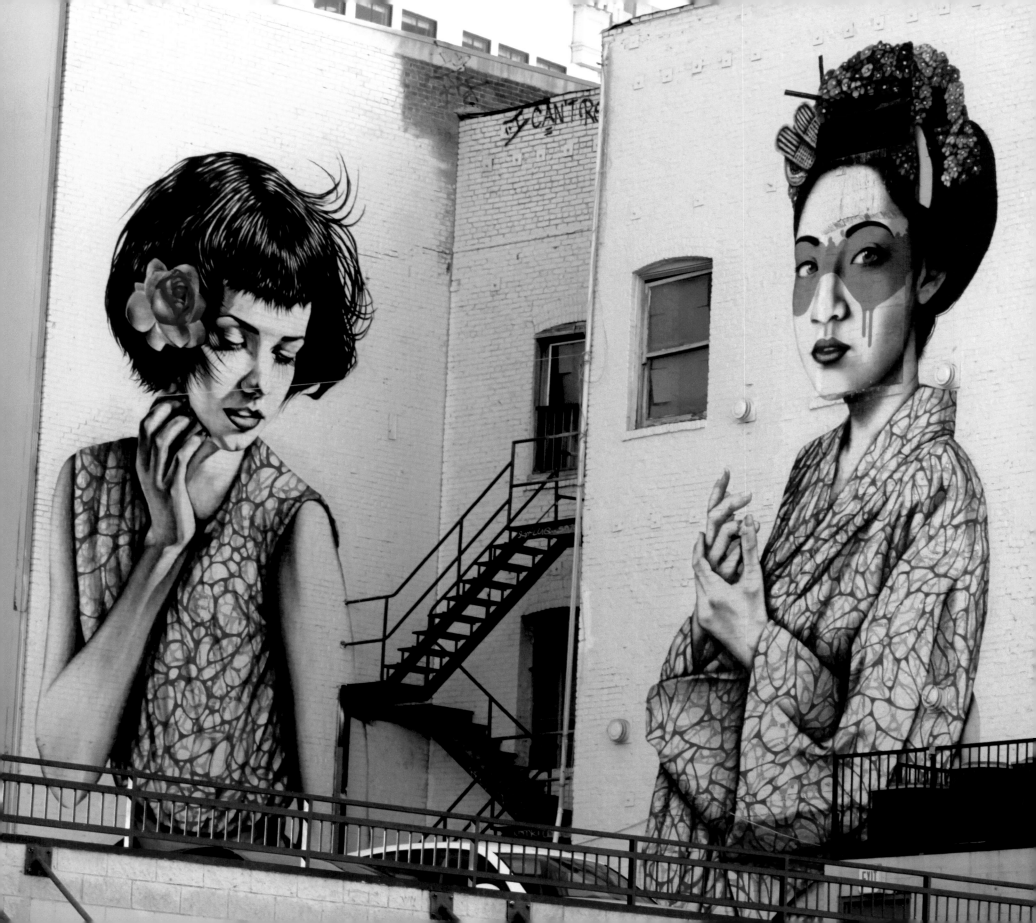

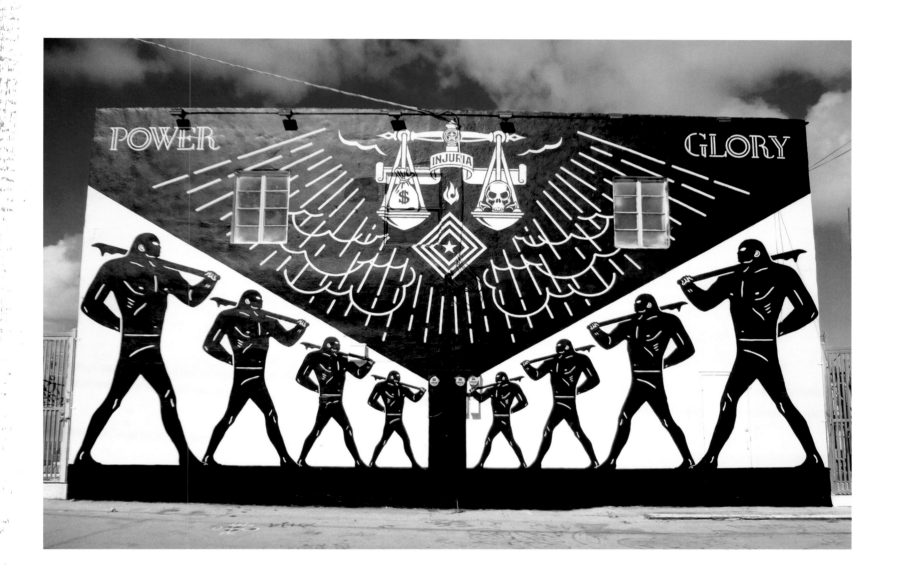

OPPOSITE **Fin Dac**, Los Angeles, California | ABOVE **Shepard Fairey and Cleon Petersen**, Miami, Florida

Jeff Soto, Los Angeles, California

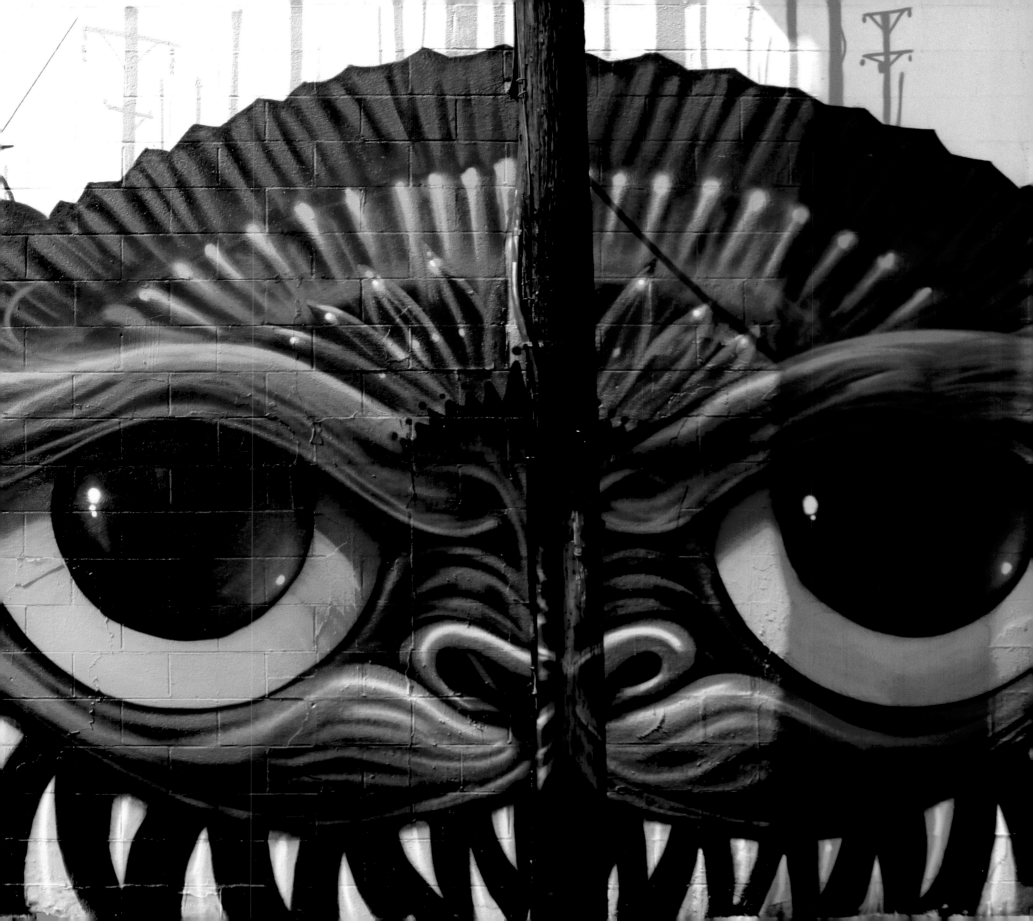

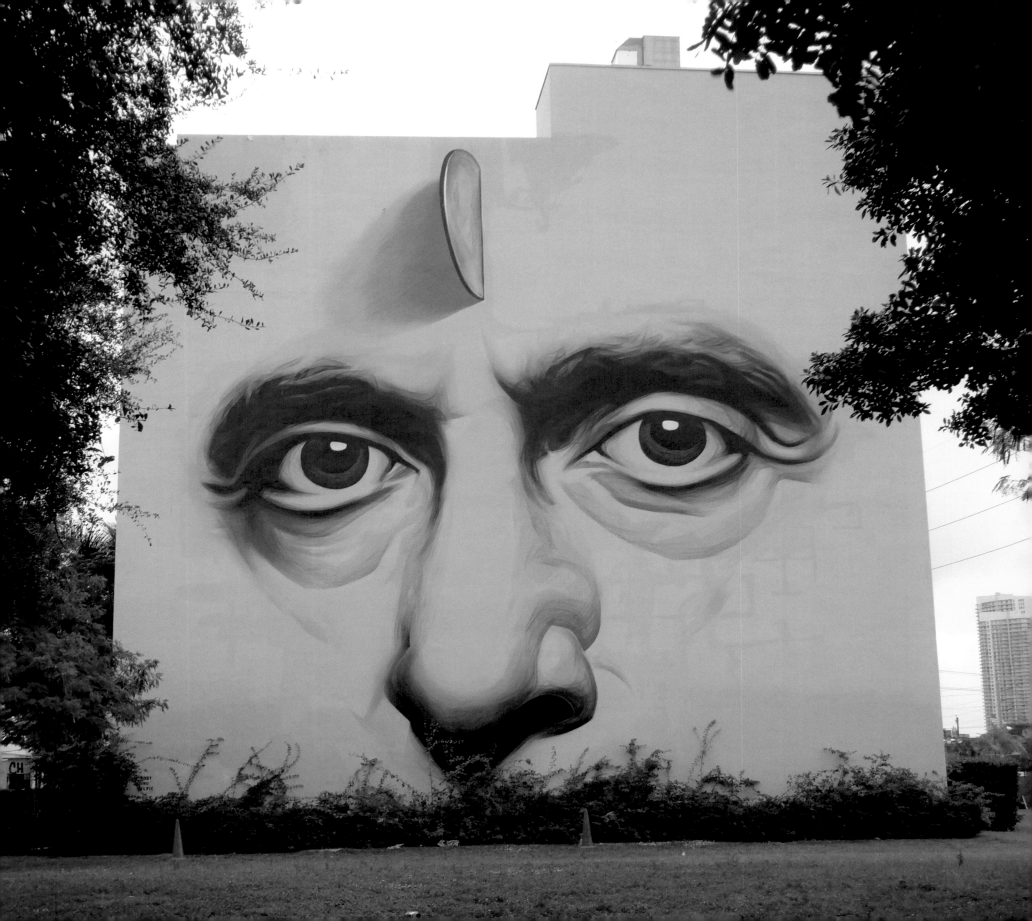

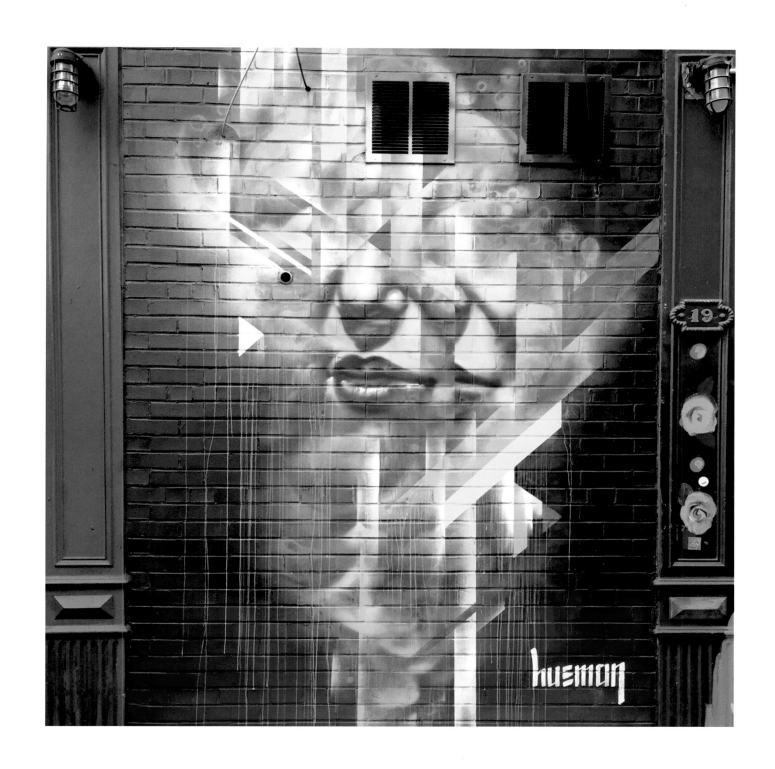

OPPOSITE **INo**, Miami, Florida | ABOVE **Hueman**, New York, New York

45

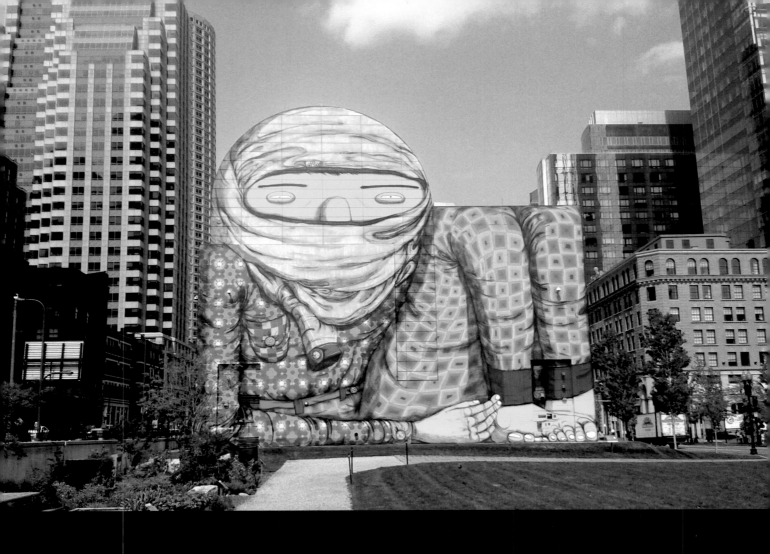

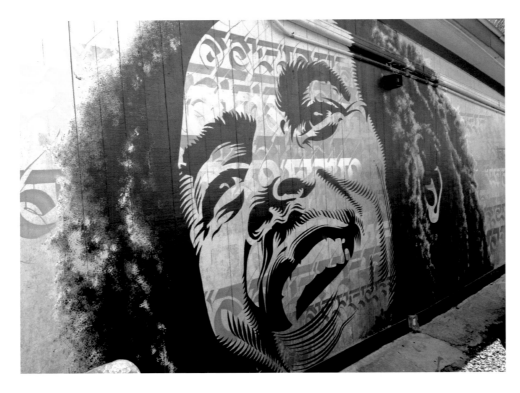

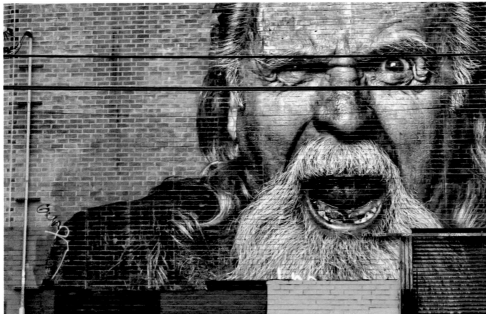

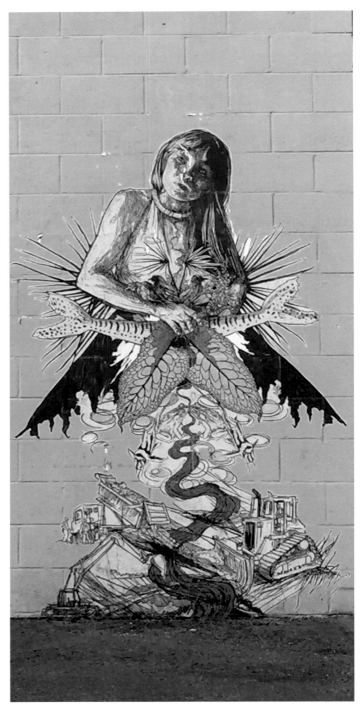

CLOCKWISE FROM TOP LEFT **Cryptik**, North Shore, Oahu | **Swoon**, Honolulu, Hawaii | **JR**, Los Angeles, California | OPPOSITE **Vhils**, Honolulu, Hawaii |
NEXT SPREAD, LEFT **David Flores**, Los Angeles, California | RIGHT **Morley**, Los Angeles, California

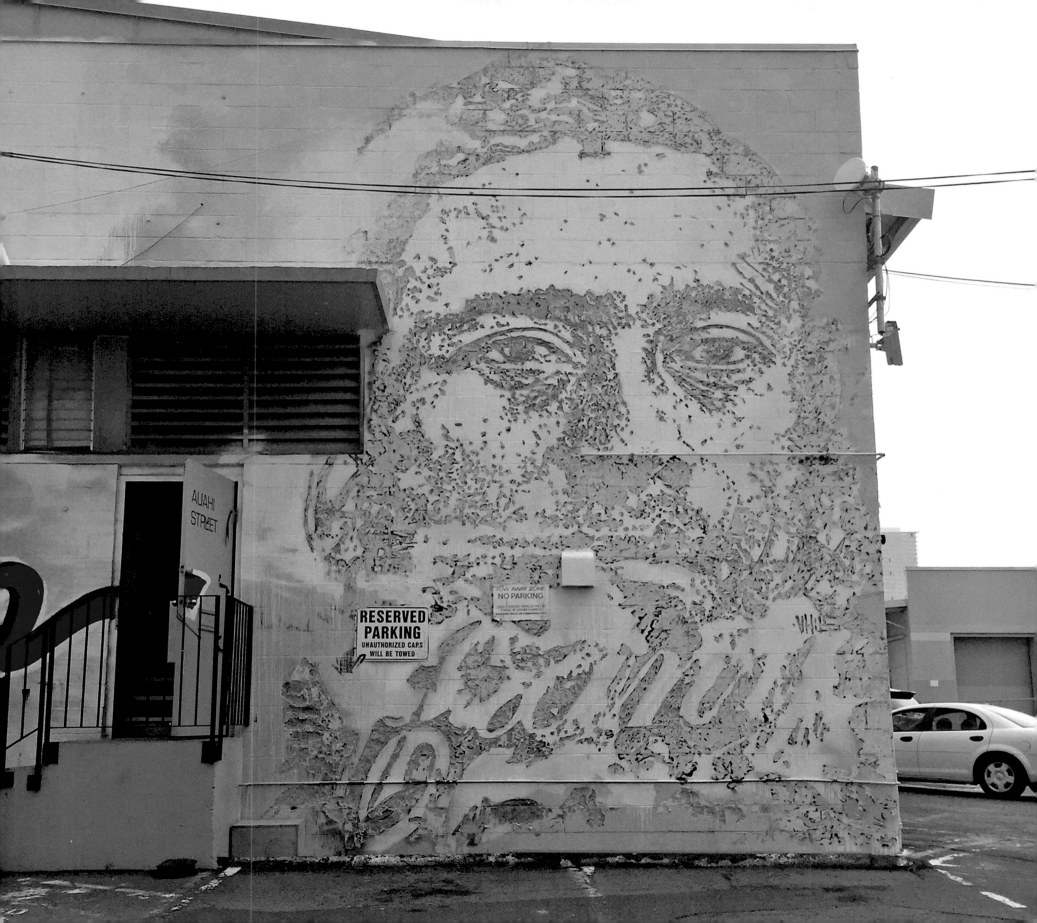

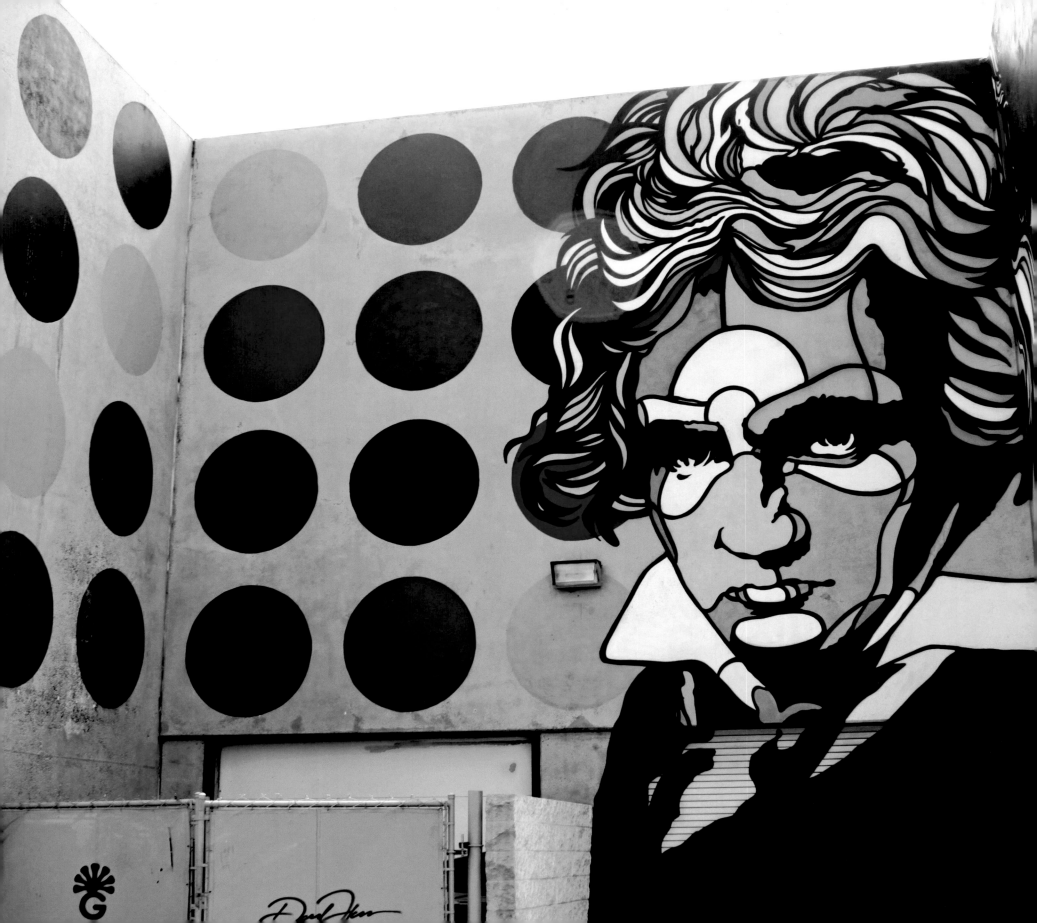

YOU AND I ARE LIKE THESE HEADPHONES FROM MY POCKET... FOREVER ENTANGLED

— Morley.

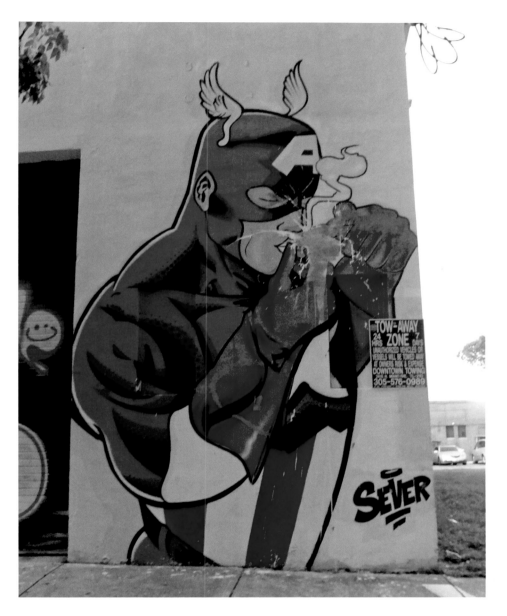

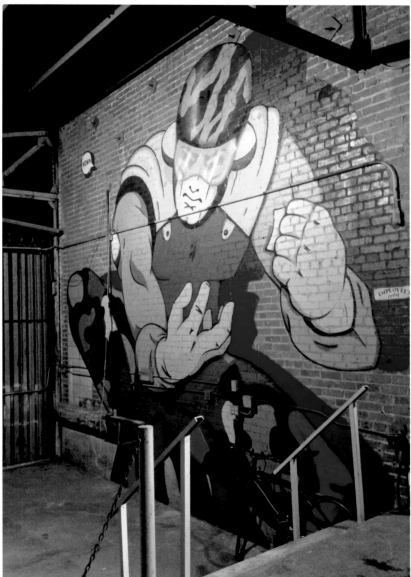

OPPOSITE **Bicicleta Sem Frieo**, Las Vegas, Nevada | ABOVE LEFT **Sever**, Miami, Florida | ABOVE RIGHT **Madman**, Los Angeles, California

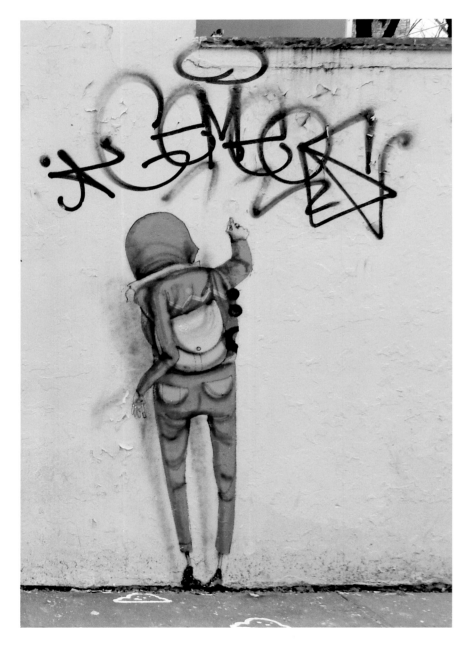

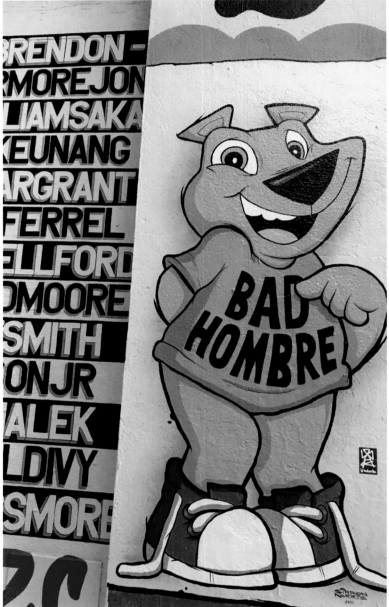

ABOVE LEFT **Os Gêmeos**, New York, New York | ABOVE RIGHT **Sirron Norris**, San Francisco, California | OPPOSITE **Ron English**, Los Angeles, California

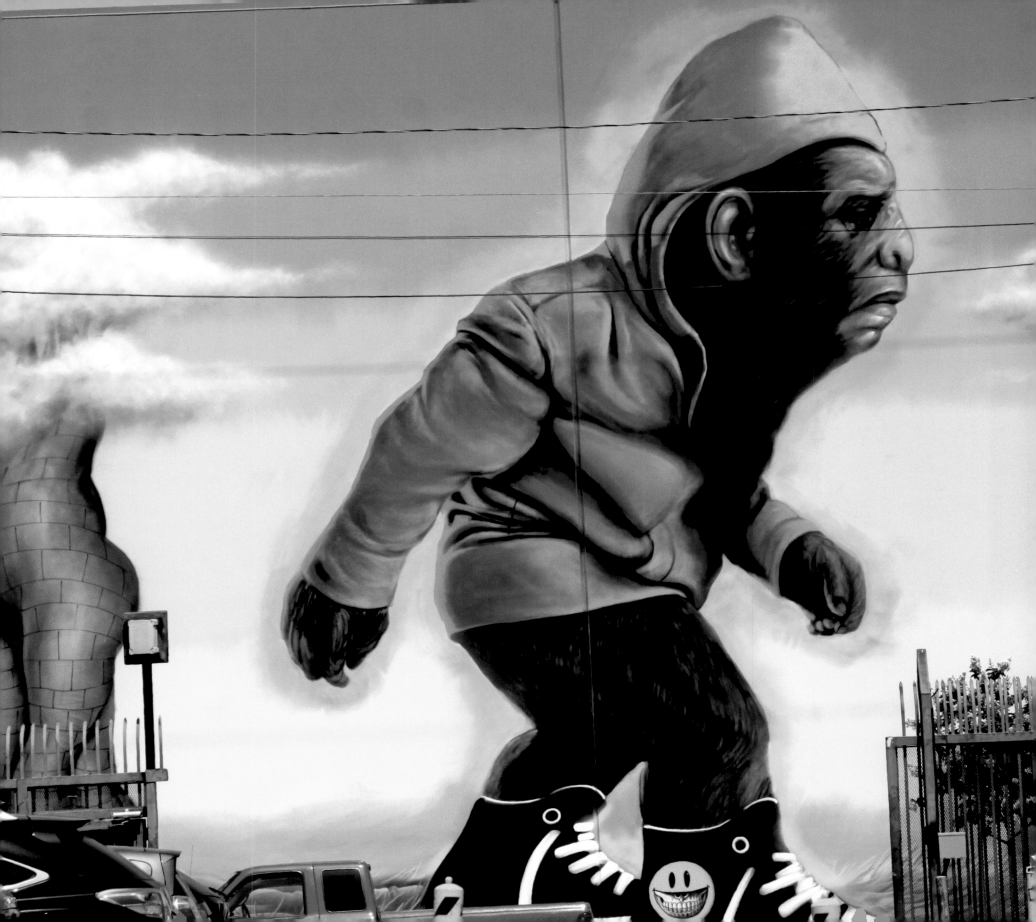

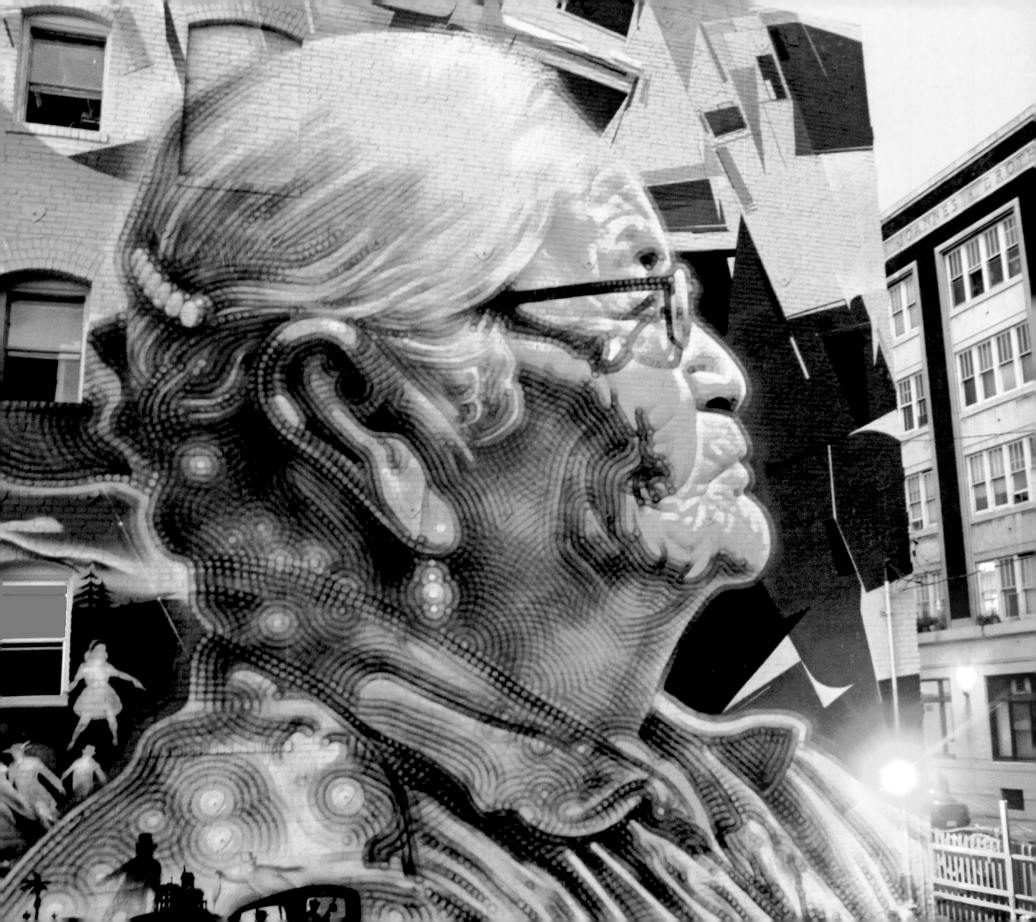

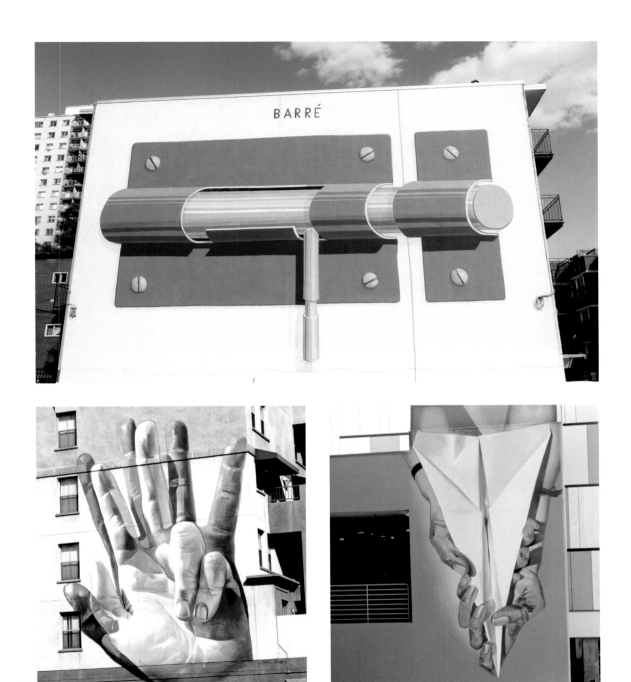

OPPOSITE **El Mac, Augustine Kofie, and Joseph Manuel Montalvo**, Los Angeles, California | CLOCKWISE FROM TOP **Escif**, Montreal, Canada | **Case Maclaim**, Los Angeles, California | **Case Maclaim**, Los Angeles, California

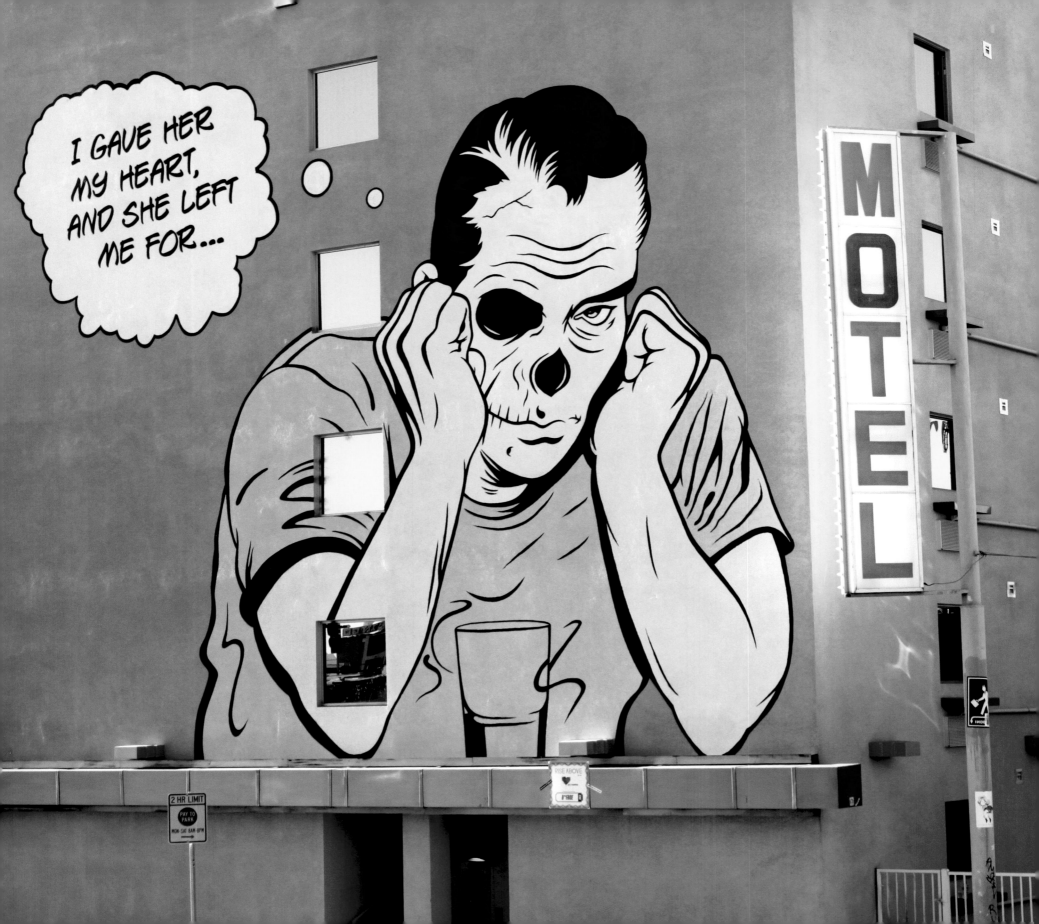

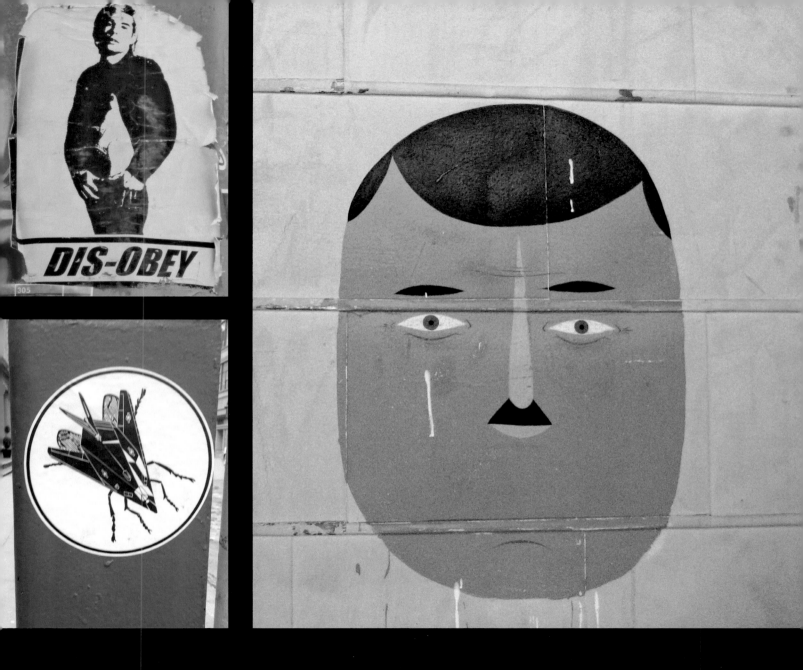

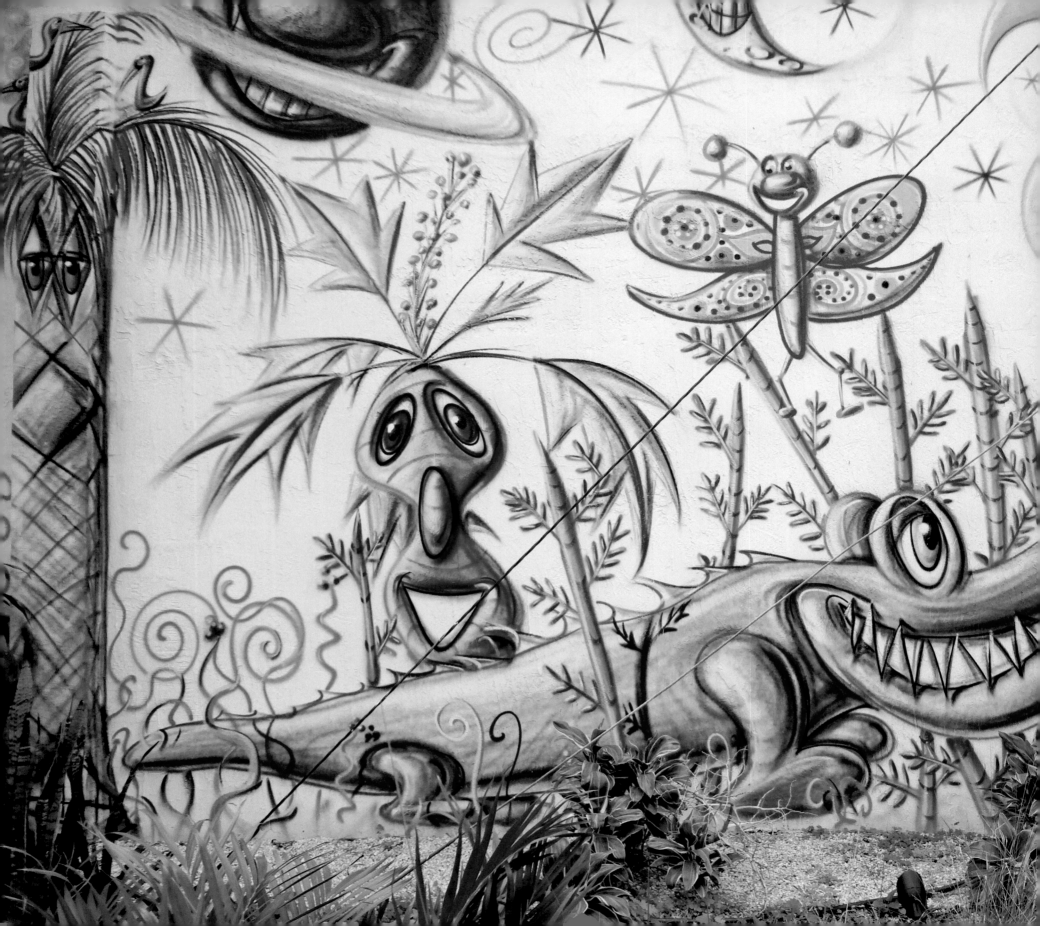

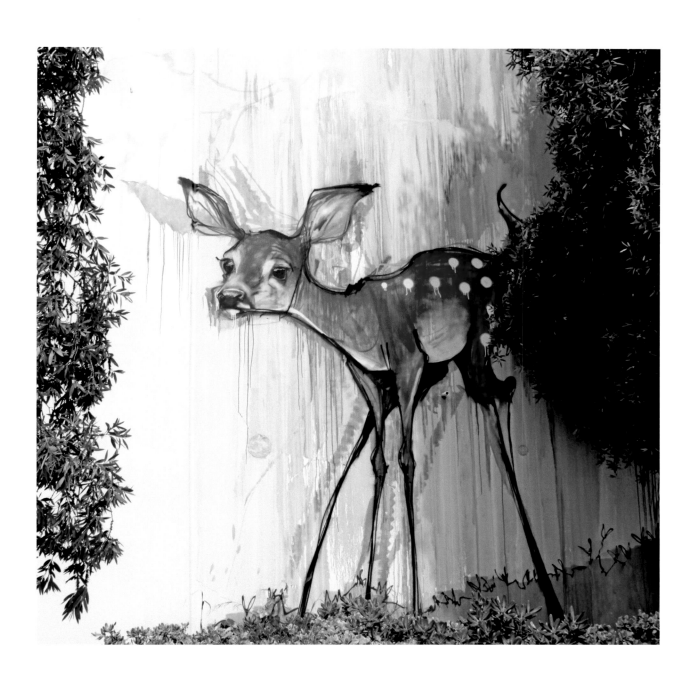

OPPOSITE **Kenny Scharf**, Miami, Florida | ABOVE **Herakut**, Los Angeles, California

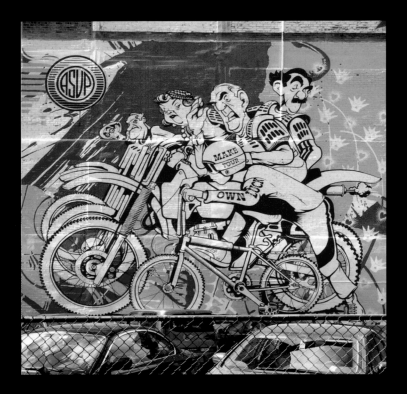

CLOCKWISE FROM TOP LEFT **ASVP**, Chicago, Illinois | **El Mac**, Costa Mesa, California | **Kevin Ancell X Saber**, Honolulu, Hawaii | OPPOSITE **Earsnot and Nemel**, Miami, Fl

62

64

OPPOSITE TOP **Floripa**, Miami, Florida | OPPOSITE BOTTOM **Opire and Bonar**, Miami, Florida | ABOVE **Nychos**, Oakland, California

Enjoy

A GIFT FROM

FRUITS OF
OUR LABOR

MOTHER NATURE
ON THE RUN

THE NEW GODS

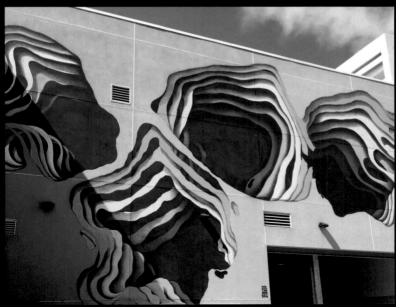

OSITE **Shepard Fairey**, Miami, Florida | TOP **RISK**, Honolulu, Hawaii | ABOVE **1010**, Honolulu, Hawai

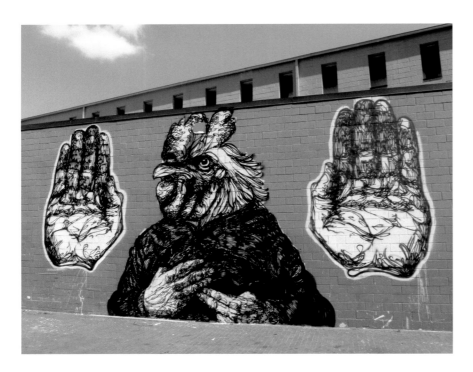

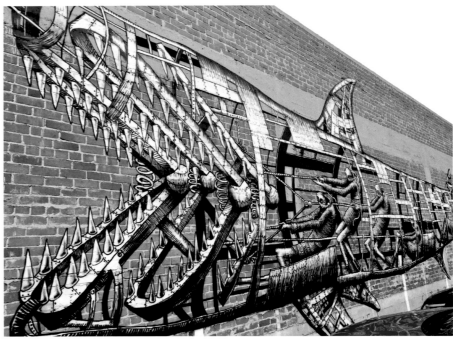

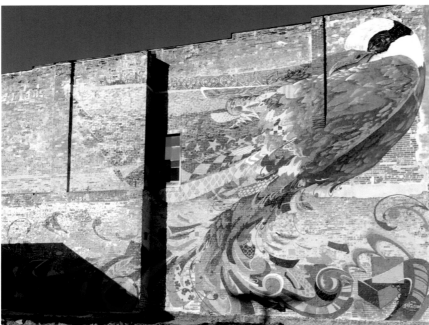

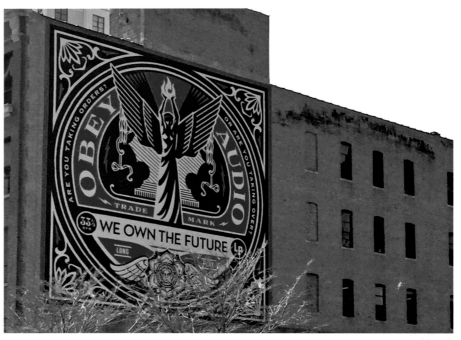

CLOCKWISE FROM TOP LEFT **Gaia**, Washington, D.C. | **Phlegm**, San Diego, California | **Shepard Fairey**, Chicago, Illinois | **CAMER1**, San Francisco, California | OPPOSITE **Martin Whatson**, Miami, Florida | NEXT SPREAD **Bumblebee**, Los Angeles, California

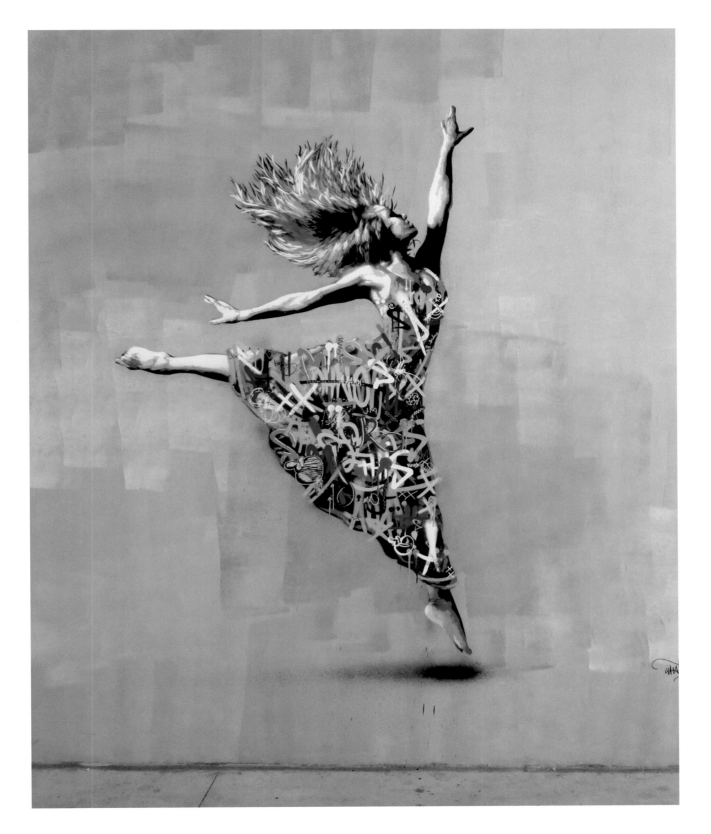

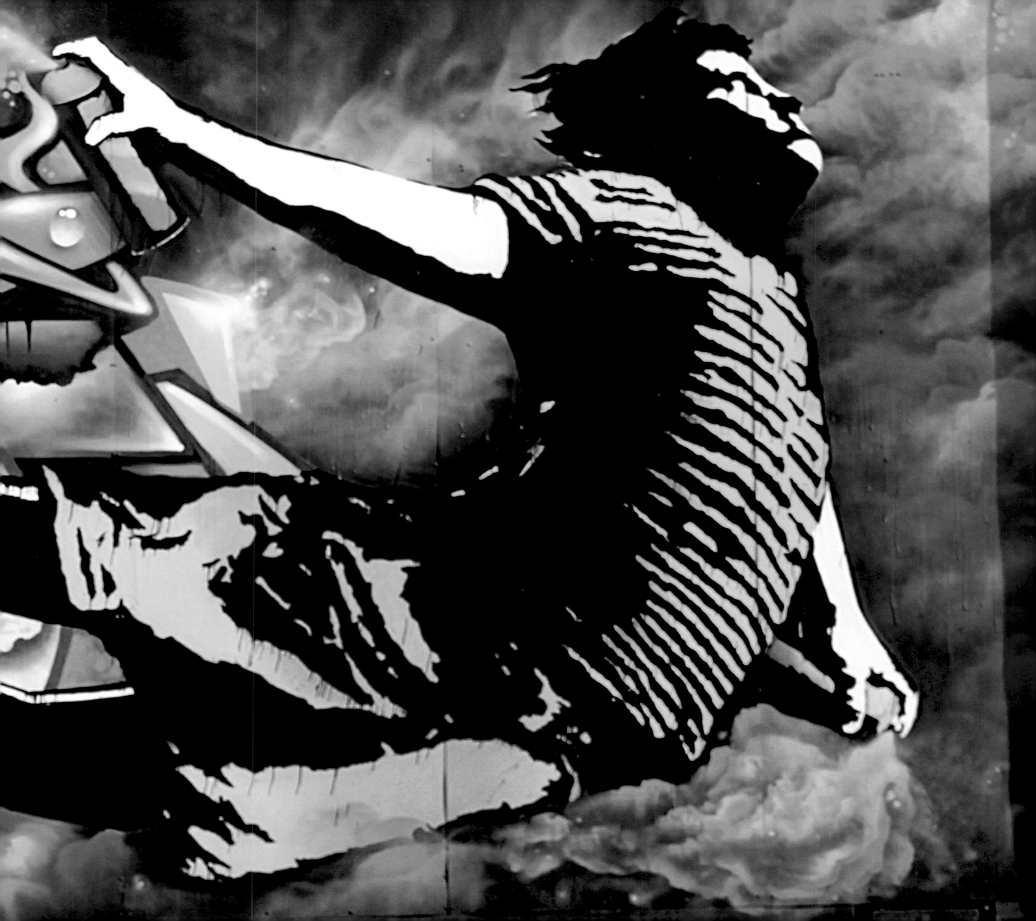

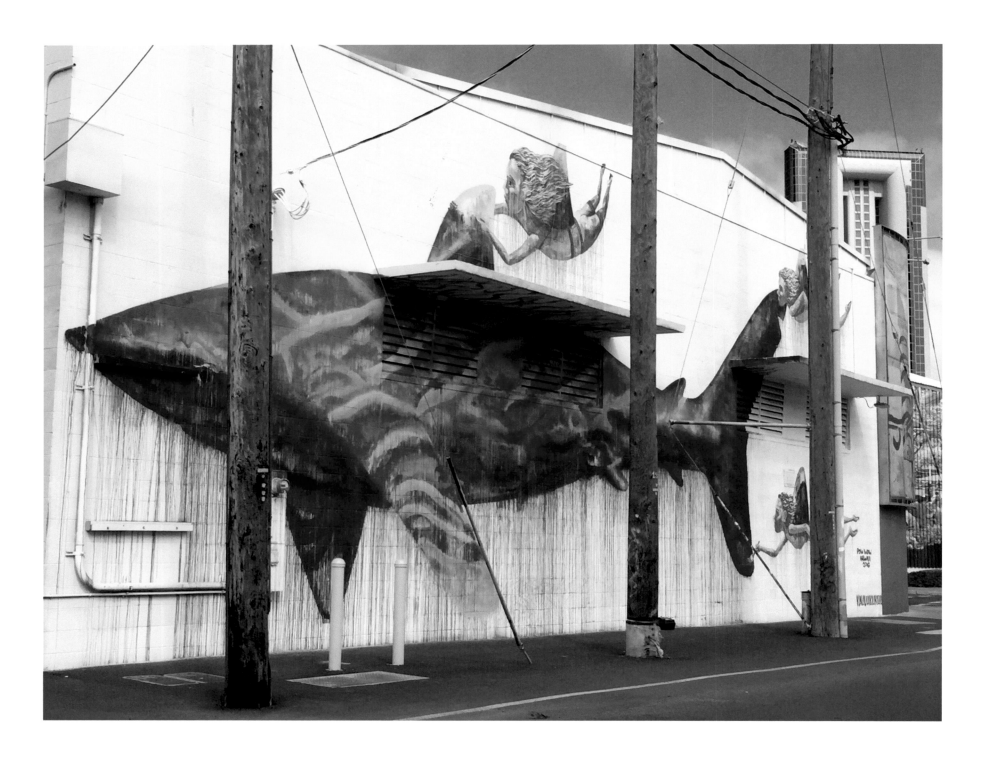

ABOVE **Kai'ili Kaulukukui**, Honolulu, Hawaii | OPPOSITE **Shark Toof**, Miami, Florida

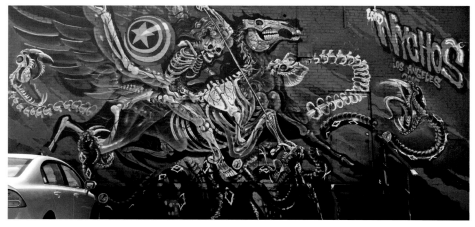

CLOCKWISE FROM TOP **David Flores**, Los Angeles, California | **Nychos**, Los Angeles, California | **Evoca1**, Miami, Florida | OPPOSITE **Madsteez**, Miami, Florida

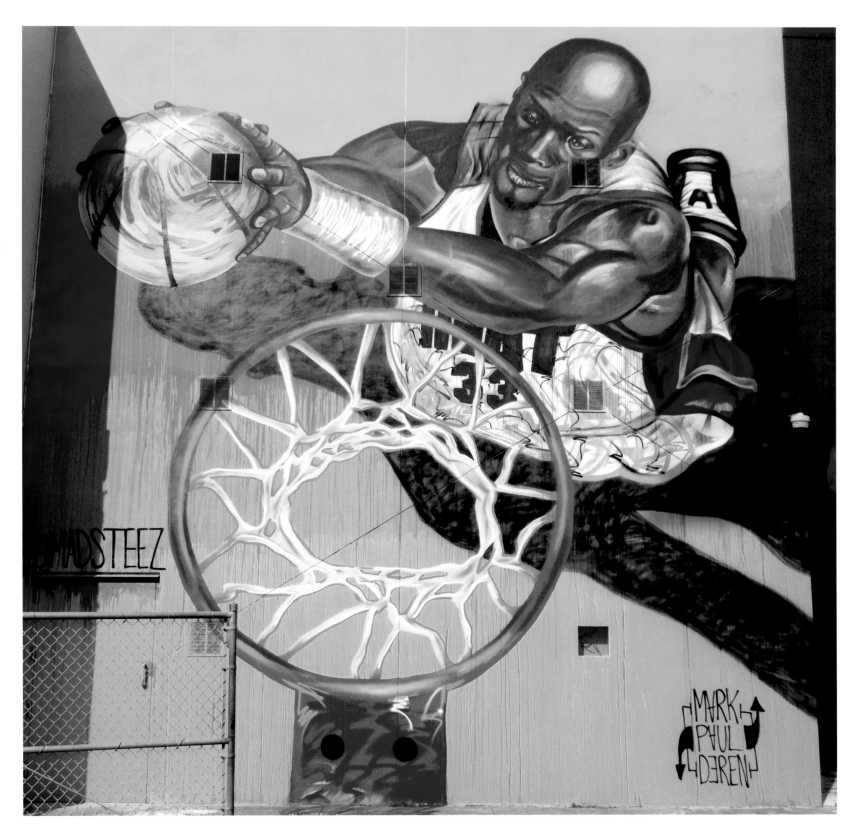

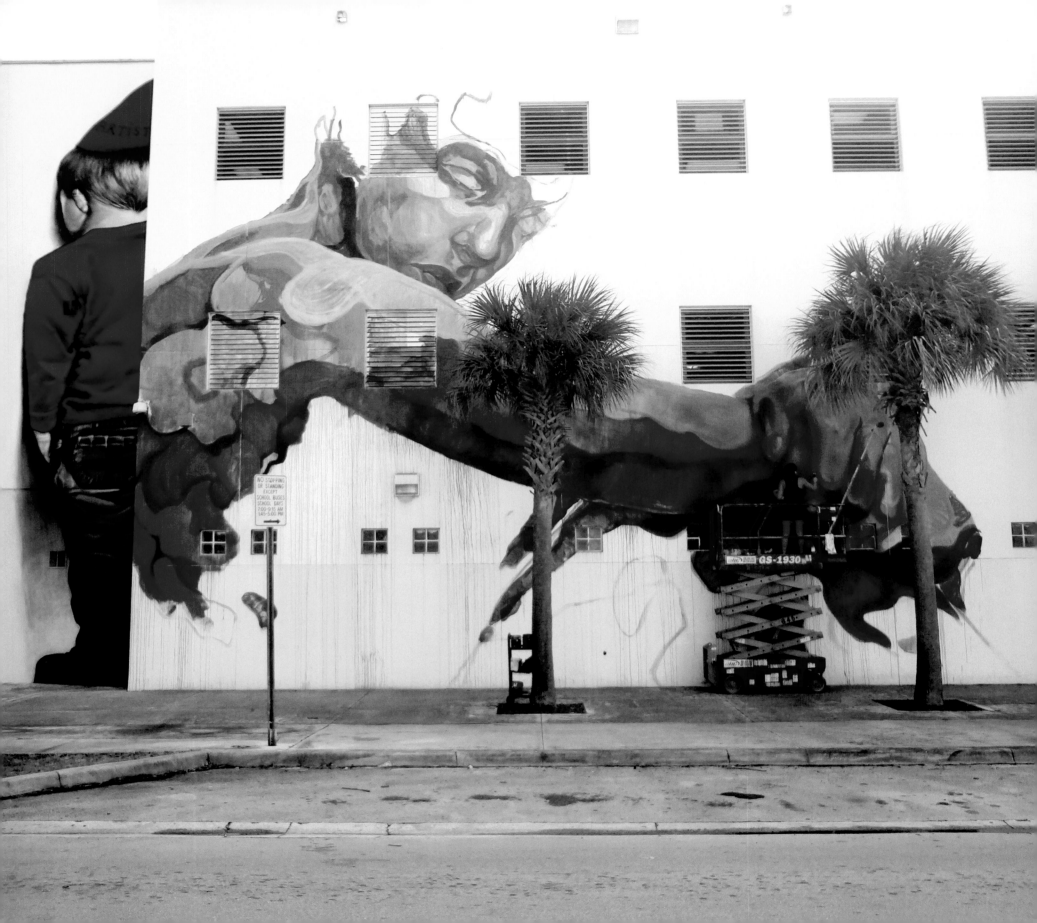

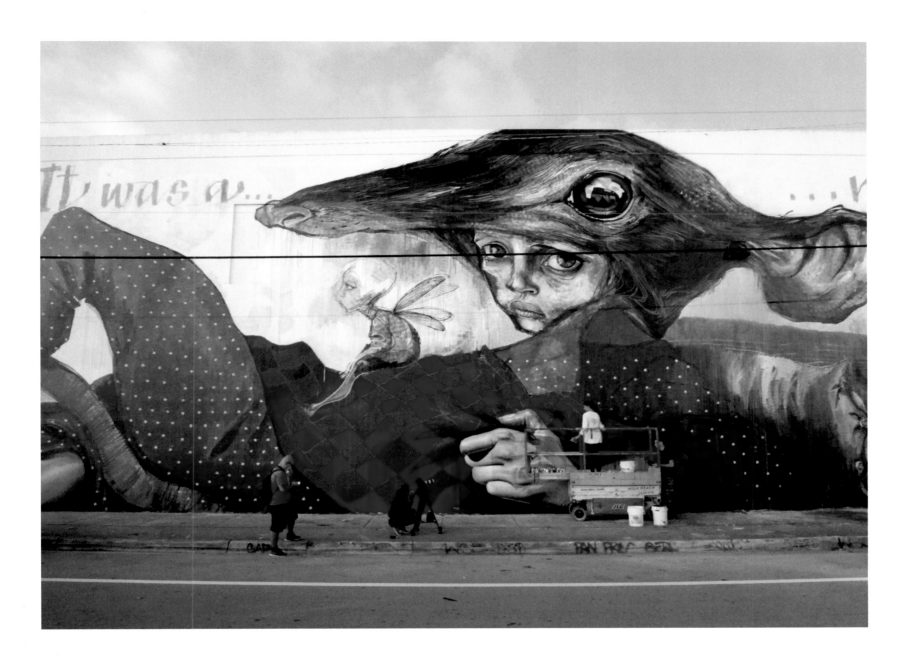

OPPOSITE **Paola Delfin**, Miami, Florida | ABOVE **Herakut**, Miami, Florida

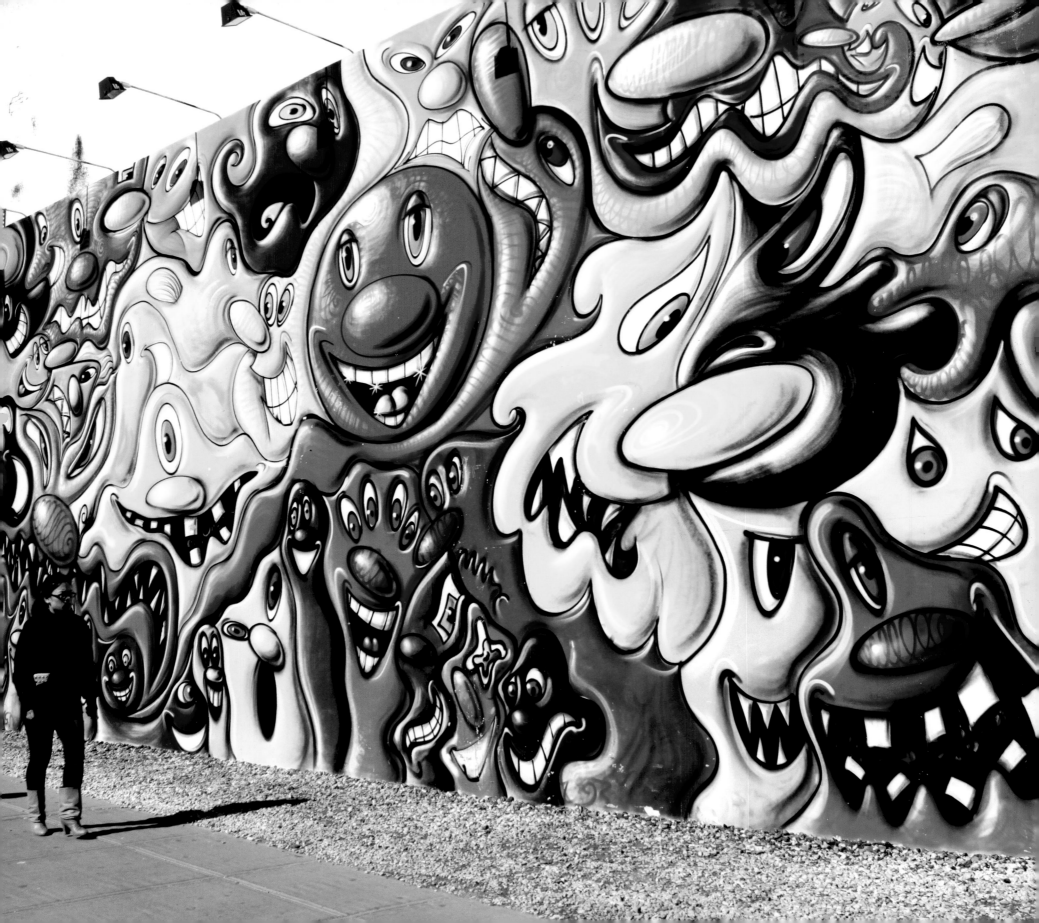

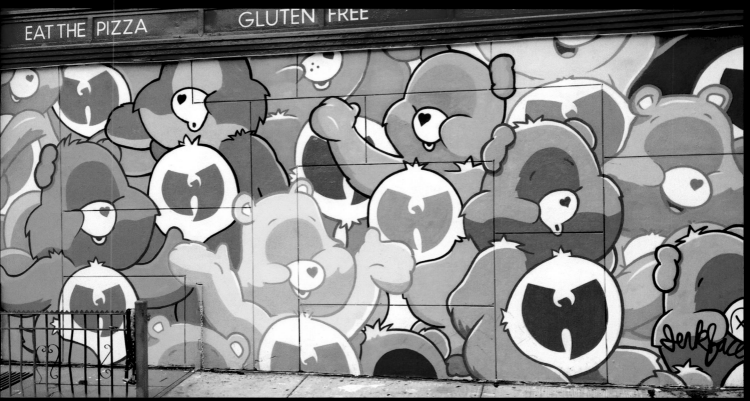

SOUTH AVMERICA

With street art shared globally, followers can witness charged commentary in public space, sometimes before the paint dries. So it is not shocking that street art is a trend in South America, where politics are layered with the dense complexity of the region's stacked living spaces. What is surprising is seeing how direct political messages in street art coming out of cities like Buenos Aires, São Paulo, and Bogotá function as subtext. The real insurgence is in the style and form—bold, brave work that is ready to topple North American street art regimes.

South American street art, large or small, is diverse and filled with indigenous aesthetic references, lessons learned from decades of fine art, graphic design, and landscape architecture. What is compelling is finding how unsanctioned art infiltrates the visual narrative of the city with works illuminated by decades of regional art history. It touches on mid-twentieth-century concrete art and the neo-concrete movement, while also referring to magical realism, which allows street art to adapt to scale and structure with surreal grace.

And street art is indigenous. South America is not directly influenced by tagging in the 1970s boroughs of New York City or by cholo West Coast script. Any protests from early examples of South American graffiti were busy targeting military regimes. Governing has changed, and while not flawless, left-leaning leadership gives street artists different political fires to put out, which include critiques against corruption. What seems more important is the commitment by South American artists to lead a revolution of national identity.

"Everything goes and skills are amazing," says Isabel Rojas-Williams, former director of the Mural Conservancy of Los Angeles, who spends reflective time in her homeland of Chile. "It's not as political as in the '70s, but still has social content."

The work is not always designed to change political leadership, but is sometimes intended to make sure the people and environment are not abandoned. One example is Brazilian artist Eduardo Kobra, who is known for color-driven portraits of pop culture and regional figures embedded in kaleidoscope mosaics. The geometric layers refer to the minimalist work of abstract concrete artists. Yet the figurative illustration, which concrete poetry was designed to rebel against since it was the art of the bourgeoisie, is a throwback to the literary mode of magic realism. Kobra and many other street artists use mystical images, fiction mixed with myth, to shift magic realism from literary references to its original purpose of defining a visual art form.

There is magic when colorful figurative works claim the crowded space and are portrayed as escaping the confines of hard geometric surfaces. That gives South American street art a concrete mysticism.

—ED FUENTES, art journalist who reports on murals and street art, is also an MFA fine art candidate at the University of Nevada, Las Vegas.

Stinkfish, Colombia

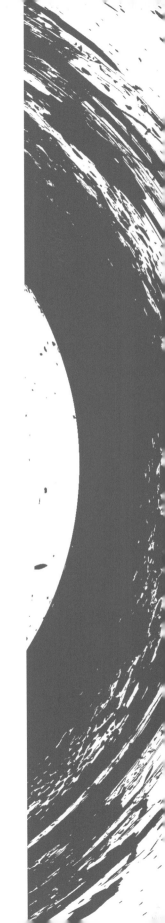

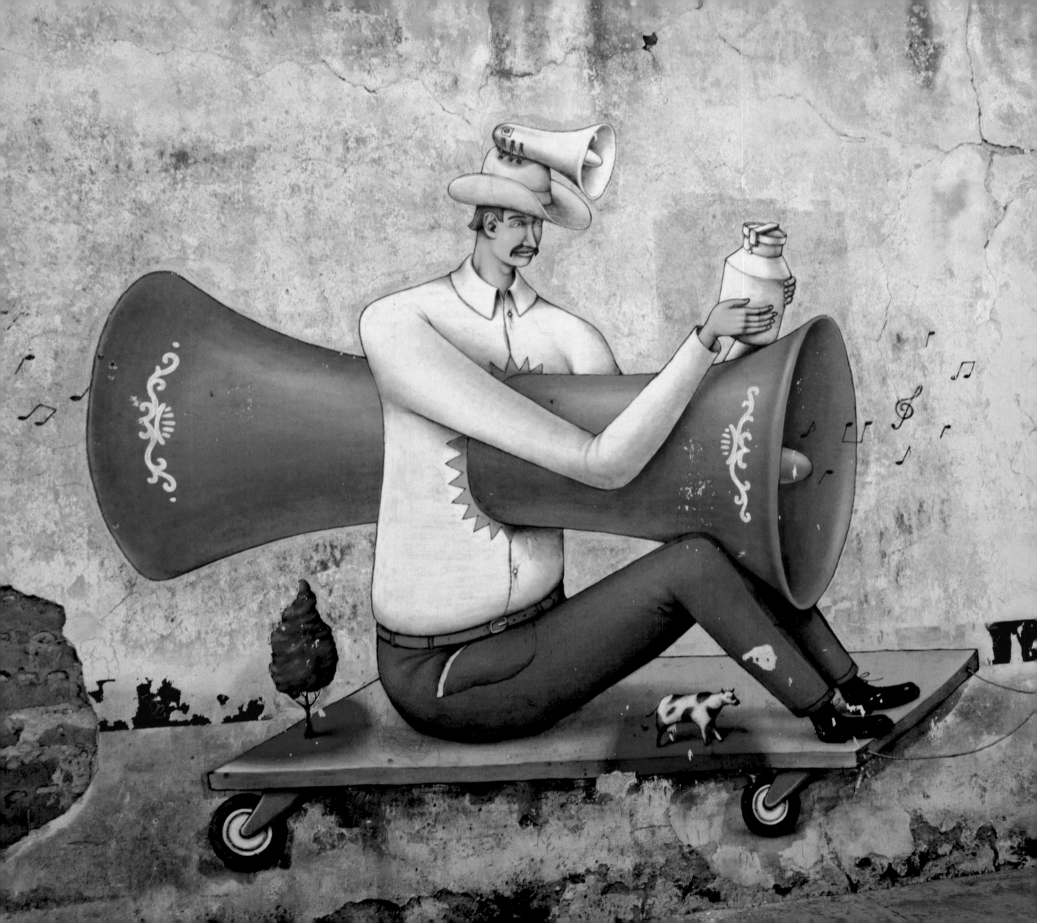

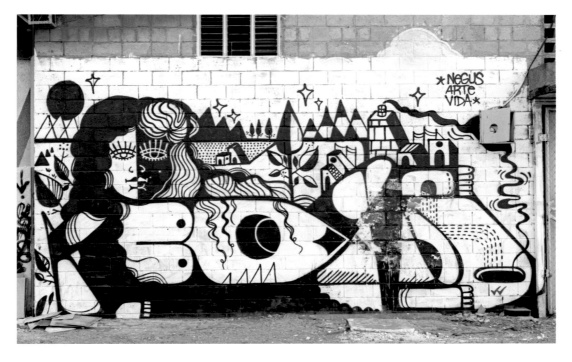

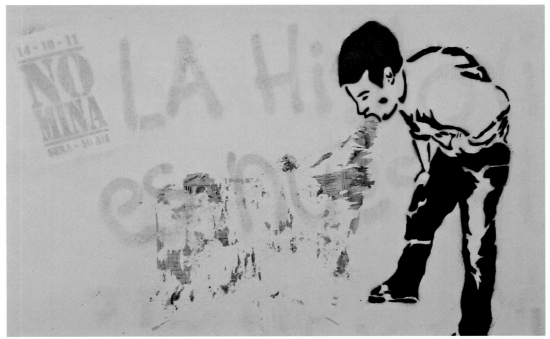

OPPOSITE **Aec Interesni Kazki,** Mexico | TOP **Negus Arte Vida,** Costa Rica | ABOVE **Unknown,** Colombia

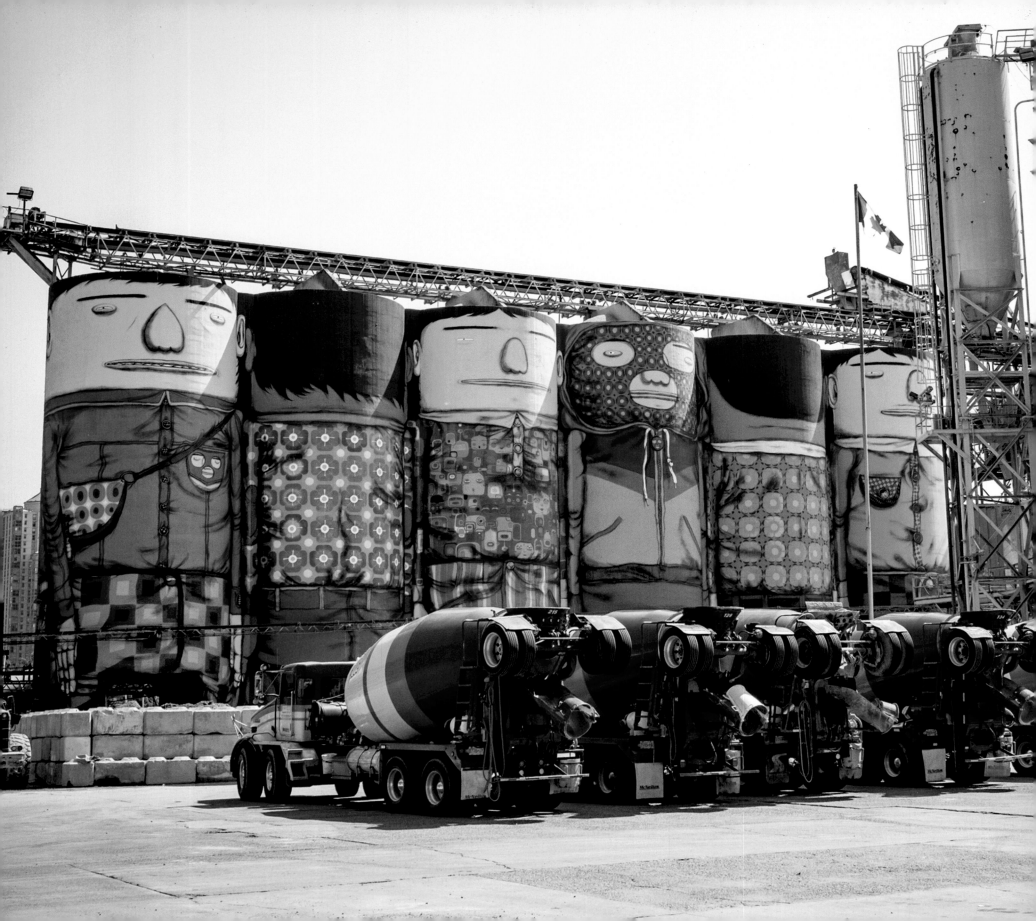

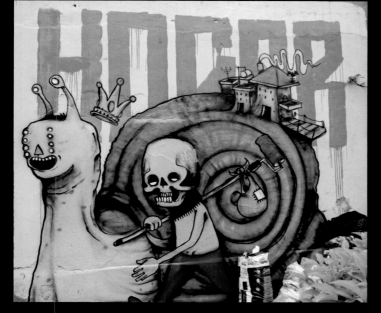

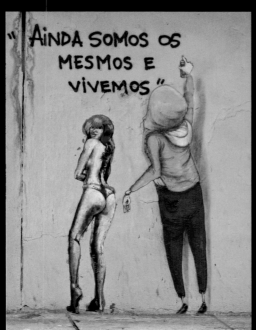

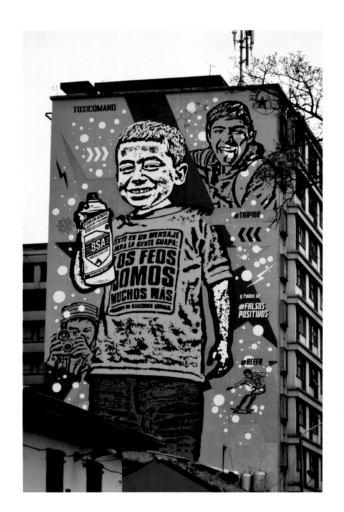

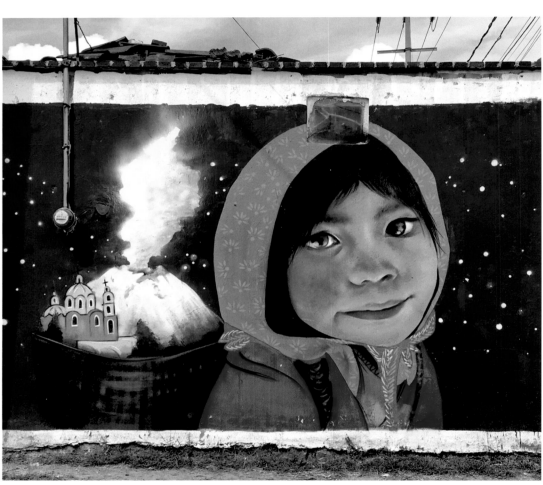

ABOVE LEFT **Toxicómano**, Bogotá, Colombia | ABOVE RIGHT **Unknown**, Cholula, Mexico | OPPOSITE **Unknown**, Mexico

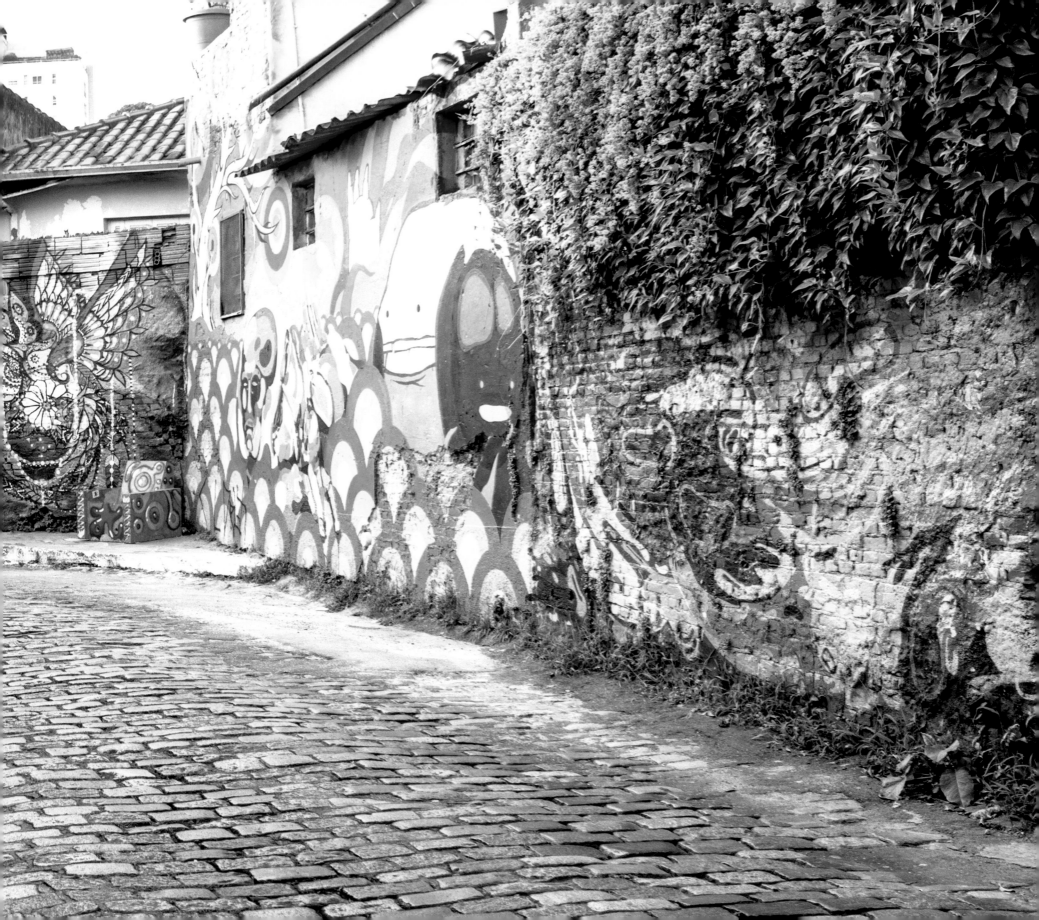

ABOVE **Unknown**, Santiago, Chile | OPPOSITE **Unknown**, Guadalajara, Mexico

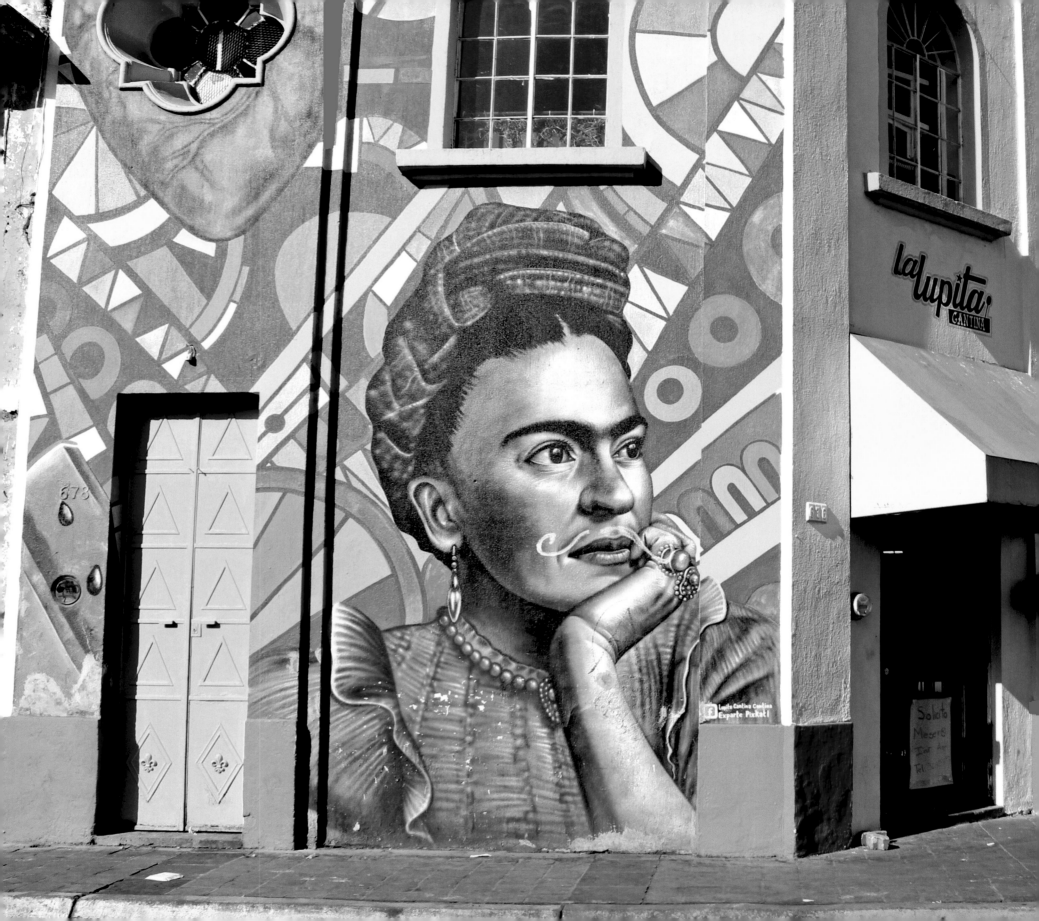

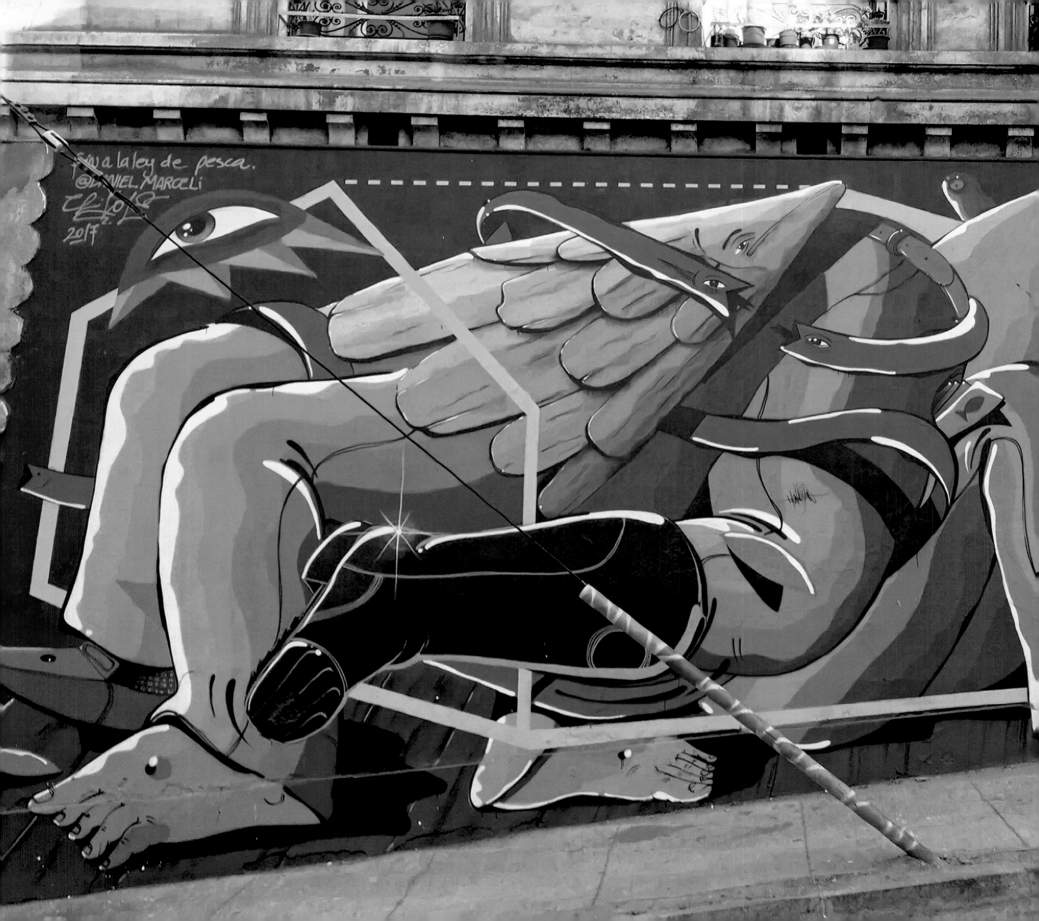

OPPOSITE **Daniel Marceli**, Colombia | ABOVE **Unknown**, Mexico

ABOVE **Thierry Noir**, Chile | OPPOSITE TOP **DjLu**, Bogotá, Colombia | OPPOSITE BOTTOM **DjLu**, Bogotá, Colombia | NEXT SPREAD **Jaz**, Buenos Aires, Argentina

ABOVE **Unknown**, Chile | OPPOSITE **Unknown**, Chile

AUSTRALASIA

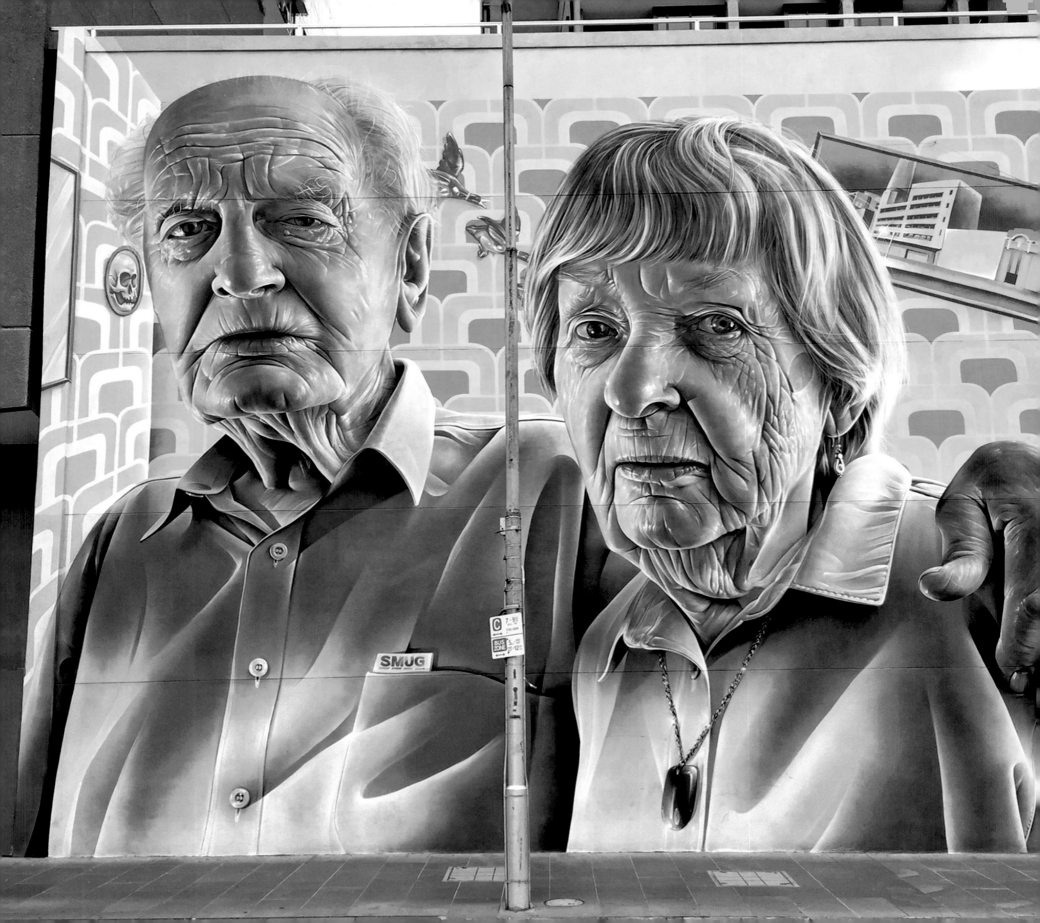

AUSTRALASIA

Melbourne is known to be Australia's creative hub. The central business district (CBD) tourist office arranges tours or can provide a substantial map of the best street art locations in town. Most are laneways such as Hosier Lane and ACDC Lane, where painting is allowed and walls are completely covered. I was surprised by the diversity of those who had come to see the art as well as the sheer footfall. All forms of public art are there, from stencils, stickers, and paste-ups to tags and graffiti lettering, as well as large-scale portraits and paintings. If you look carefully, small to midsize installations such as those by Invader or Mr Will Coles can also be found. The area is a showcase of a long-standing tradition of public art, which points to an acceptance of, if not appreciation by, the general public and the local government.

The next logical move is to explore Melbourne's suburbs like Fitzroy and Collingwood, where one huge wall backs on to the next. Brunswick and Prahran also need to be mentioned as areas with a high density of art to explore. By no means do these locations cover all the areas where street art can be found in Melbourne, but they're great areas to find work of high caliber.

Then there's Sydney, home to work by international stars like Fintan Magee. Sydney's points of interest spread from the CBD to Surrey Hills and Newtown, which was a real highlight for me, as walls by local artists such as Ears, Jodee Knowles, Goodie, and Scottie Marsh are on offer. What really touched me was a commissioned piece by Adnate in Darling Harbour on the side of an eight-story Sofitel Hotel showing the aboriginal elder Jenny Munro rising high over the city, inspiring the local community. Sydney also has a number of great laneways full of visual treasures, such as King Lane and Teggs Lane and, of course, the Bondi Beach Wall.

While Melbourne and Sydney have an established art scene, there are also interesting works in more remote cities like Perth. That said, street art is widely on offer and extends to smaller neighborhoods as well as the charming beachside suburbs.

Australia has a rich history of graffiti that goes back as far as the 1970s. The scene appears to be highly active, and walls change very frequently. Murals often have very short life spans due to tagging and vandalism, or simply because walls are being repainted regularly. Nothing is permanent on Australia's colorful streets, which underlines the importance of books like this that capture street art through photography. I recommend the adventure of pounding the pavement yourself. You never know what you're going to find.

— TIM JENTSCH, world traveler and avid street art photographer.

Smug, Melbourne, Australia

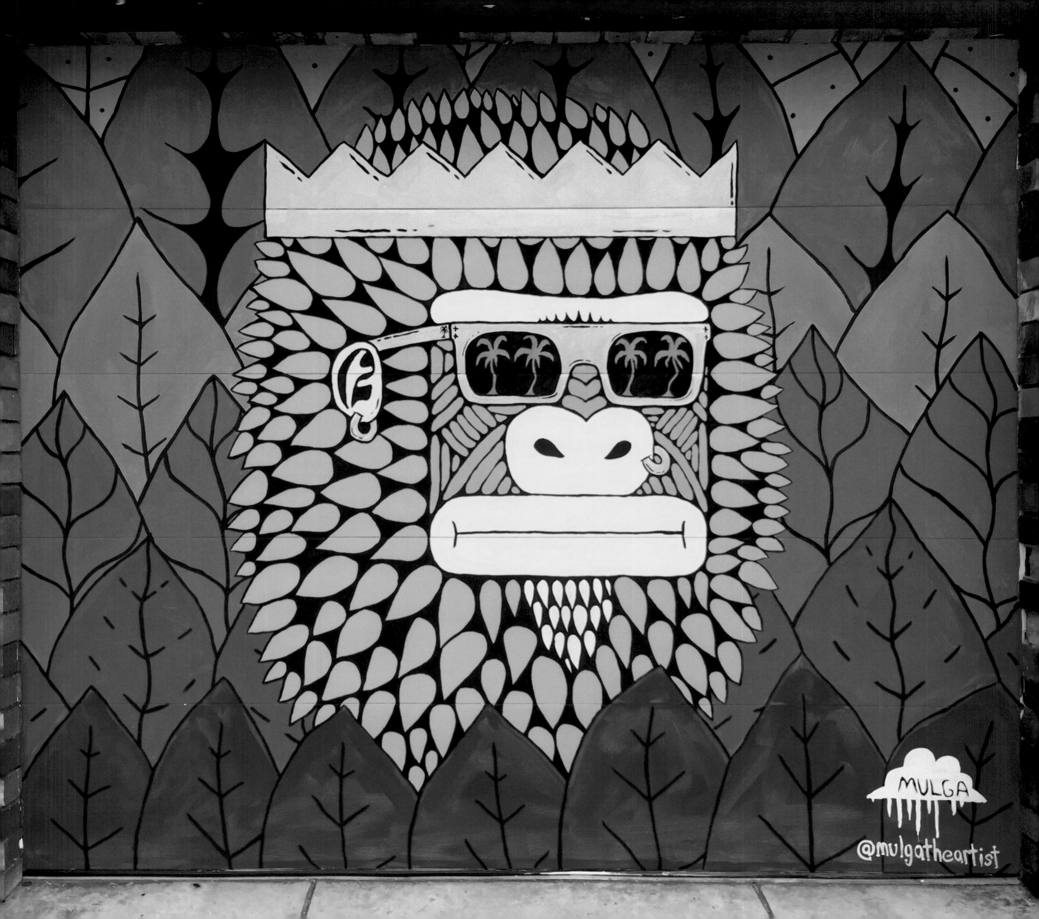

OPPOSITE **Mulga,** Australia | ABOVE **Maya Hayuk,** New Zealand

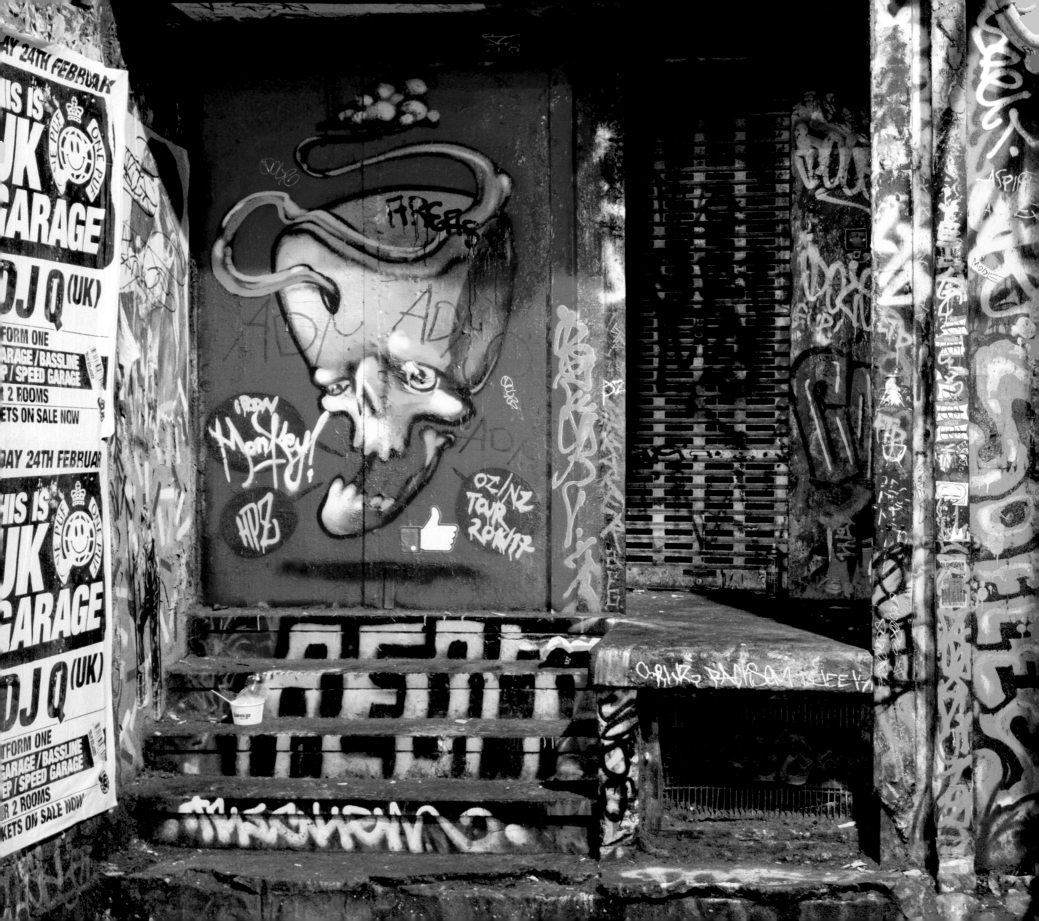

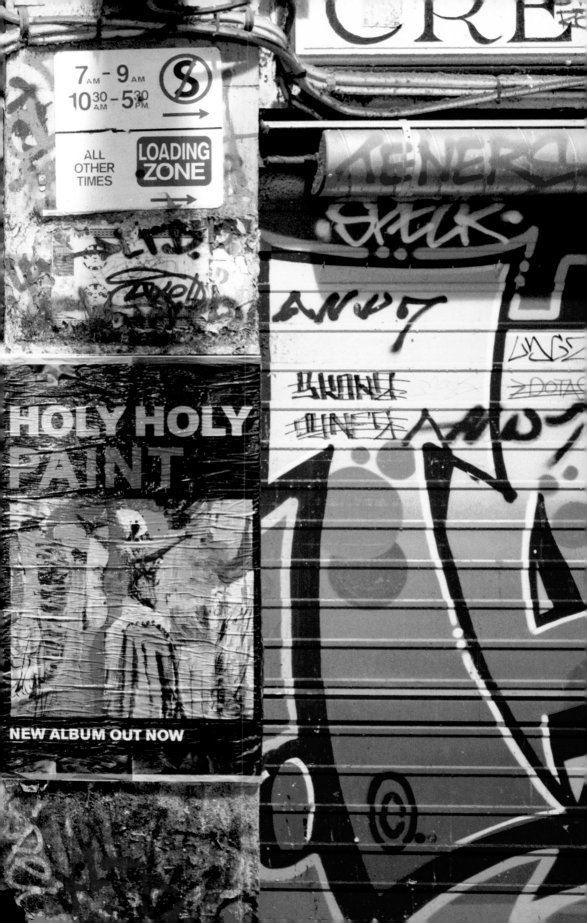

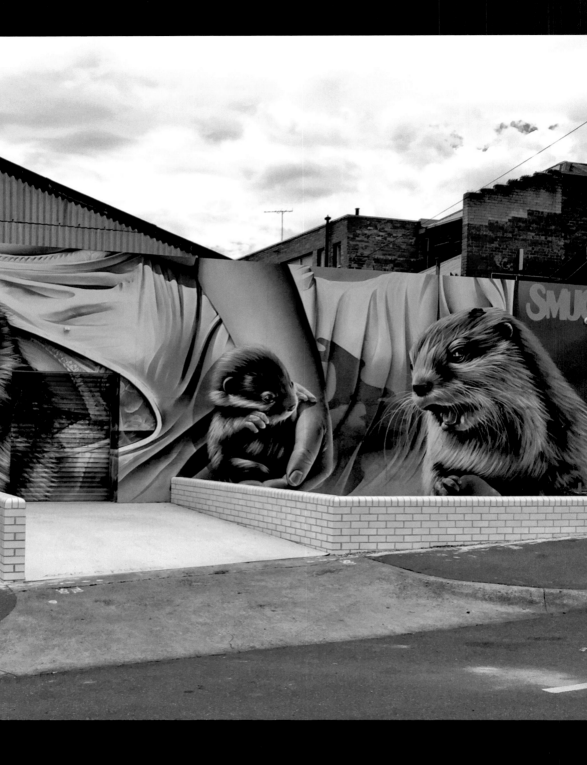

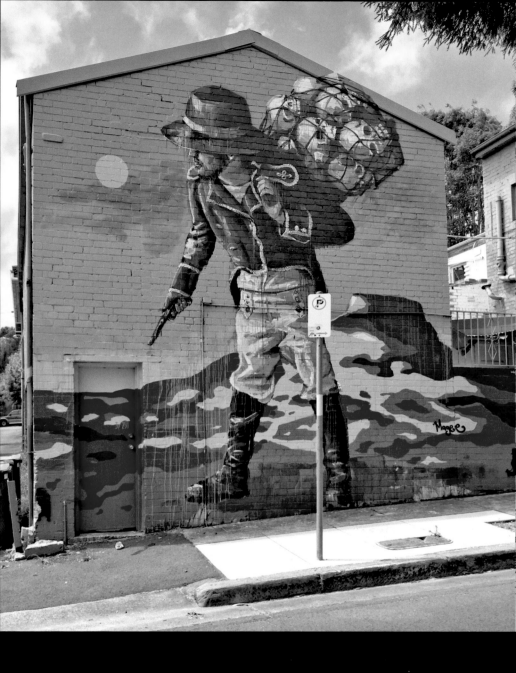

OPPOSITE **Smug**, Melbourne, Australia | ABOVE **Fintan Magee**, Sydney, Australia

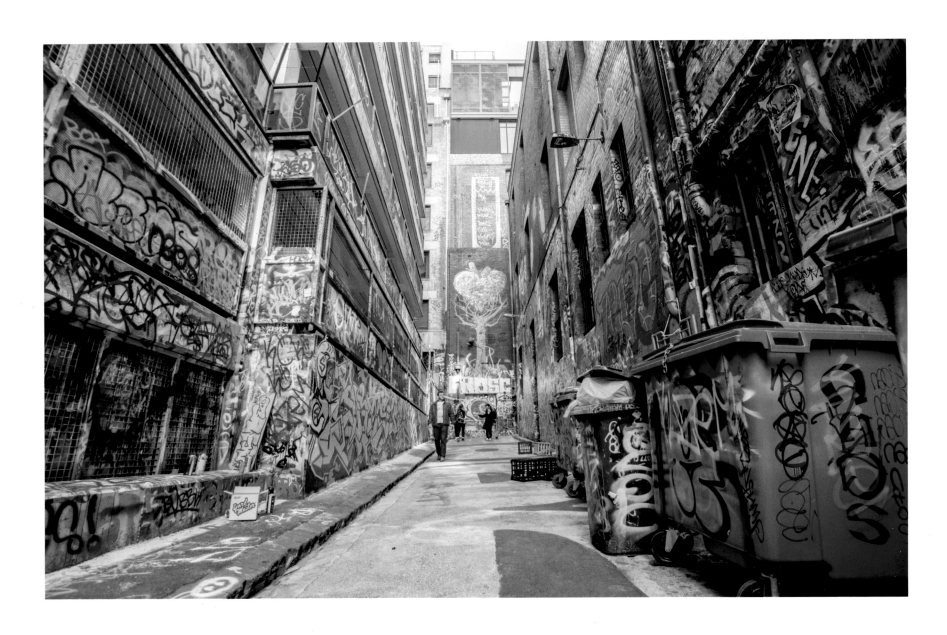

ABOVE **Unknown**, Melbourne, Australia | OPPOSITE **Cam Scale**, Australia

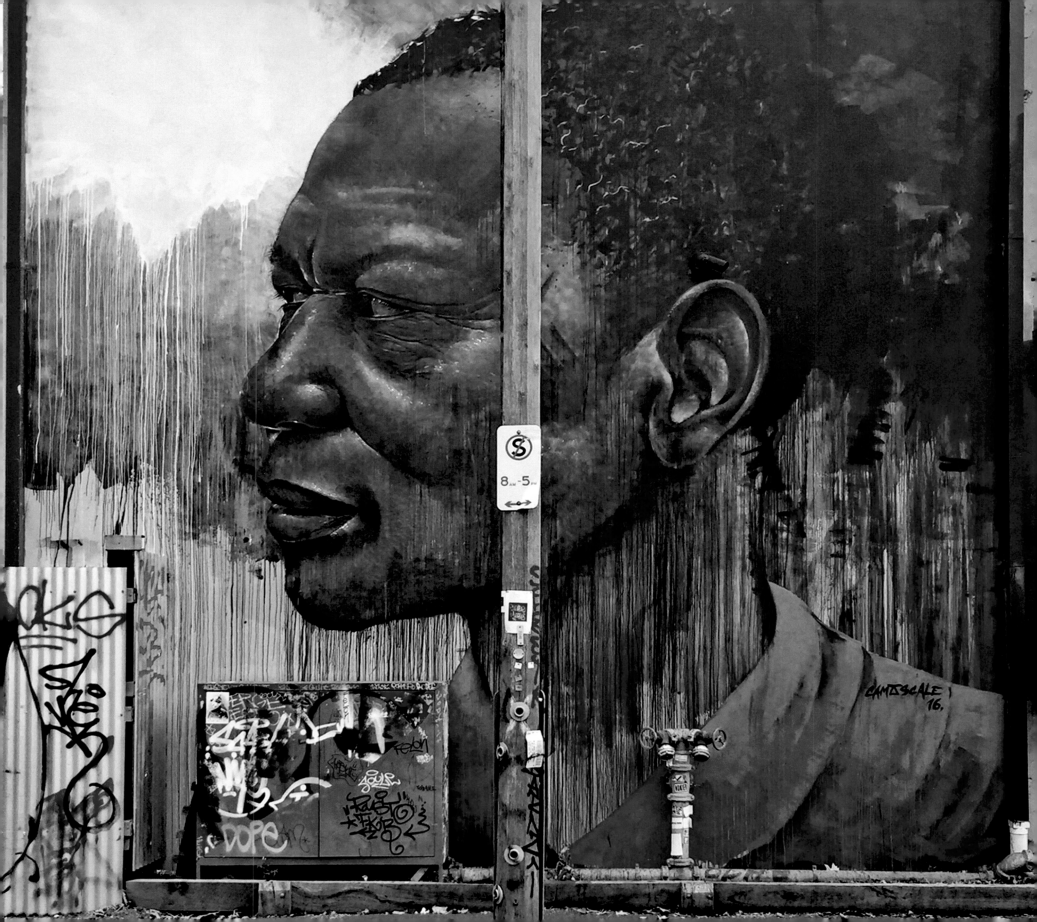

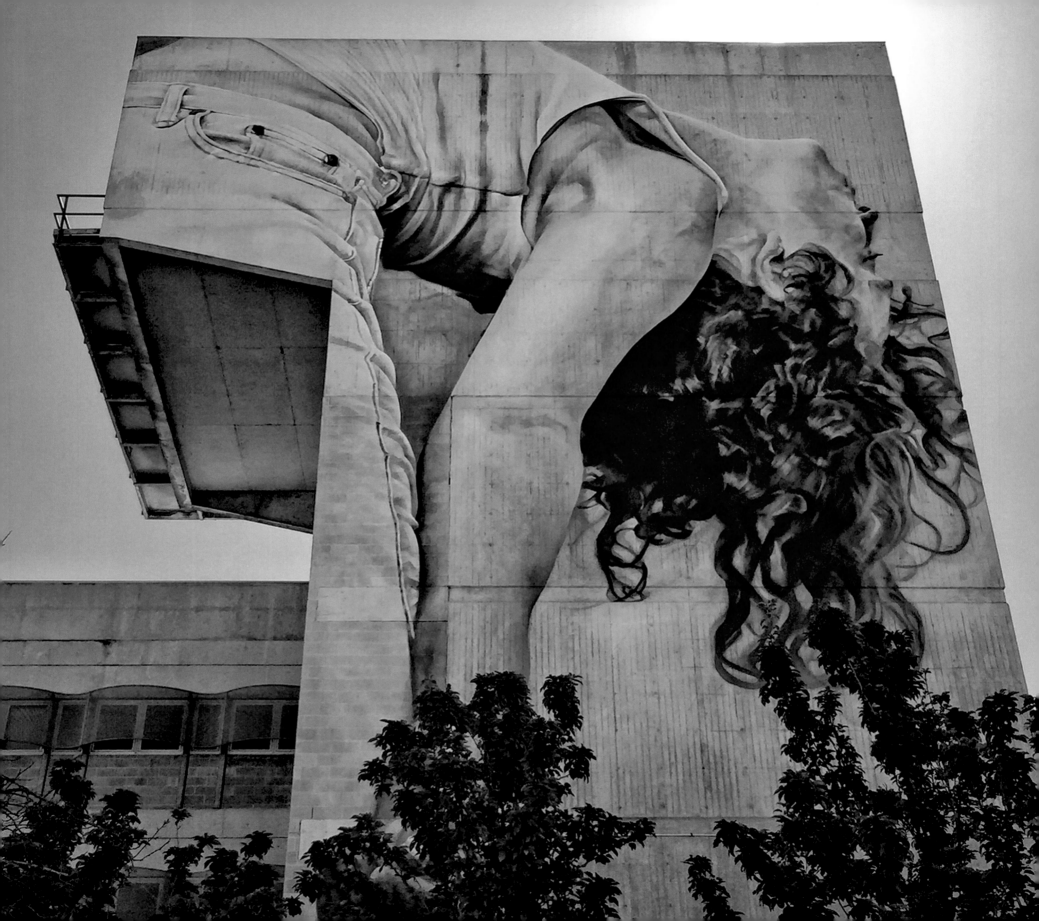

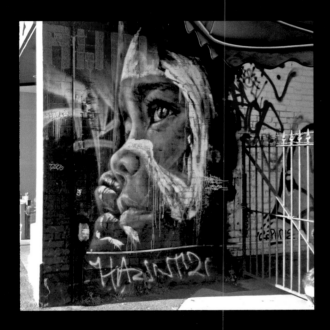

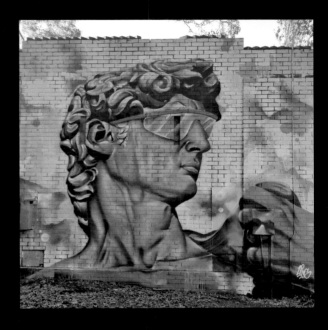

OPPOSITE **Guido van Helten**, Melbourne, Australia | ABOVE LEFT **Adnate**, Melbourne, Australia | ABOVE MIDDLE **Elle and Vexta**, Melbourne, Australia | ABOVE RIGHT **Lingerid**, Melbourne, Australia | NEXT SPREAD **Elk**, Melbourne, Australia

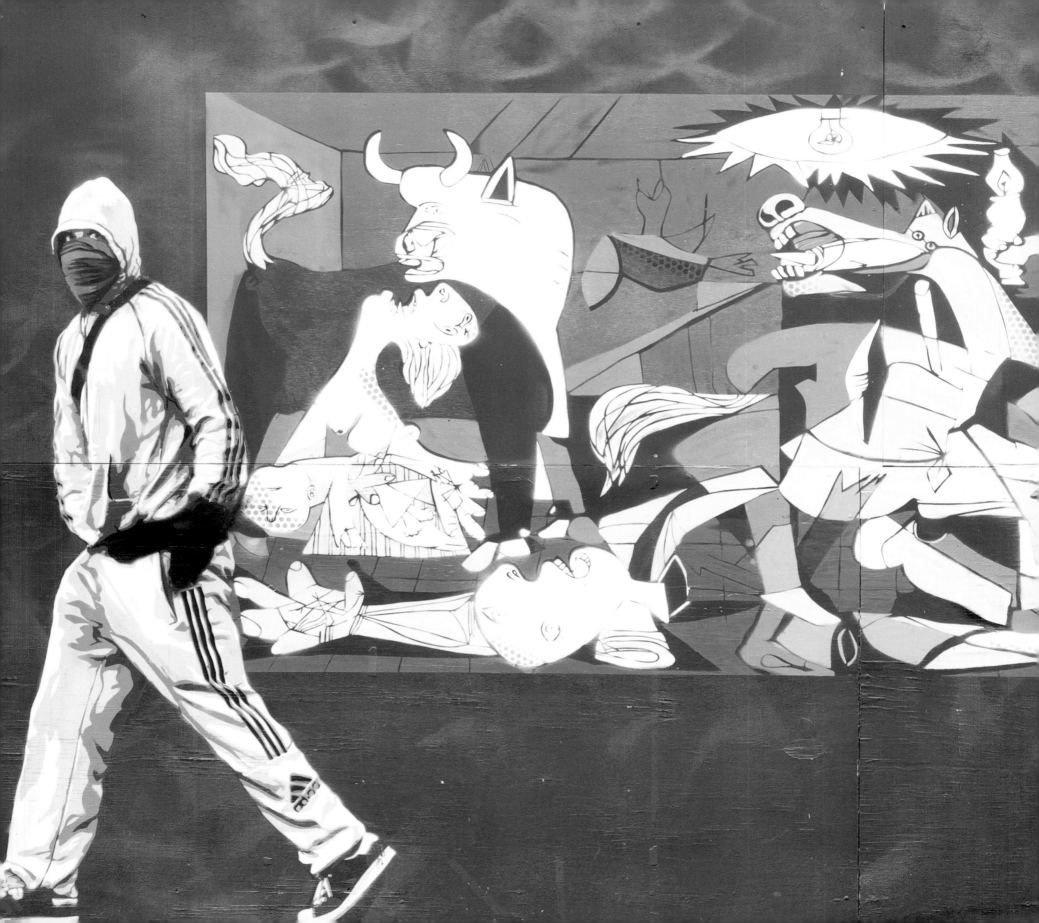

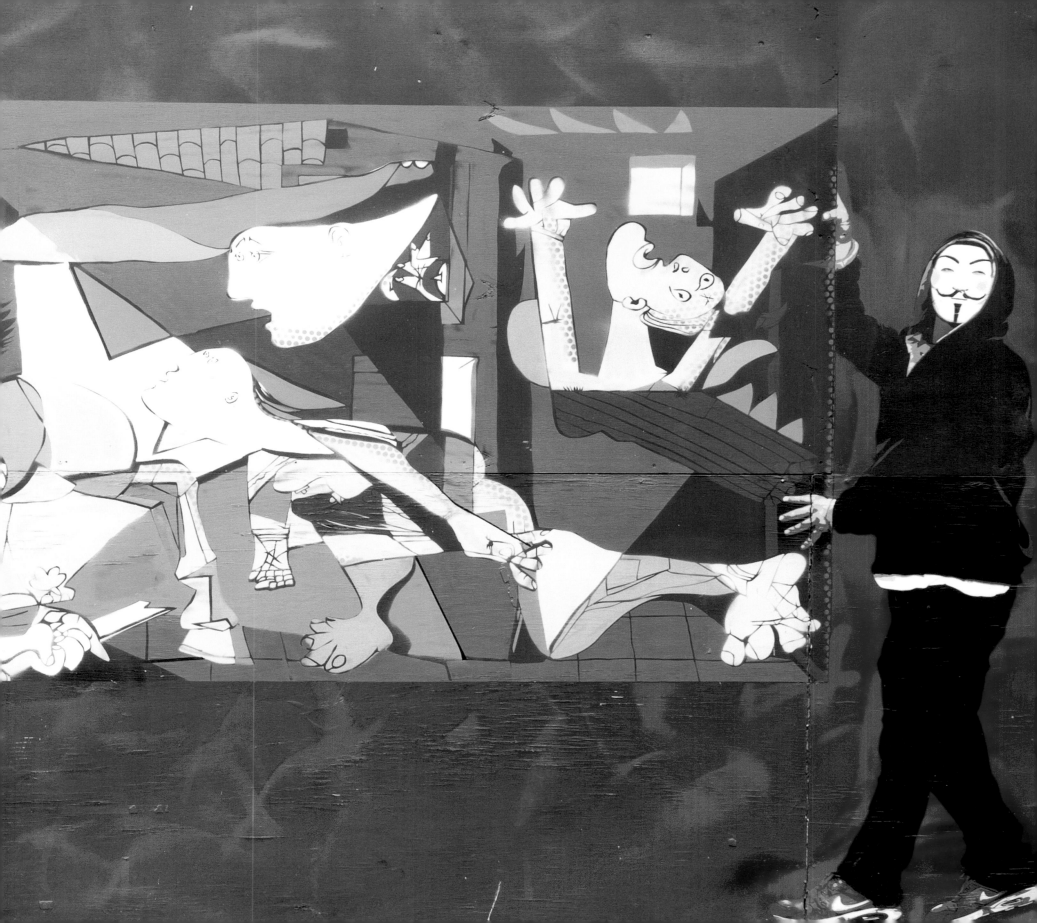

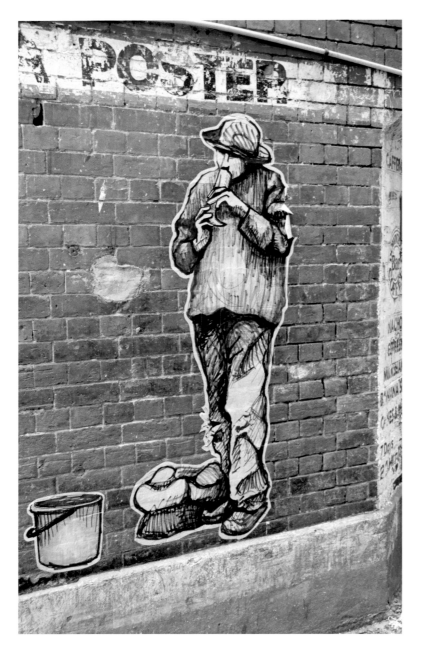 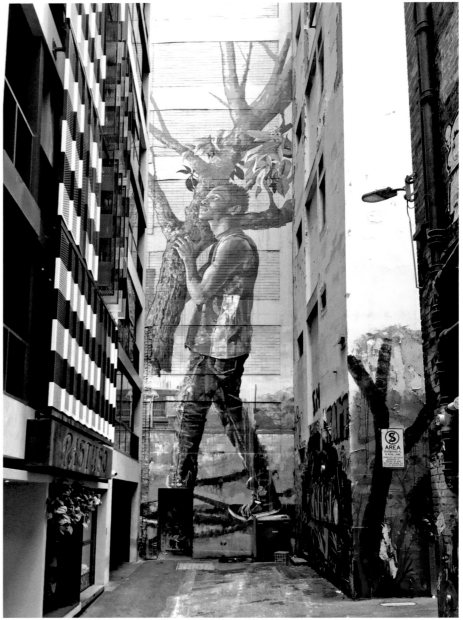

ABOVE LEFT **Unknown**, New Zealand | ABOVE RIGHT **Fintan Magee**, Melbourne, Australia | OPPOSITE LEFT **Pleghm**, Perth, Australia | OPPOSITE RIGHT **Fintan Magee**, New Zealand

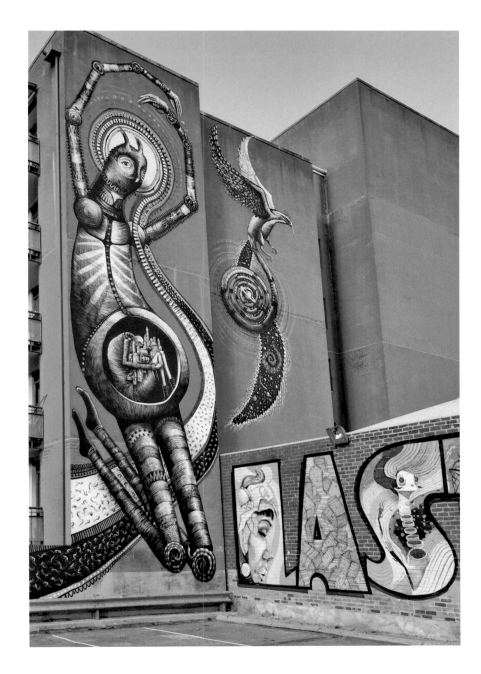

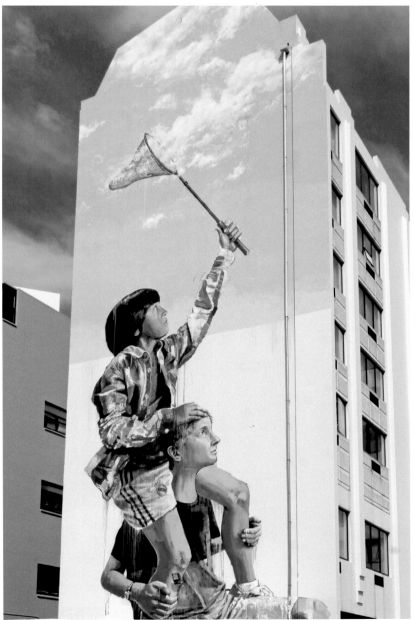

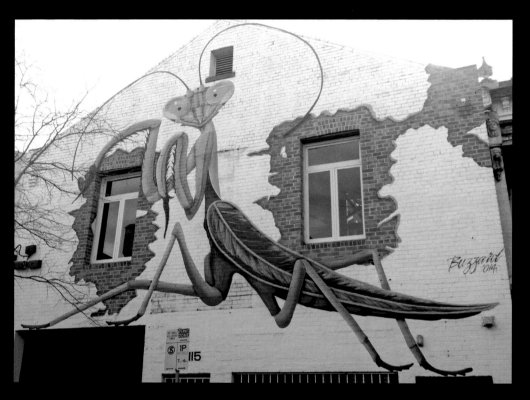 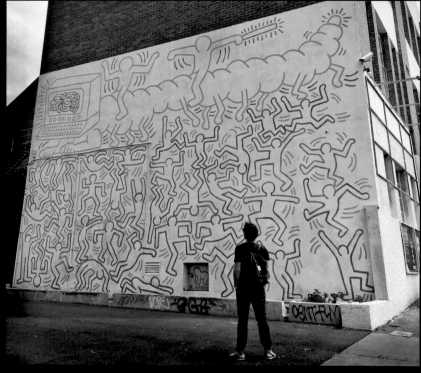

ABOVE LEFT **Buzzard**, Melbourne, Australia | ABOVE RIGHT **Keith Haring**, Collingwood, Melbourne, Australia | OPPOSITE **Charles & Janine Williams**, Christchurch, New Zealand

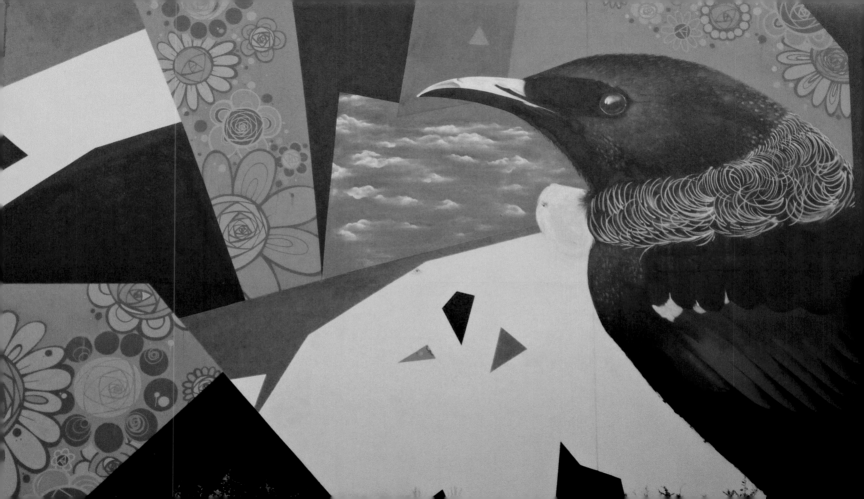

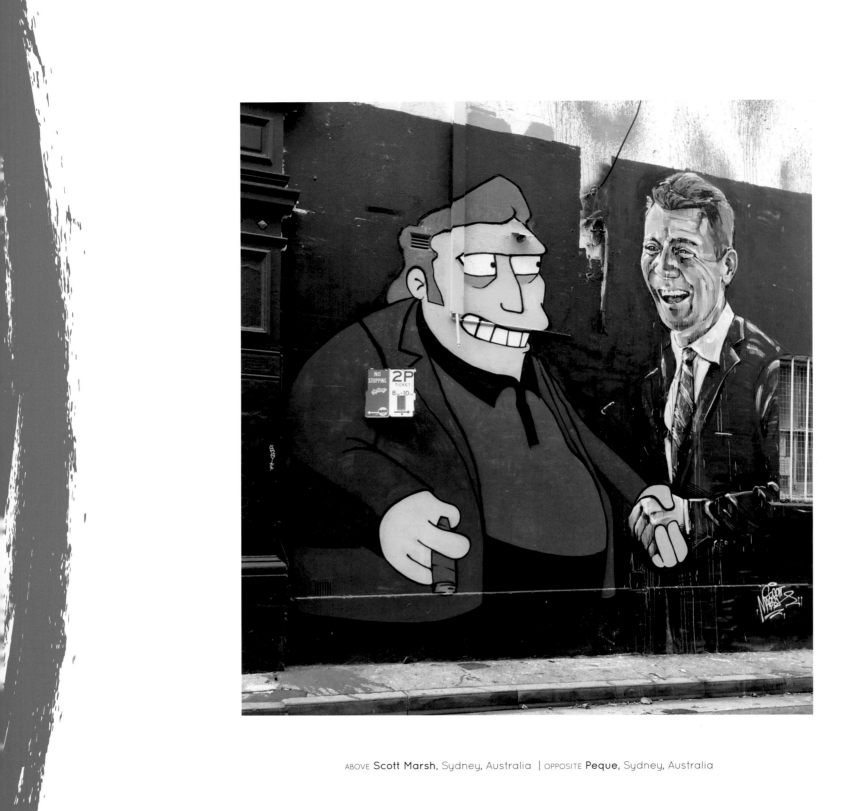

ABOVE **Scott Marsh,** Sydney, Australia | OPPOSITE **Peque,** Sydney, Australia

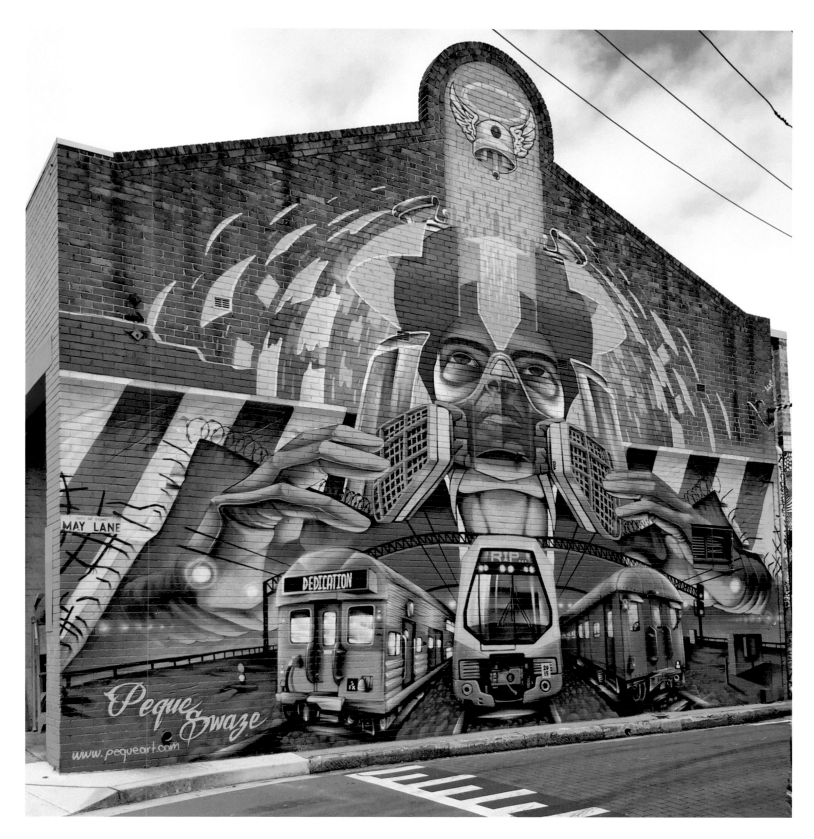

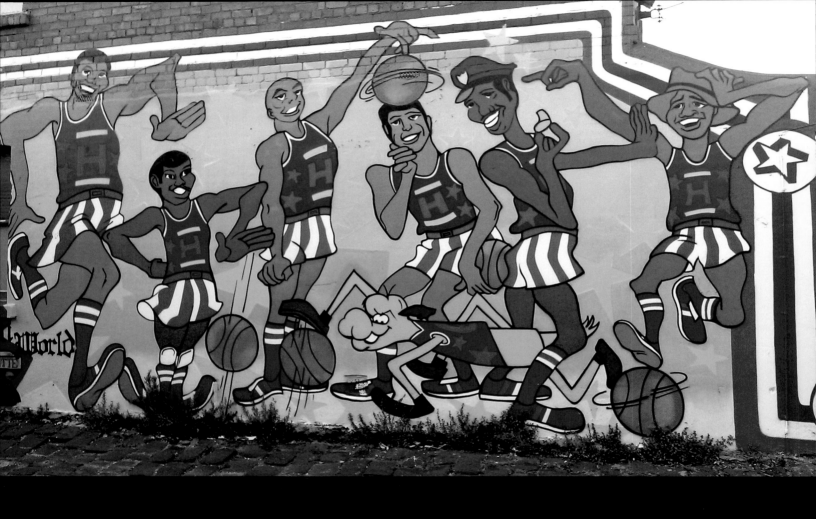

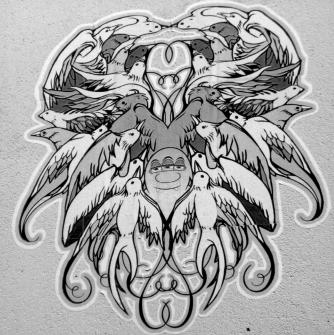

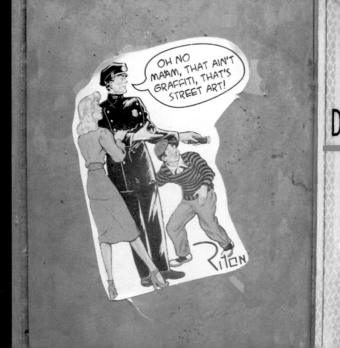

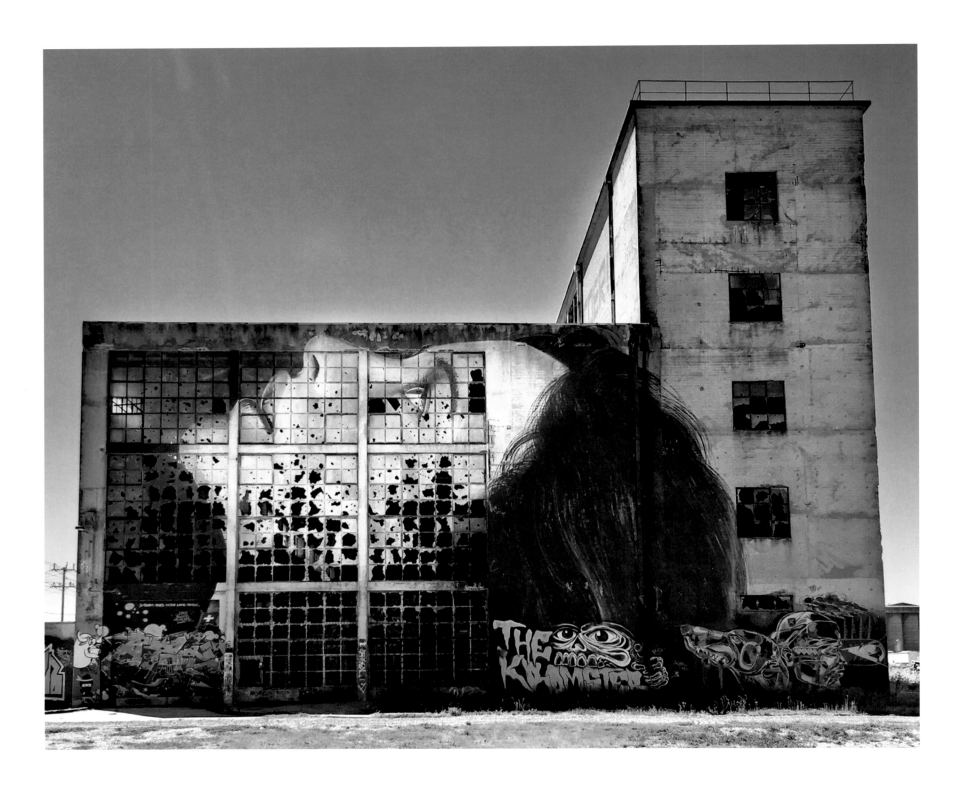

ABOVE **Rone**, Melbourne, Australia | OPPOSITE **DALeast**, Dunedin, New Zealand

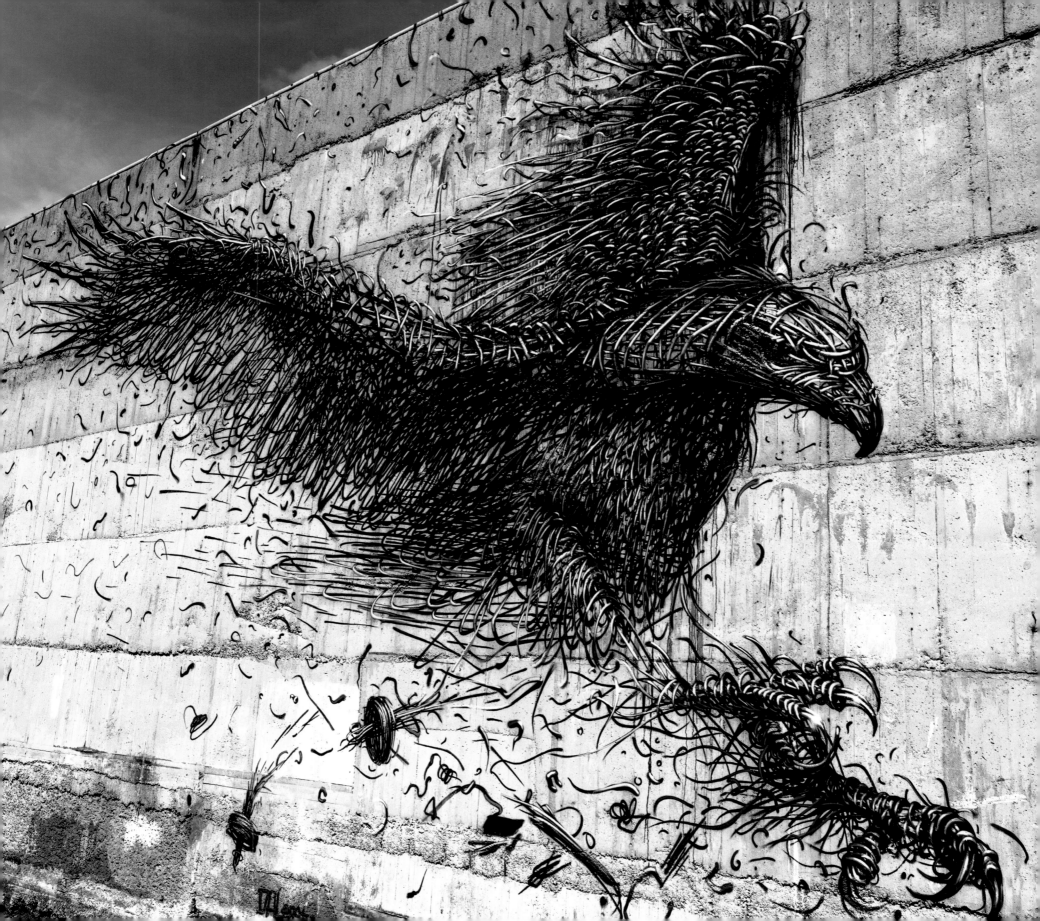

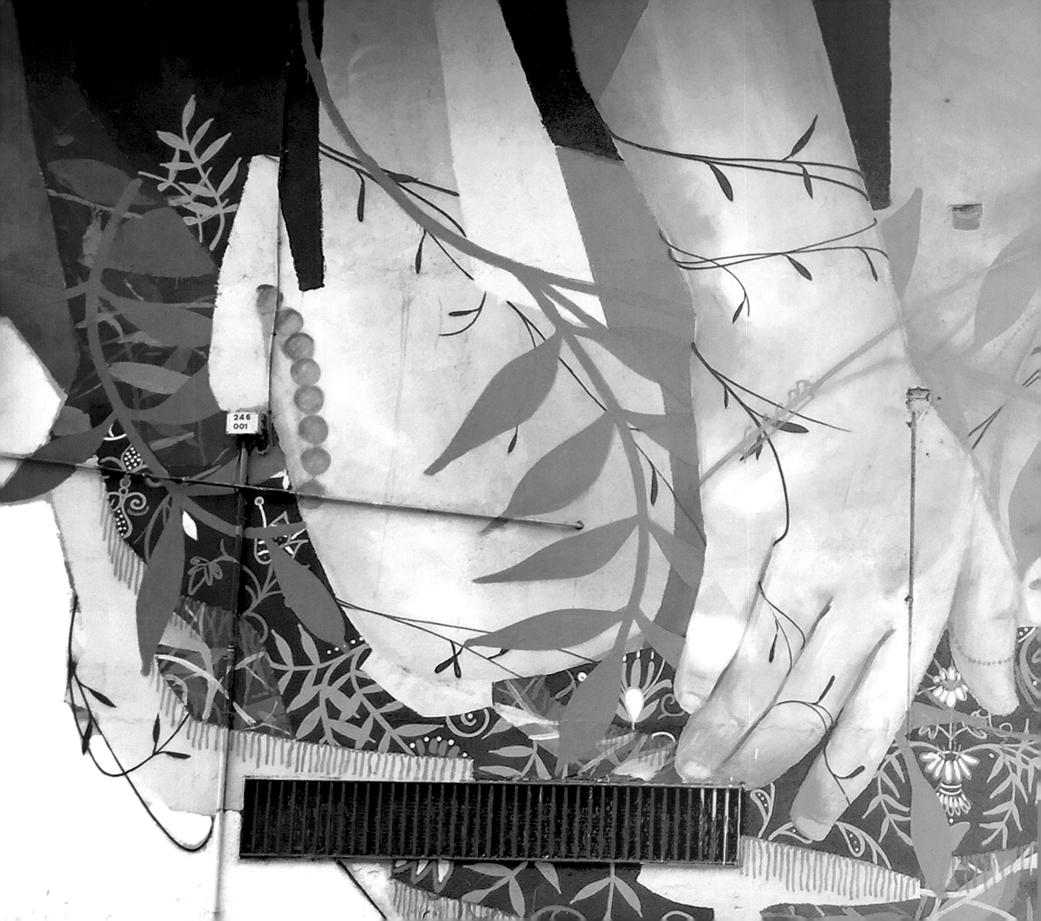

EUROPE

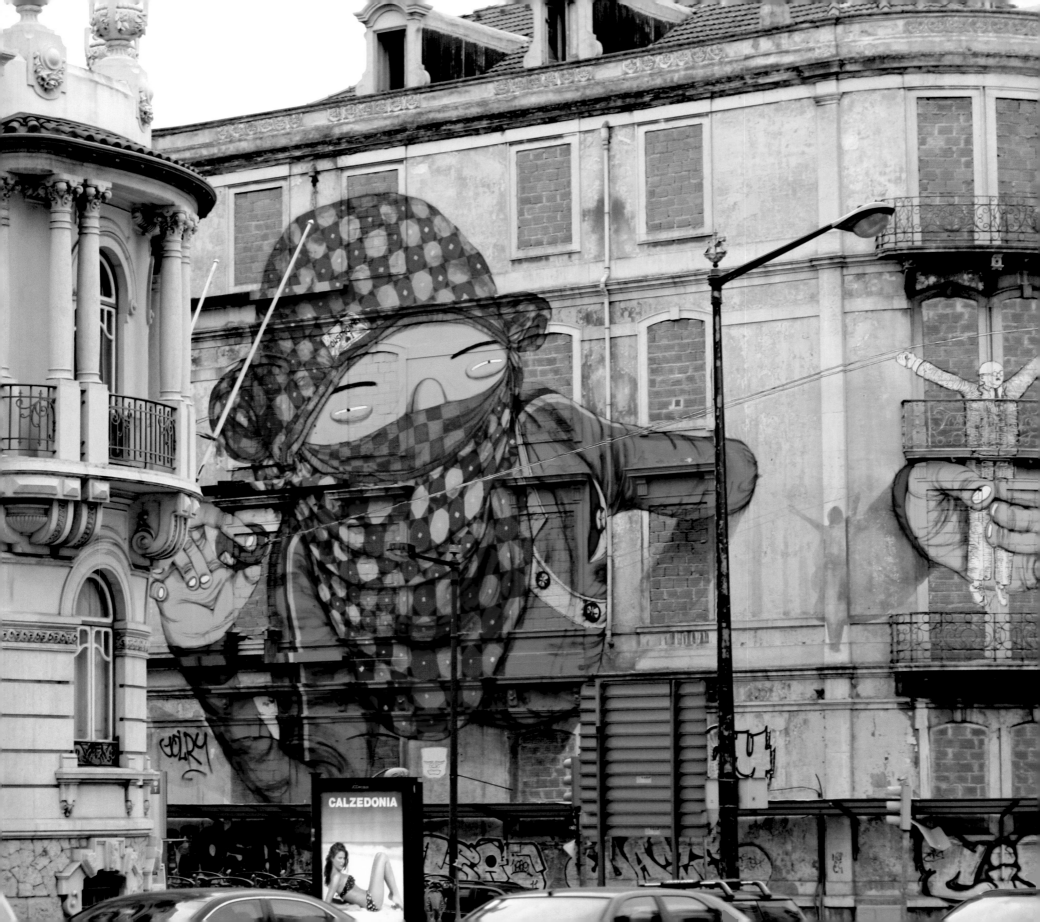

EUROPE

The history of Western art owes a great debt to a few Western European countries and their art institutions. The art academies—which first appeared in Italy in the sixteenth century and spread to France and other European countries in the seventeenth century—became the premier centers for arts education and models for art schools around the world. The political power of these countries significantly contributed not only to the increasing number of artists, but also to the acquisition of masterpieces, which supplied many of Europe's museum collections. Academic art history casts a large shadow over contemporary artists working in these countries, and it becomes a necessary backdrop for understanding the emergence of street art in Europe.

Street art in the twenty-first century looks very different in cities that wear their history throughout their urban and suburban landscapes. It's an art form that contrasts sharply with this history and provides an alternative to tradition and to the establishment. While the great museums of Europe collect and preserve masterpieces, street art is a fresh and exciting development that was born in spontaneity and opposition to the heavy hand of history. Because it is created out of doors in public spaces, its placement alone is revolutionary.

The Italian and French academies were among the first to professionalize the discipline of art in the sixteenth and seventeenth centuries. By imbuing certain values and establishing charters for regulating the practice and organization of teaching, these academies formulated a professional atmosphere that was quite different from that of the craftsmen workshops of the time. Young artists learned to draw and sculpt the human figure with time-tested techniques and deftness of hand. Perfection was the ideal, and the more realistic one could make the work of art, the more acclaim it received. Interestingly, as street art has evolved, artists have embraced these figurative qualities, prizing technique and realism once again.

The French Academy was the epicenter of this true-to-life approach to painting and sculpture, and this practice spread throughout the majority of European art academies. And while street art exists outside the traditional academic institutions, both physically and conceptually, this rich history of artistic tradition is a wonderful backdrop for art in streets. Although the grand history of European art and the age of Europe's cities may not compare to the younger and less-established locales portrayed here, the stark contrasts that we have come to associate with and appreciate about street art are accentuated.

—G. JAMES DAICHENDT

Os Gêmeos, Portugal

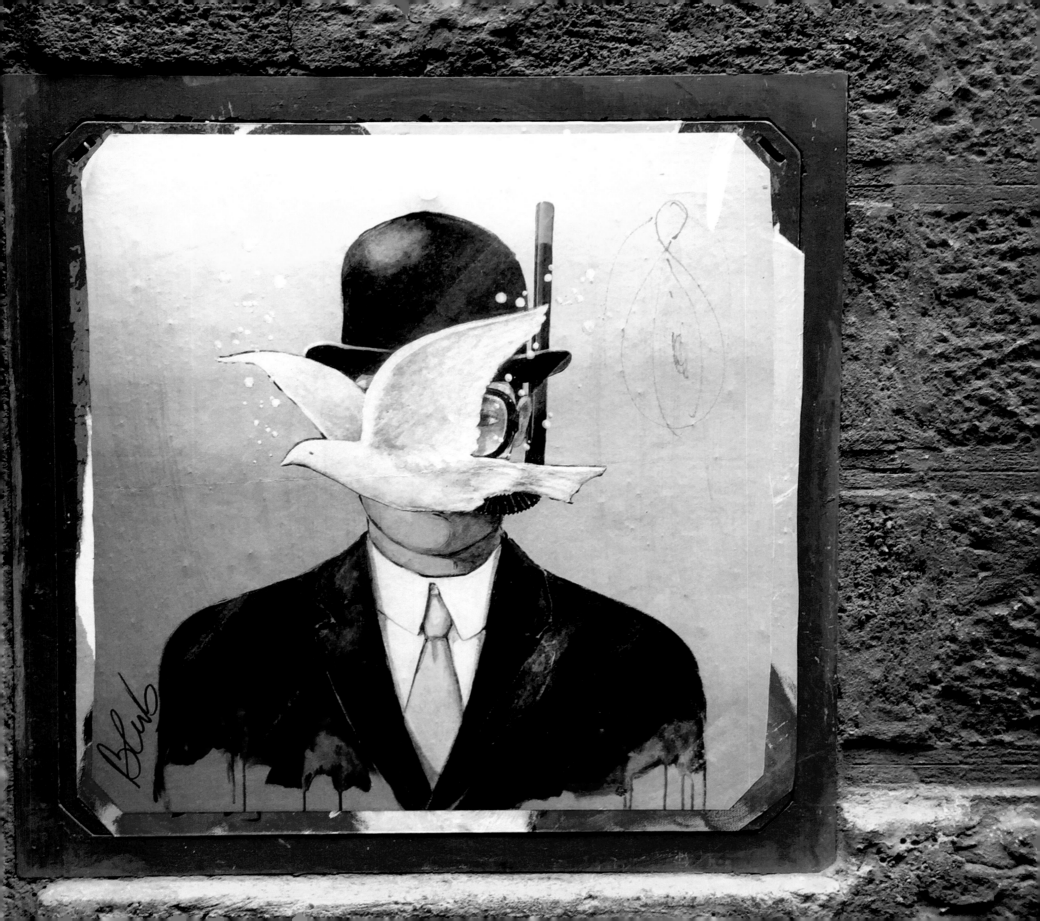

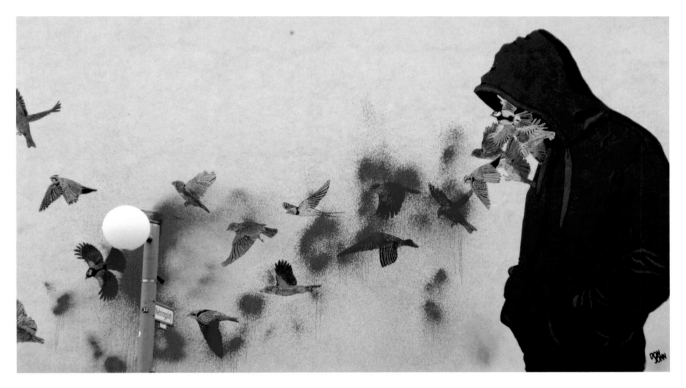

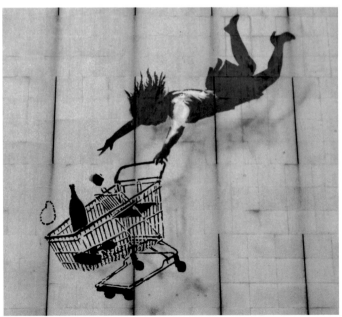

OPPOSITE **Blub**, Florence, Italy | CLOCKWISE FROM TOP **Don John**, Berlin, Germany | **Banksy**, London, UK | **Gregos**, London, UK

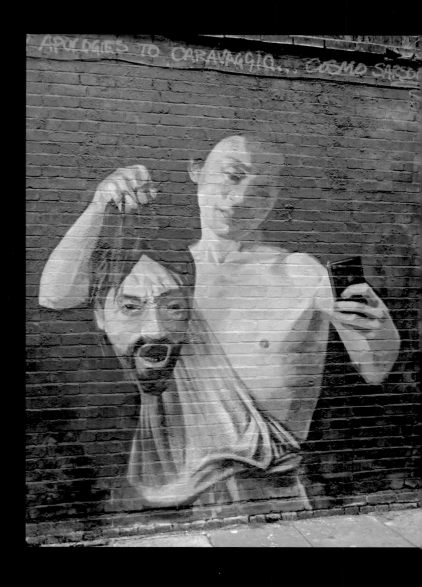

OPPOSITE **Luis Gomez de Teran**, London, UK | ABOVE **Cosmo Sarsen**, London, UK

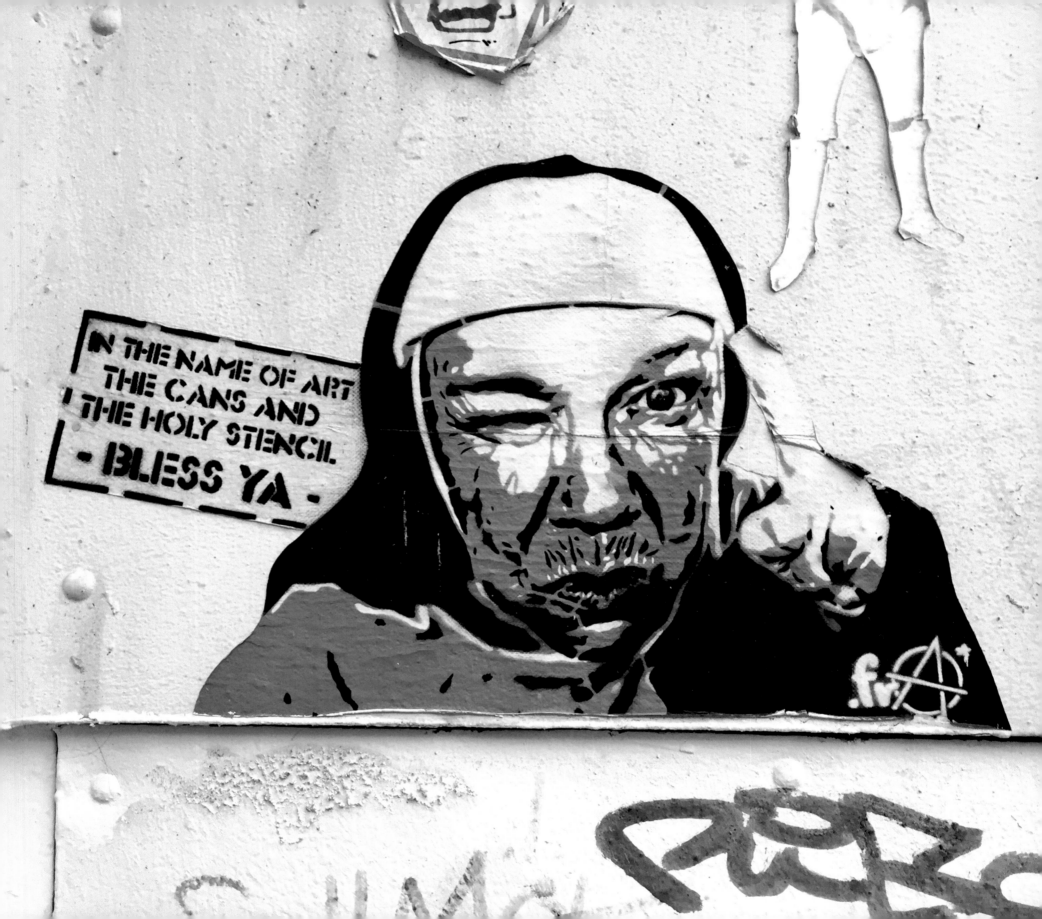

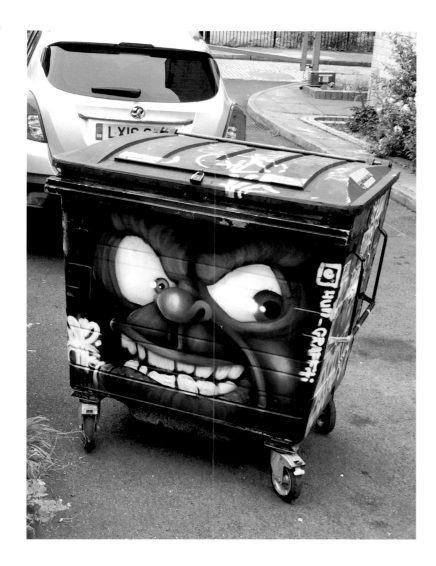

OPPOSITE **Fra**, London, UK | ABOVE LEFT **Hull Graffiti**, London, UK | ABOVE RIGHT **Unknown**, Amsterdam, the Netherlands

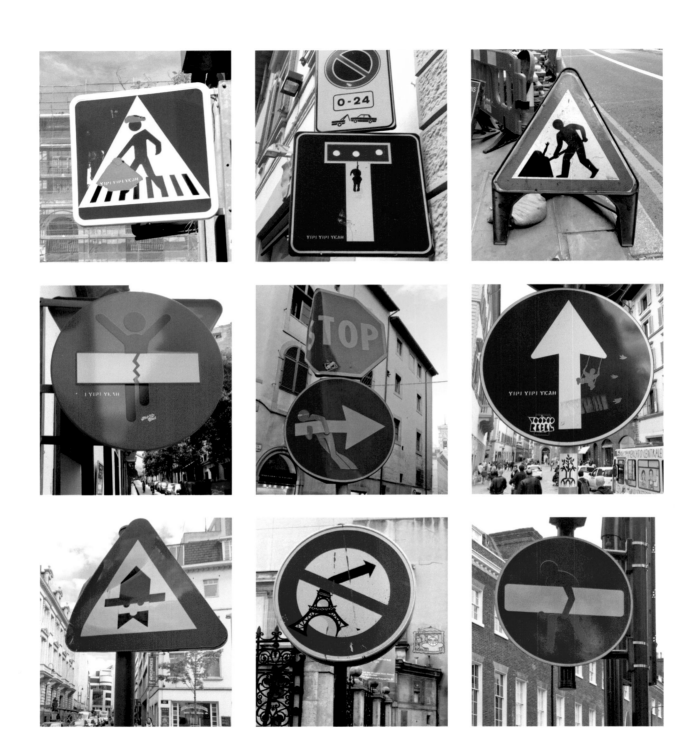

ABOVE, CLOCKWISE FROM TOP LEFT **Yipi Yipi Yeah**, Madrid, Spain | **Clet**, Florence, Italy | **Unknown**, London, UK | **Yipi Yipi Yeah**, Florence, Italy | **Clet**, London, UK | **Clet**, Paris, France | **Clet**, Paris, France | **Yipi Yipi Yeah**, Madrid, Spain | **Clet**, Florence, Italy | OPPOSITE **Unknown**, Madrid, Spain

140

OPPOSITE **Herr von Bias**, Berlin, Germany | CLOCKWISE FROM TOP LEFT **K**, Florence, Italy | **André**, Venice, Italy | **Unknown**, Paris

OPPOSITE **Shepard Fairey**, London, UK | ABOVE **El Rey de la Ruina**, Madrid, Spain

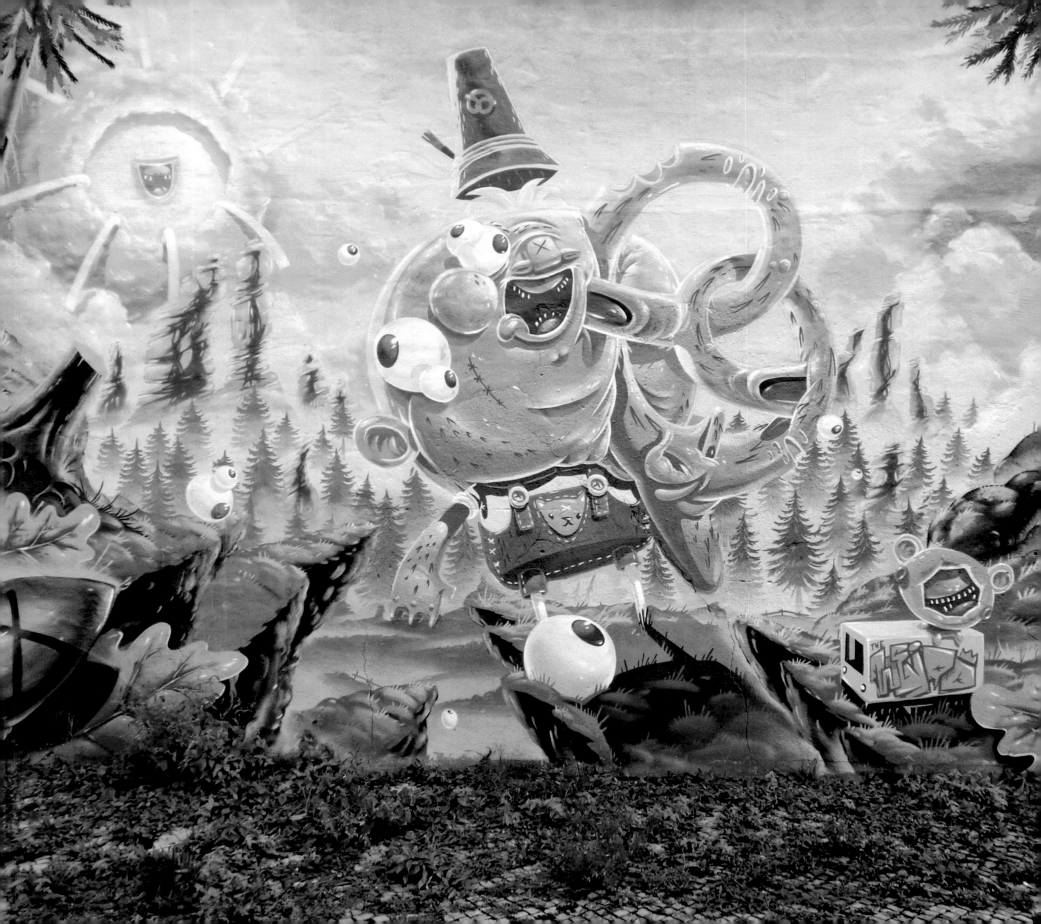

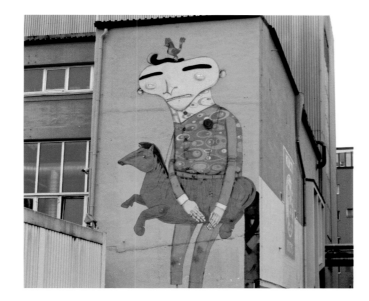
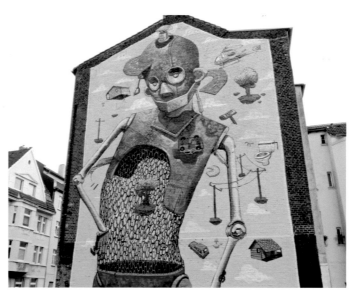
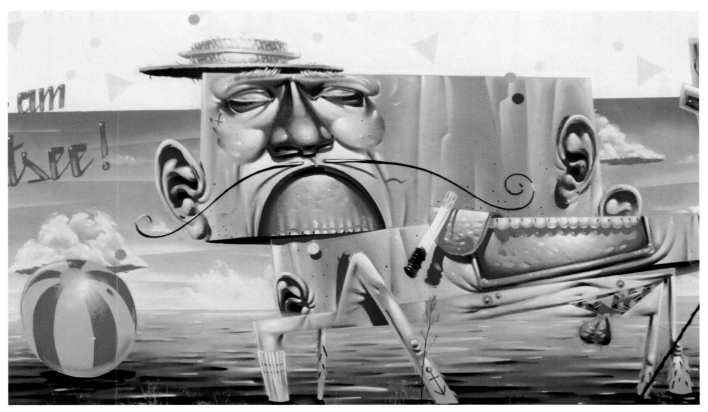

OPPOSITE **Herr von Bias,** Berlin, Germany | CLOCKWISE FROM TOP LEFT **Os Gêmeos,** Berlin, Germany | **Pixel Pancho,** Düsseldorf, Germany | **Herr von Bias,** Berlin, Germany

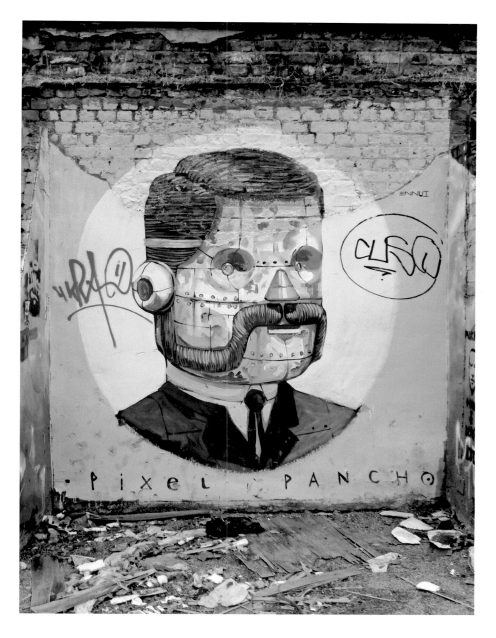

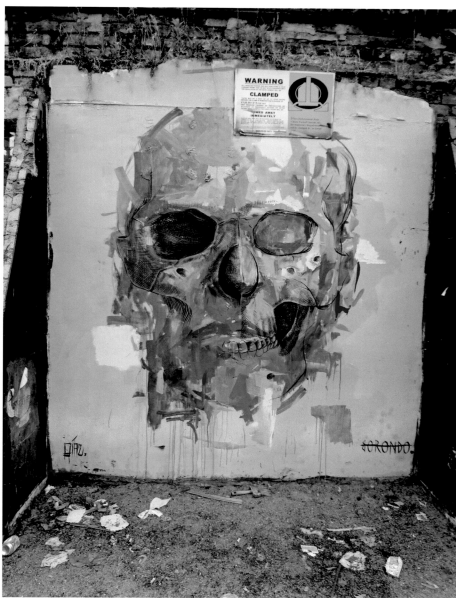

OPPOSITE **Cartrain**, London, UK | ABOVE LEFT **Pixel Pancho**, London, UK | ABOVE RIGHT **Alex Diaz & Borondo**, London, UK

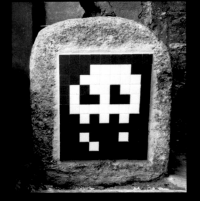

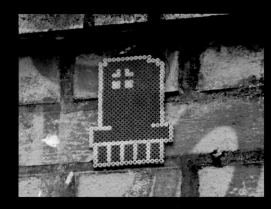

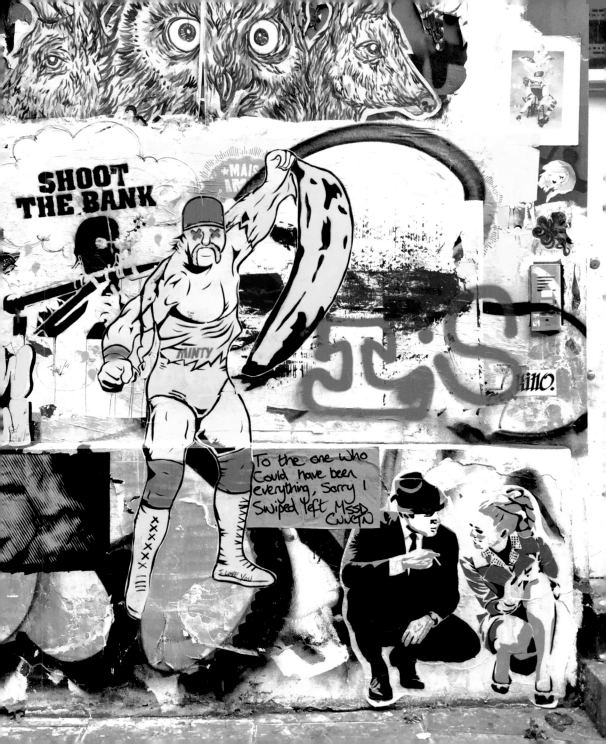

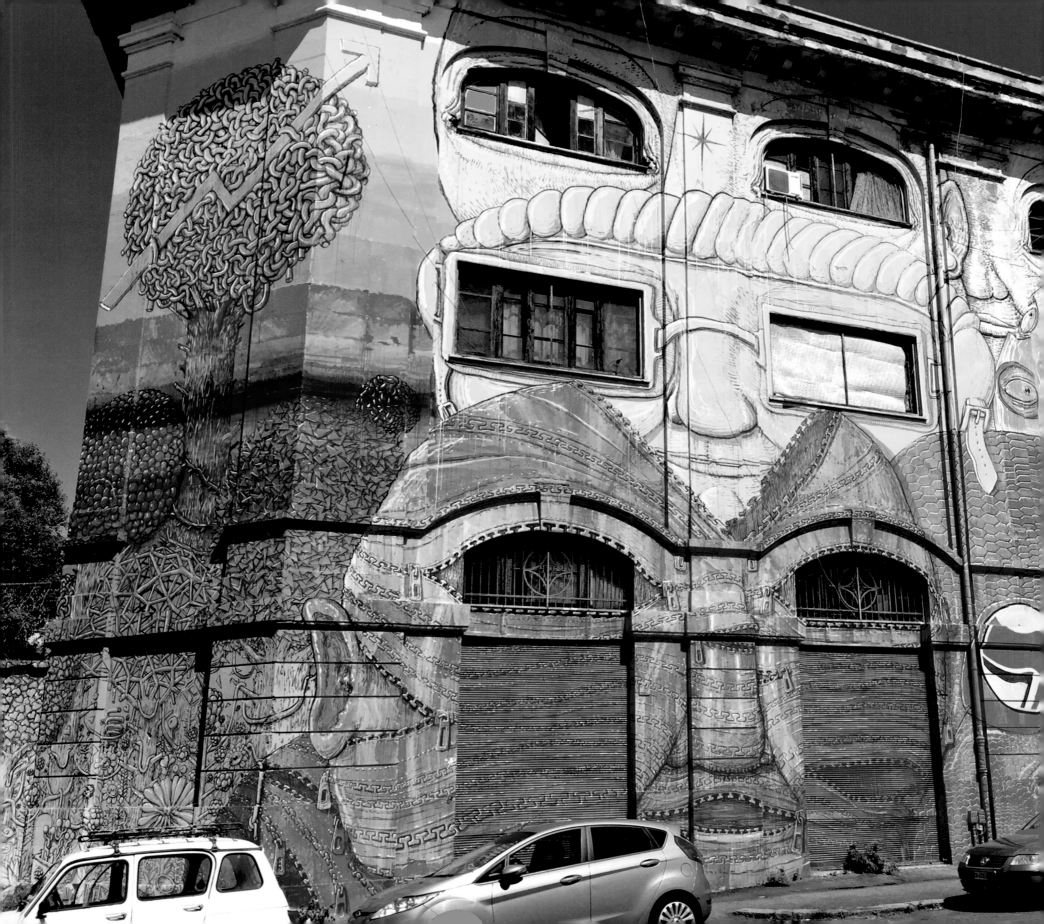

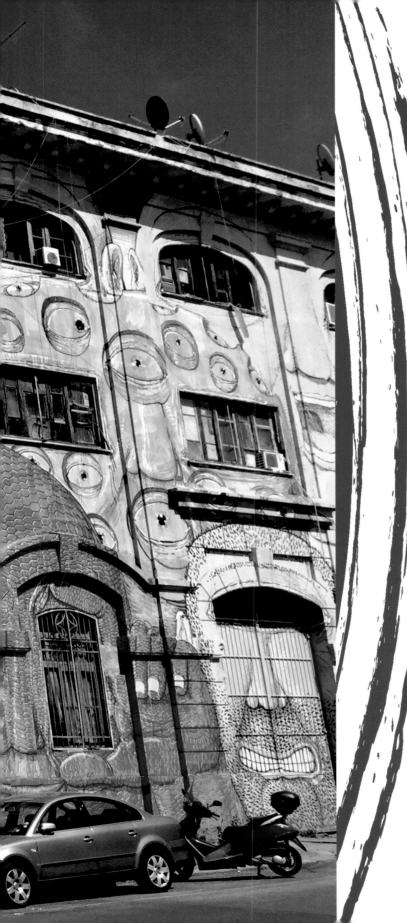

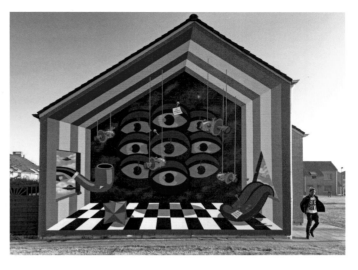

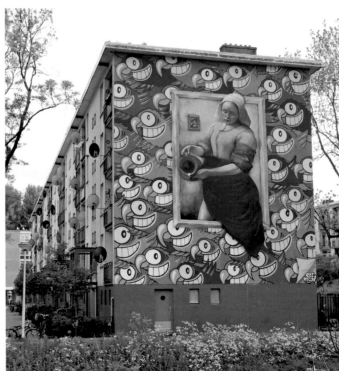

OPPOSITE **Blu**, Rome, Italy | TOP **Chase**, Belgium | ABOVE **El Pez & Danny Recal**, Amsterdam, the Netherlands

153

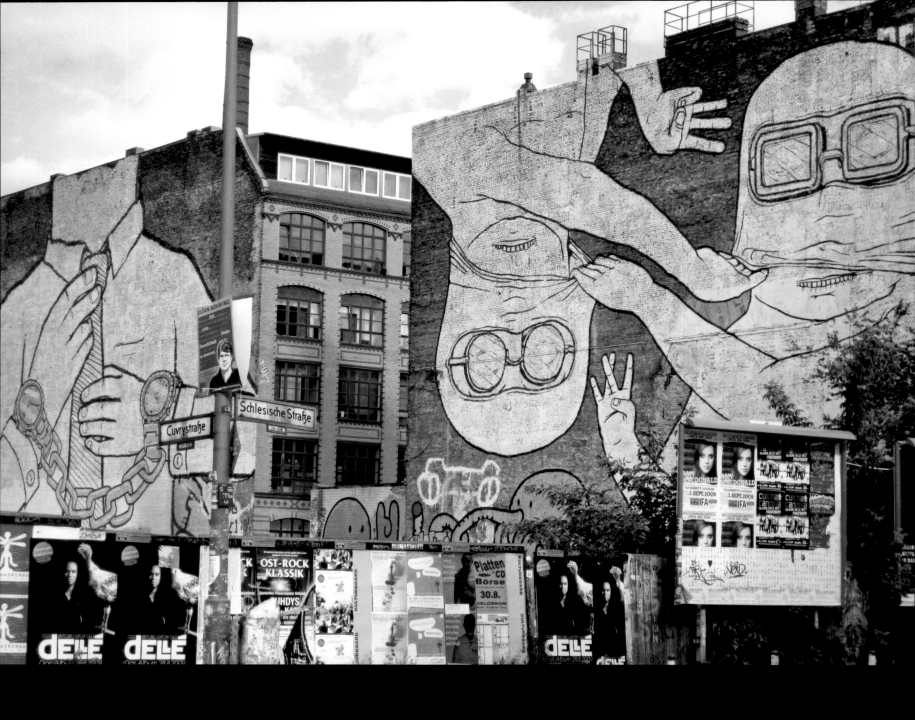

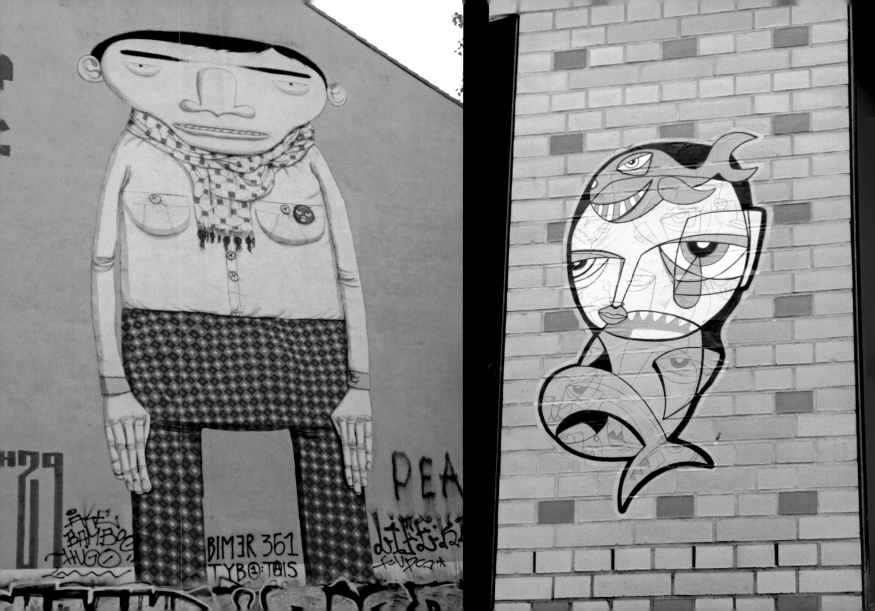

OPPOSITE **Okudart**, Madrid, Spain | ABOVE LEFT **Stinkfish**, Amsterdam, the Netherlands | ABOVE RIGHT **Fin DAC**, Madrid, Spain

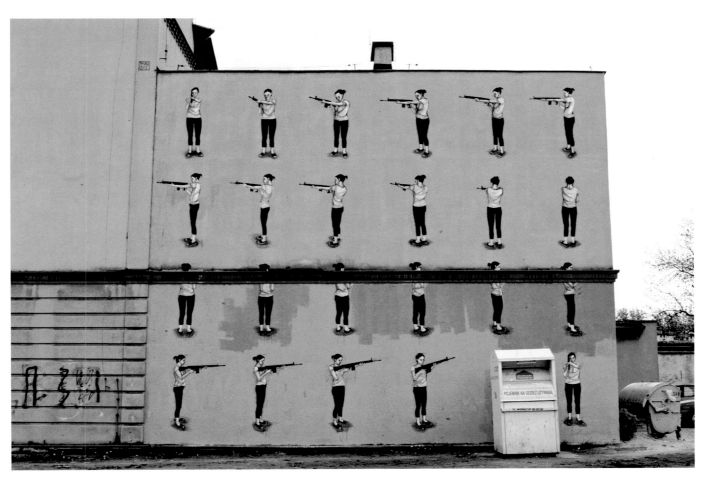

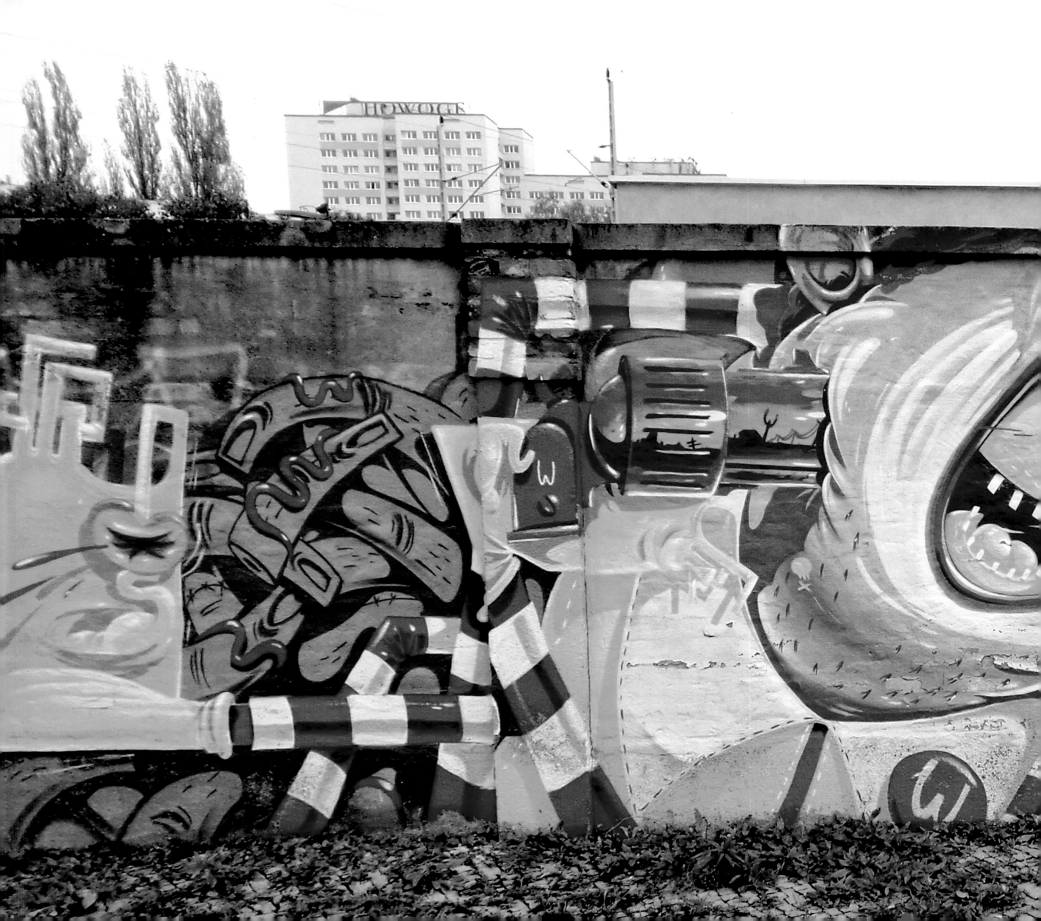

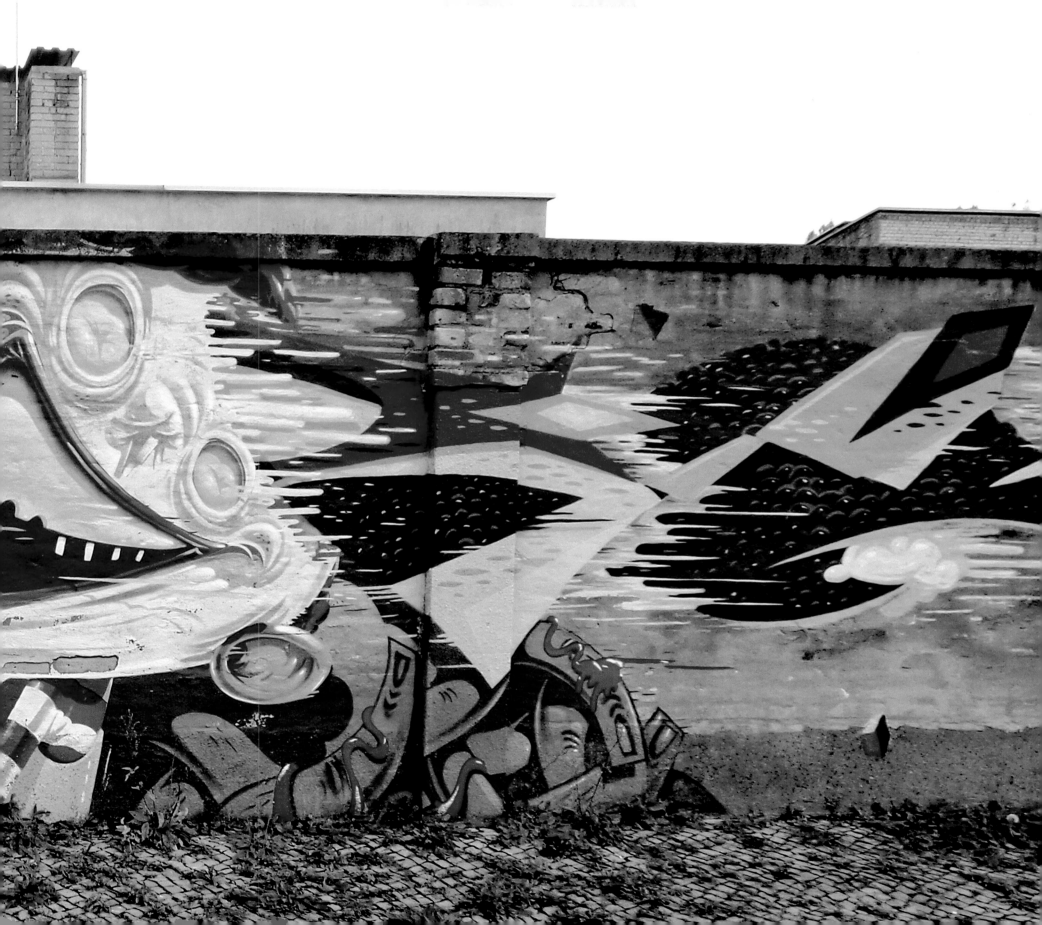

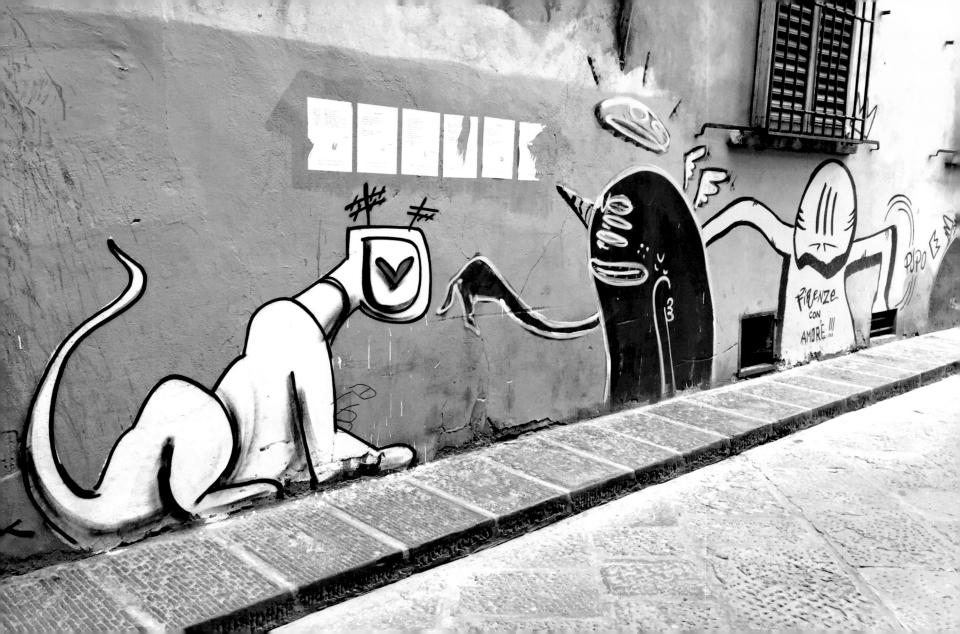

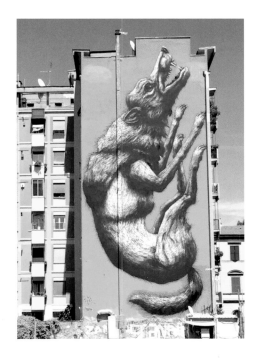
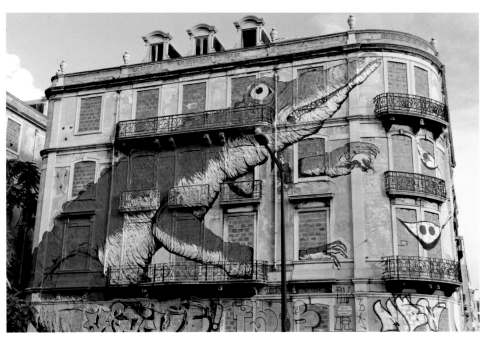
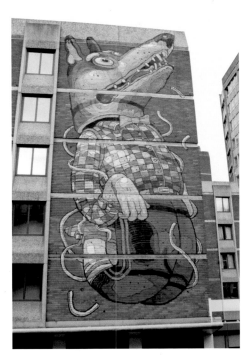
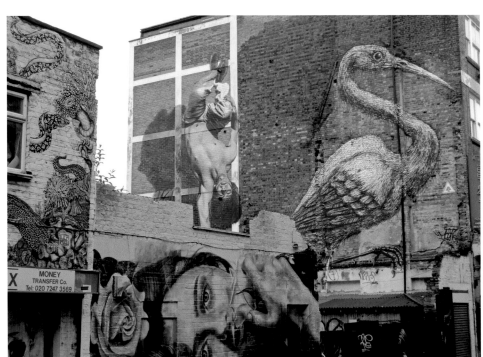

OPPOSITE **Unknown**, Florence, Italy | ABOVE, CLOCKWISE FROM TOP LEFT **ROA**, Rome, Italy | **Ericailcane**, Lisbon, Portugal | **ROA**, London, UK | **Aryz**, Bristol, UK

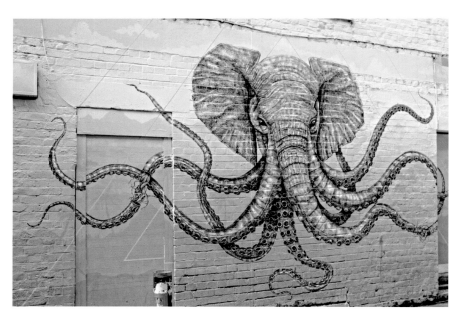

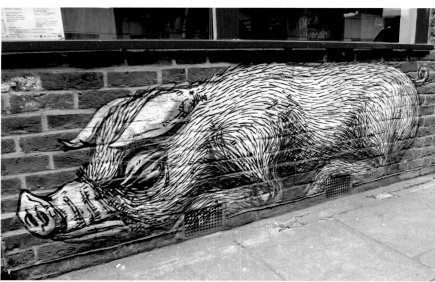

ABOVE, CLOCKWISE FROM TOP LEFT **Herakut**, Berlin, Germany | **Alexis Diaz**, London, UK | **ROA**, Madrid, Spain | **Louis Masai**, London, UK | OPPOSITE **ROA**, Copenhagen, Denmark

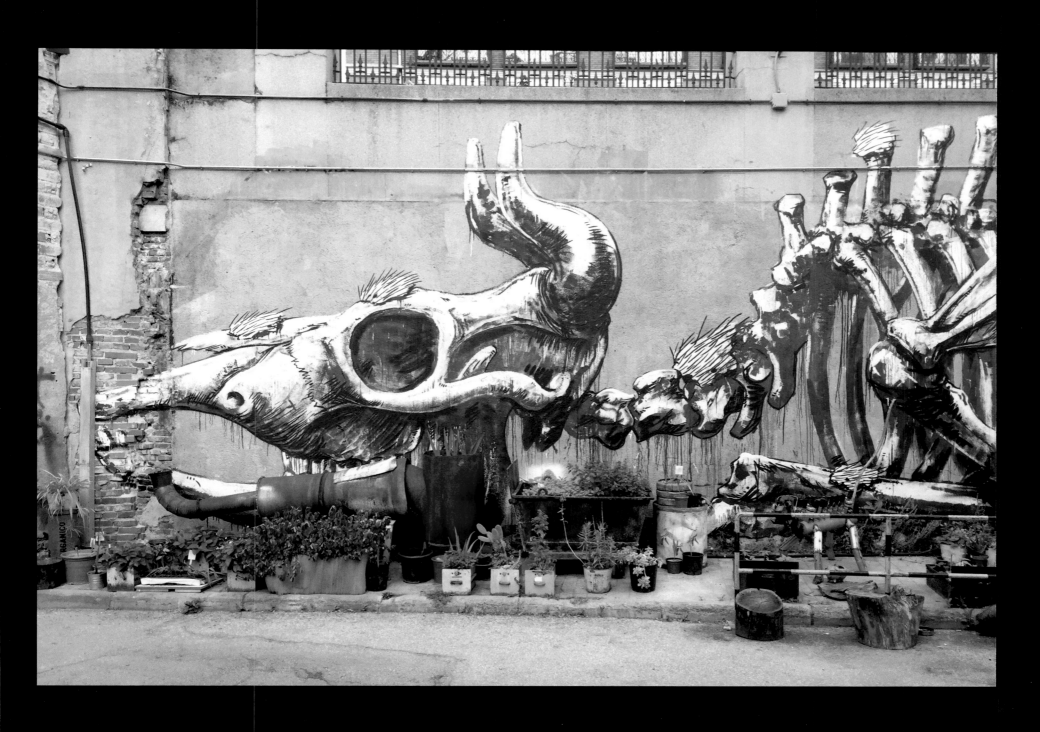

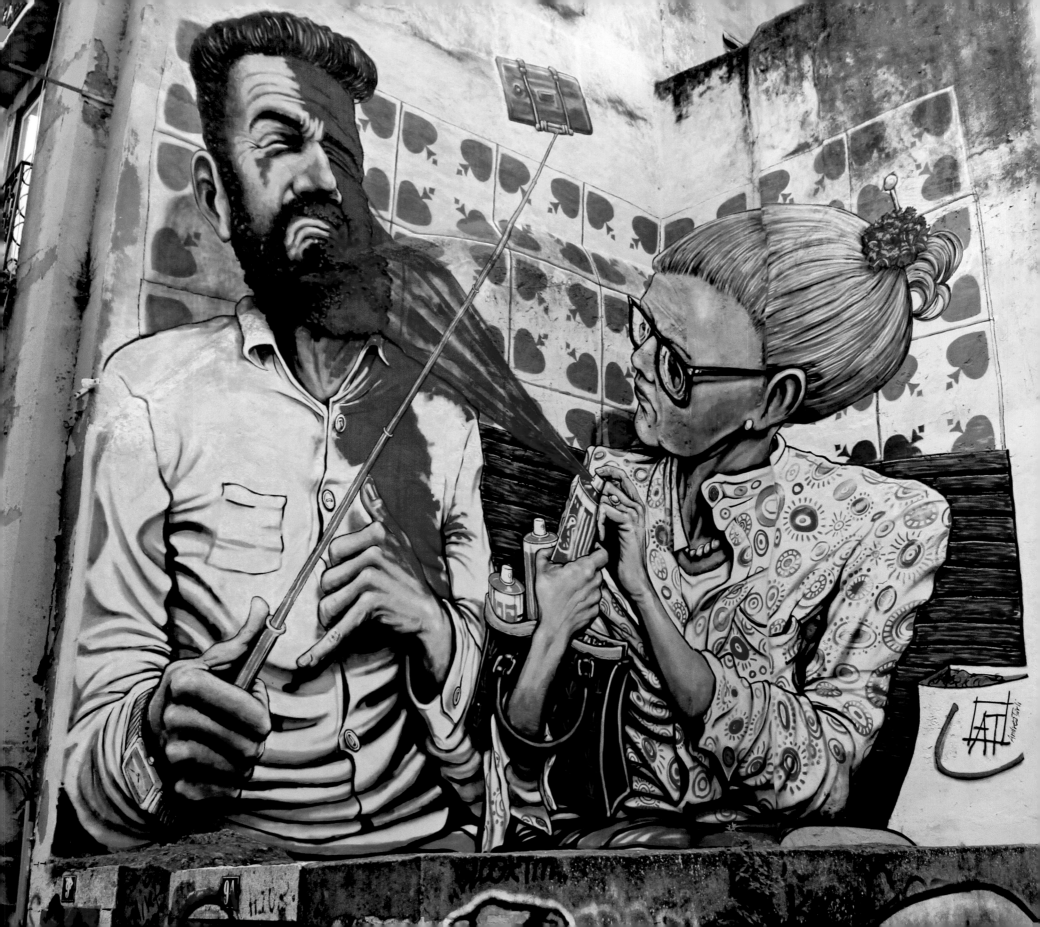

OPPOSITE **Andrea Tarli**, Lisbon, Portugal | TOP **Nomad**, Berlin, Germany | ABOVE **Fred le Chevalier**, Berlin, Germany

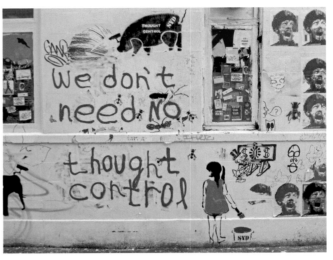

ABOVE, CLOCKWISE FROM LEFT **My Dog Sighs**, London, UK | **Unknown**, London, UK | **SYD**, London, UK | OPPOSITE **Shepard Fairey**, Berlin, Germany

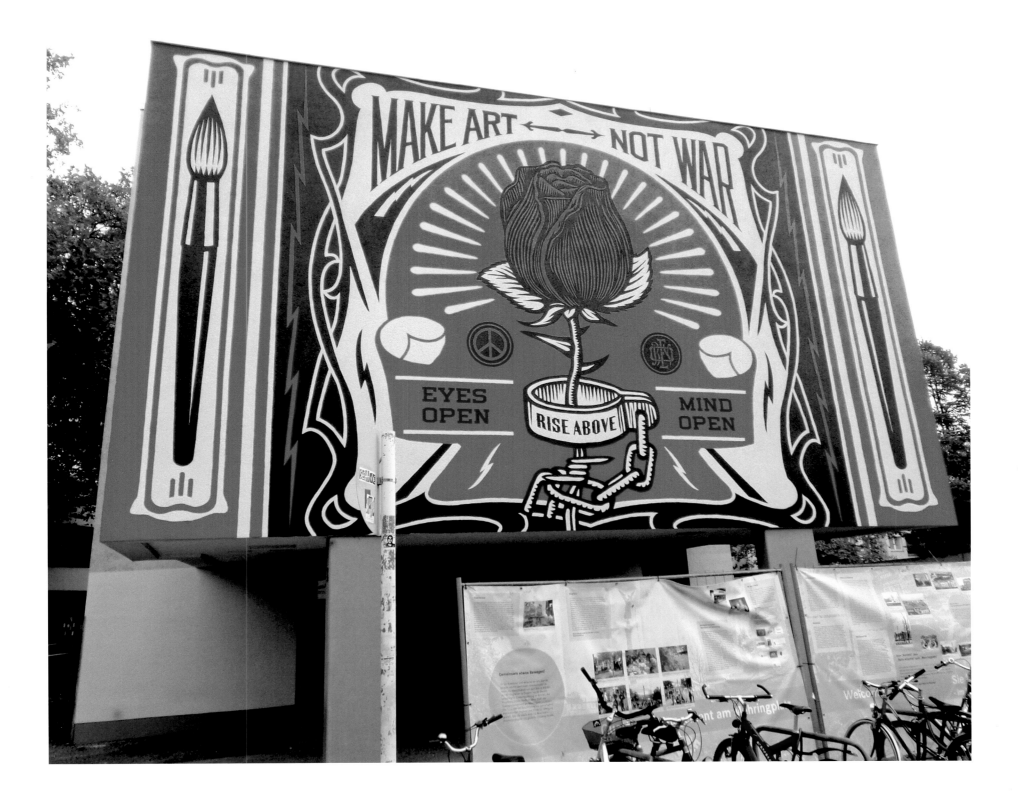

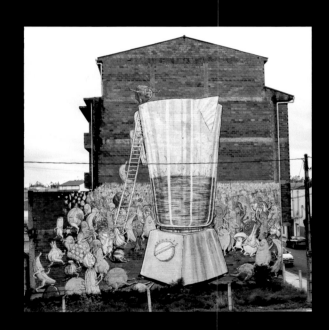
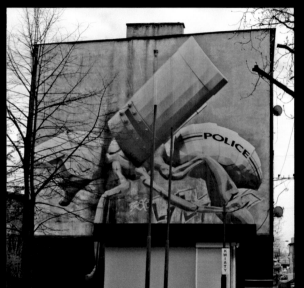

OPPOSITE **Zio Ziegler**, London, UK | ABOVE LEFT **Blu**, Krakow, Poland | ABOVE MIDDLE **Ludo**, Poland | ABOVE RIGHT **Liqen**, Spain

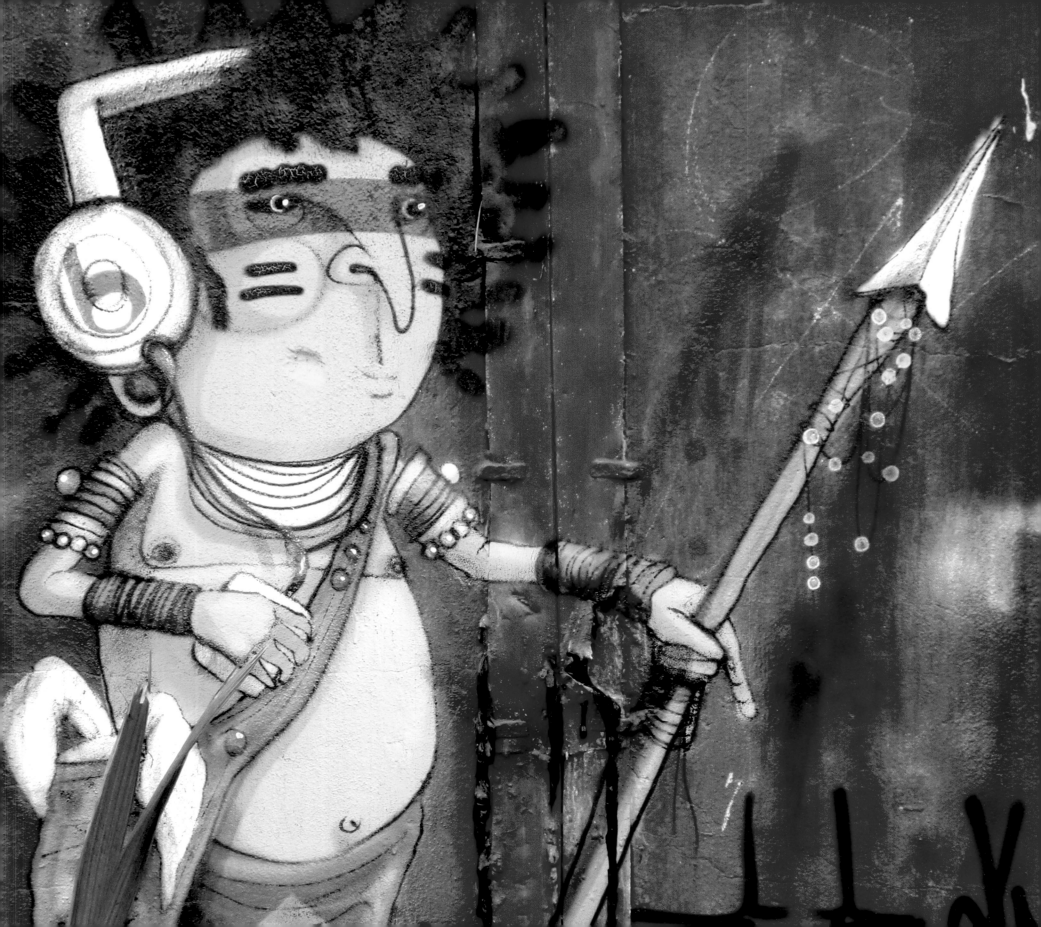

OPPOSITE **Cranio**, Berlin, Germany | ABOVE **Shepard Fairey**, Paris, France

ABOVE **Francisco Bosoletti**, Salamanca, Spain | OPPOSITE, CLOCKWISE FROM TOP LEFT **Unknown**, Paris, France | **Washfeet**, Madrid, Spain | **Authorised Graffiti Tunnel** in London, UK | **Ben Eine**, London UK | **Unknown**, London, UK

ASIA

寅

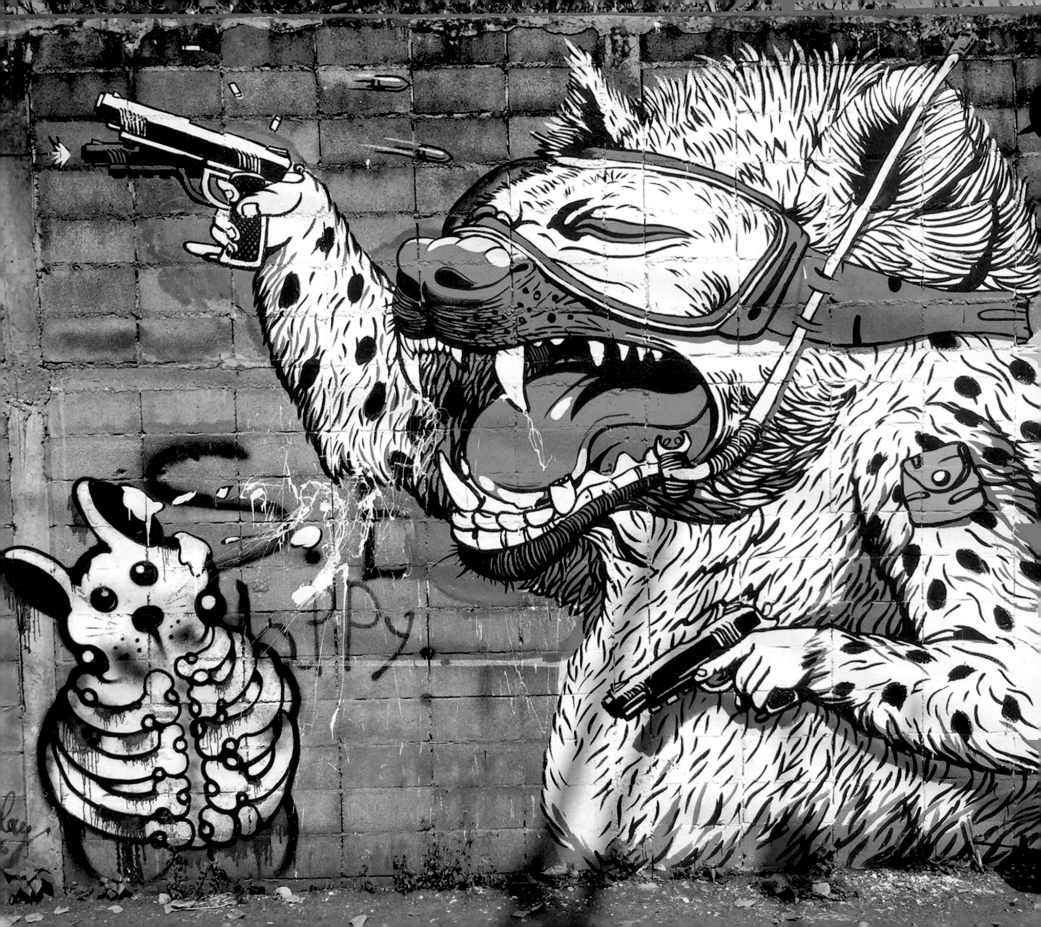

ASIA

Street artists, by design, are visual thieves who are free to draw from the entire lexicon of popular culture on a global scale. They are glorious saboteurs whose process of generating meaning through dislocation (of both image and site) simultaneously reclaims and makes exotic the cultural signs they use in their work. In many ways, this ad hoc process of cultural expression runs parallel with much of contemporary Asian culture. In cities such as Seoul, Tokyo, and Hong Kong, being Asian is defined not necessarily by physical location but by the complex intersections of East, West, and everything in between. The common patois in Singapore, Singlish, is a great example of this rich, chaotic mix, as the street language is a blend of English, Malay, Tamil, and Cantonese (along with several other Chinese dialects). While Singlish is definitely Singaporean, it is, at its core, an irreverent hybrid that challenges the cultural norm and exists because of street culture.

As a remix of signs that confronts the idea of preciousness and purity of identity, street art and the organic, unofficial contemporary culture in many Asian cities go hand in hand. Whether it's Thai-Japanese artist Yuree Kensaku's mythical Hindu/Buddhist deity Garuda, sartorially presented in a hip-hop aesthetic, complete with the signature teardrop over his left eye (a sign of mourning over the recent passing of Thailand's King Bhumibol) in Bangkok, or the legendary Indian musician Ravi Shankar with his sitar, anonymously stenciled with spray paint on a dirty wall in Udaipur, the dislocation and provocative mix of signs confront the viewer and ask, "Why the hell not?" In many Asian countries, where ongoing, rapid industrialism and globalization have raised the issue of cultural preservation as a crisis, street art questions how culture is owned and defined. The gesture of visually dislocating the definition of what is exactly Ravi Shankar or Garuda provides a critique of what culture actually is: a matrix of meanings that is constantly in flux.

For many Asian countries, their rise from third world status to emerge as economic powerhouses have shifted the direction of their cultural appetites. Gone are the times when modern Asian culture sought to copy all things Western. Now, the cultural elements that were once seen as Western derived have evolved into something wholly their own. Today, whether it's K-pop or *kawaii*, it is the West that envies the East. Nowhere is this more noticeable than in the ways in which street art, a phenomenon that originated in the United States, has been taken into various corners of Asia, absorbed and recast into something altogether new and distinctly Asian. Like Singlish, it is a multiplicity of street culture from around the world and a contradiction in what is traditionally known as the East; it is, in a word, contemporary Asia.

—CHRISTINA HYESOO VALENTINE, independent writer and curator. She is a professor of criticism and theory at the Art Center College of Design, Pasadena, California.

Bukruk, Thailand

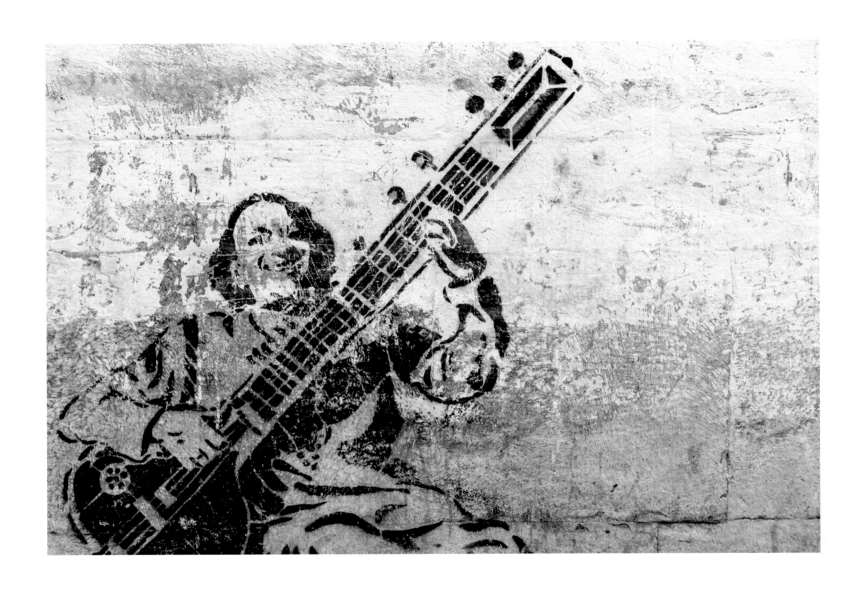

ABOVE **Unknown**, Udaipur, India | OPPOSITE **Rone**, Dubai, United Arab Emirates | NEXT SPREAD **P183**, Moscow, Russia

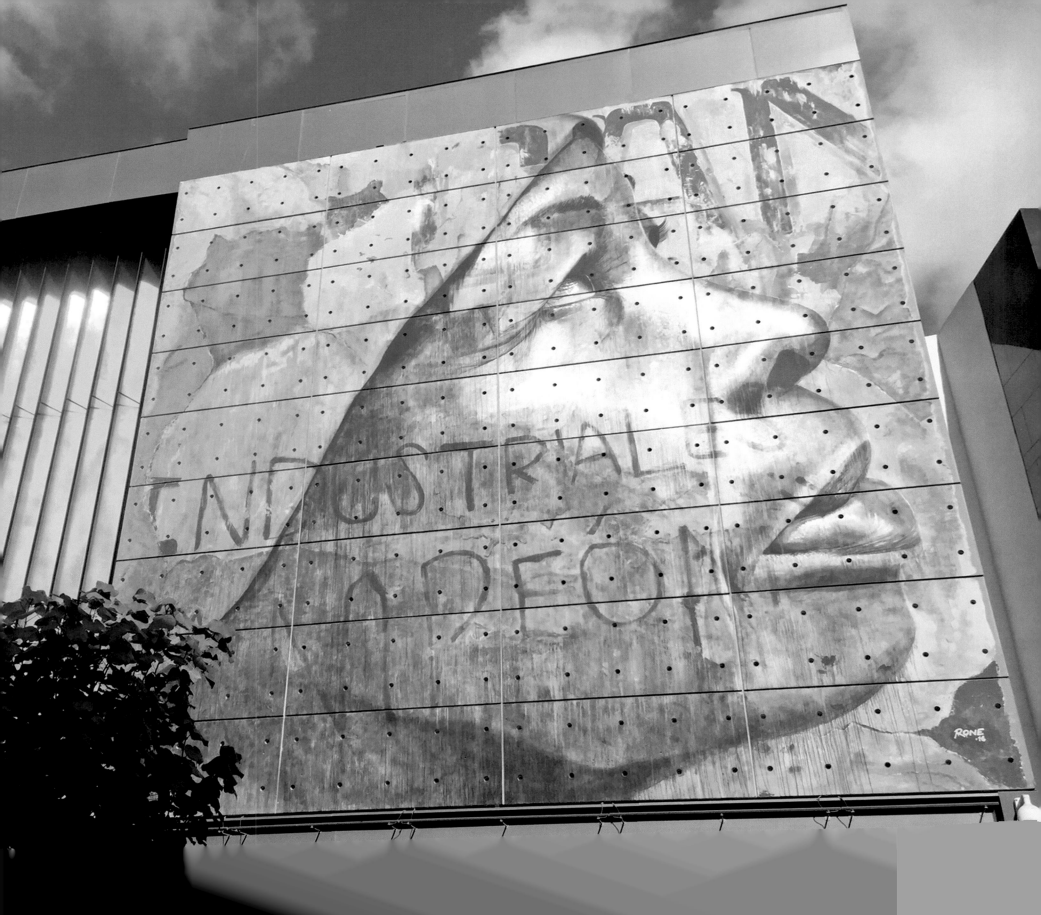

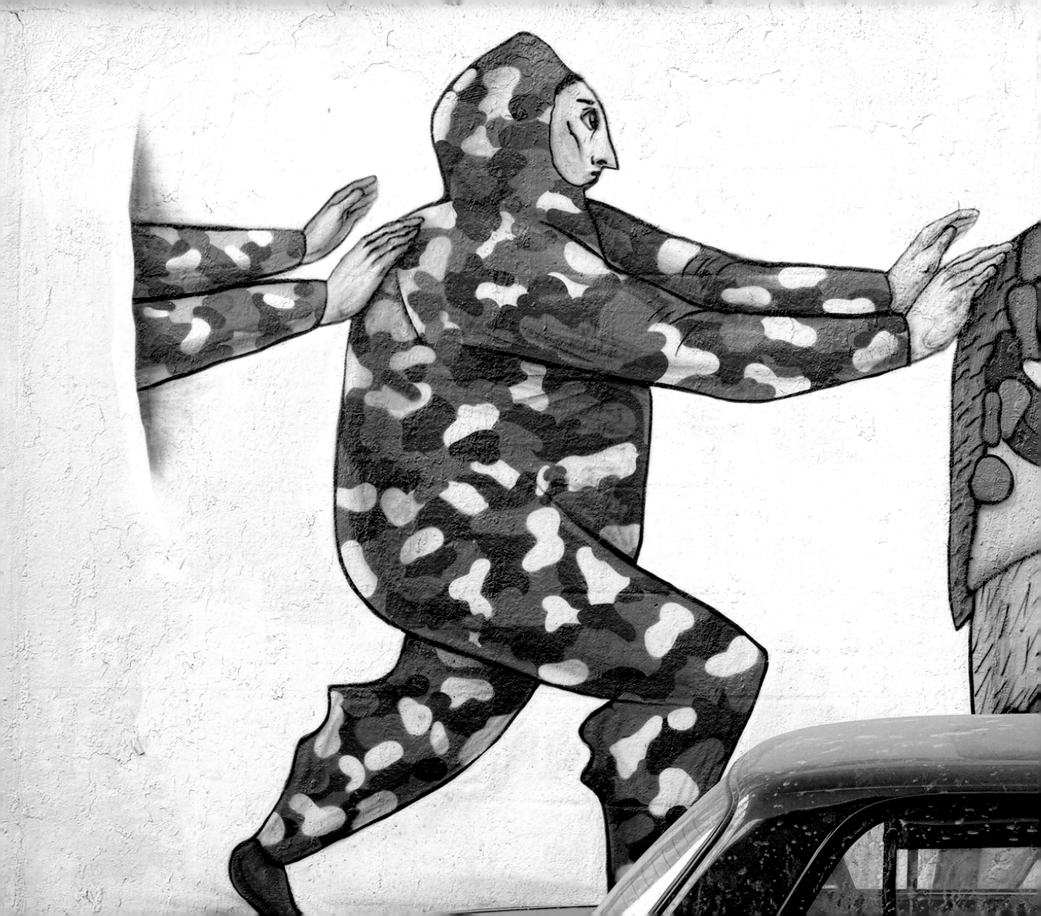

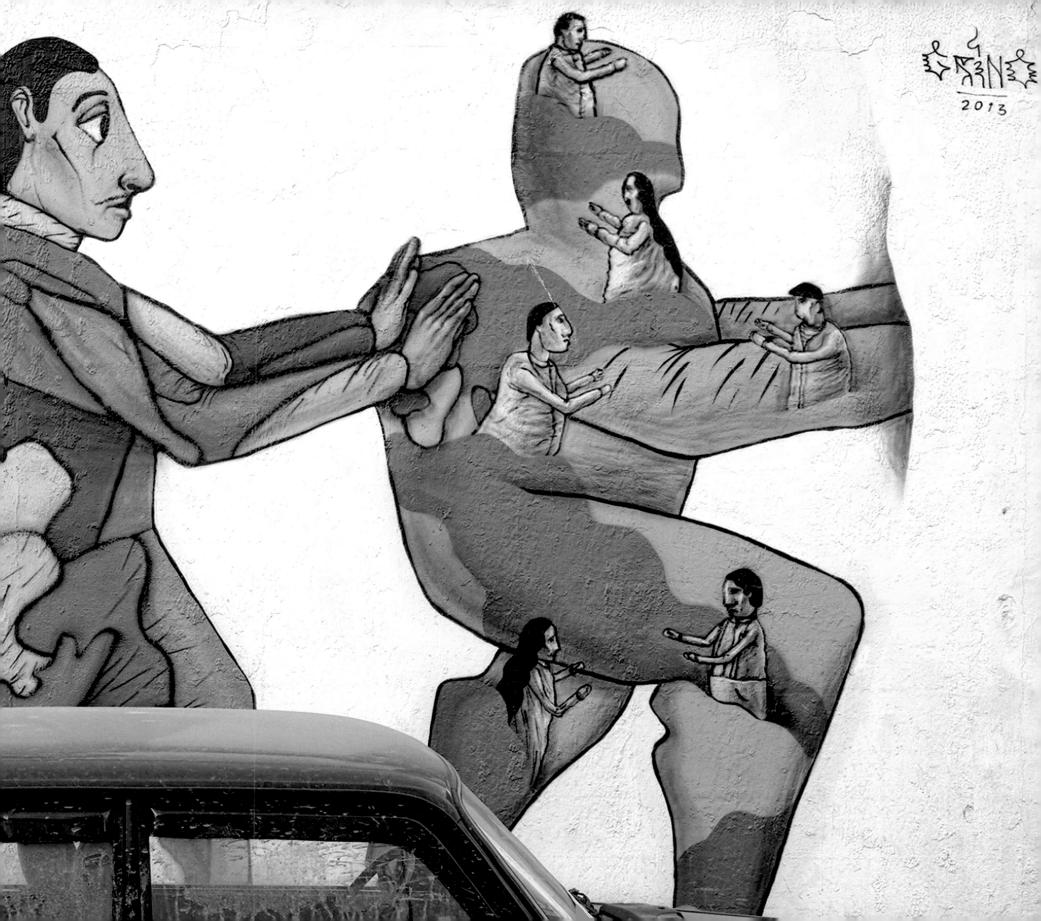

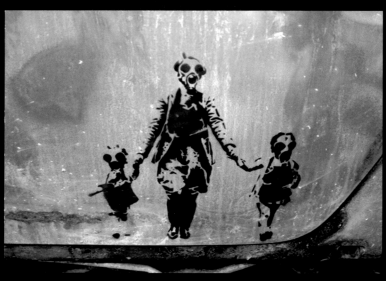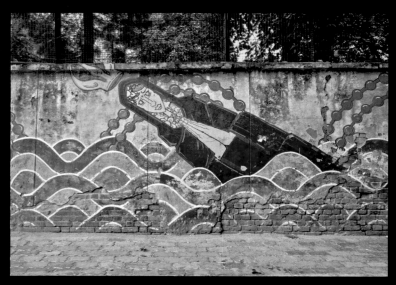

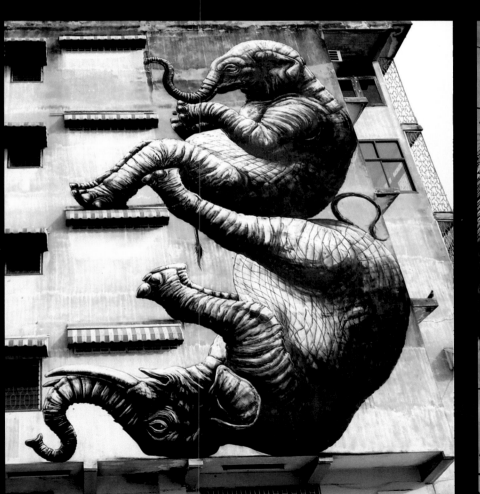
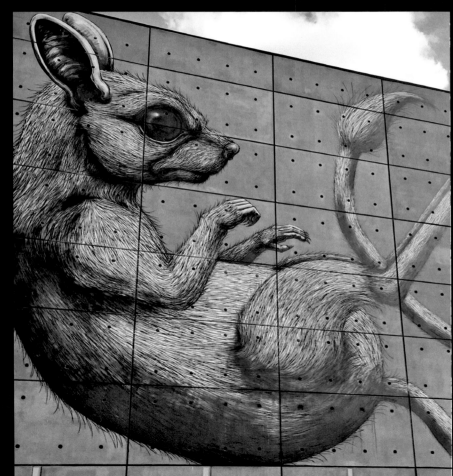

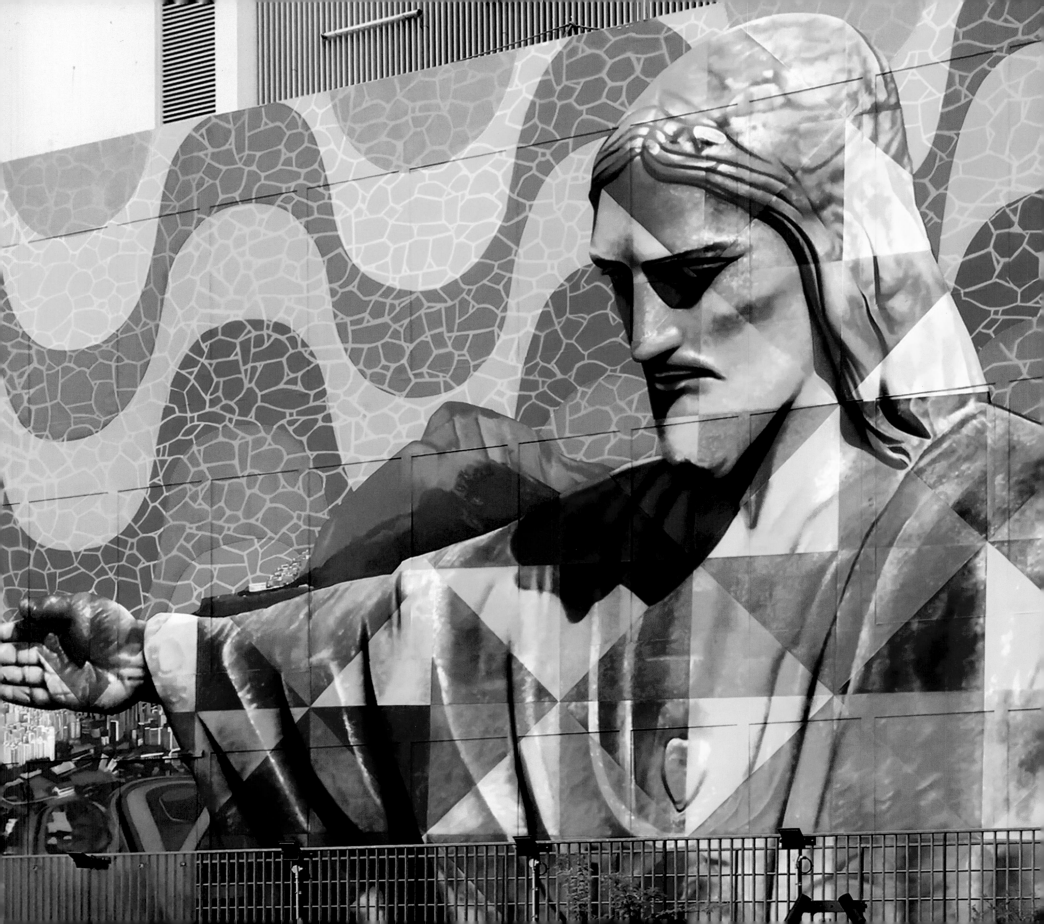

Eduardo Kobra

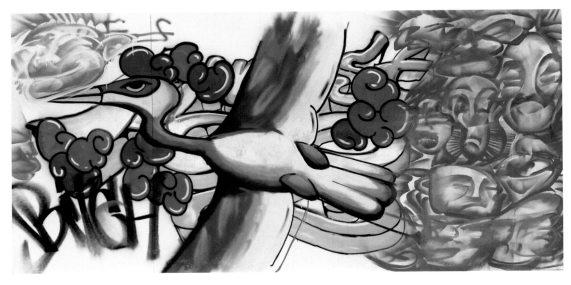

CLOCKWISE FROM TOP **Unknown**, Shanghai, China | **C215**, Istanbul, Turkey | **Tona**, India | OPPOSITE **Eduardo Kobra**, Dubai, United Arab Emirates

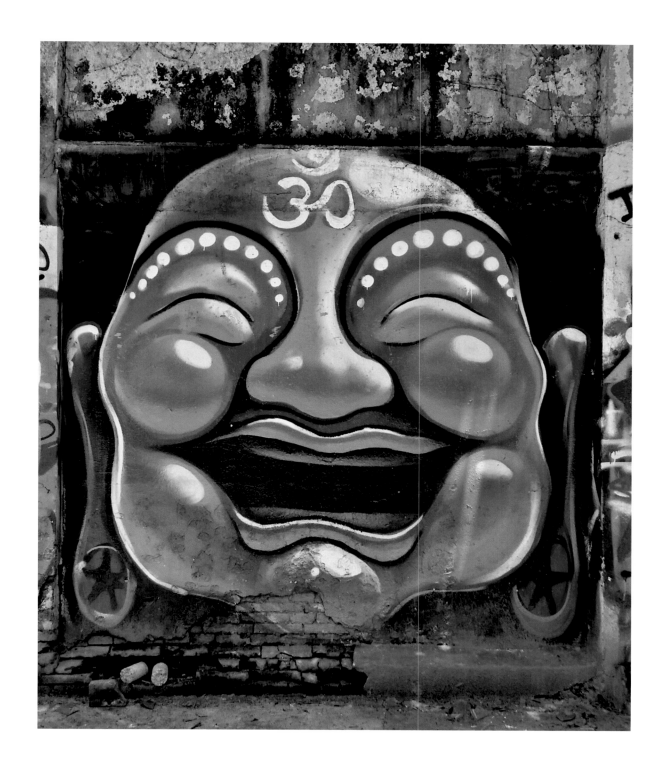

OPPOSITE **Ciao**, Taipei, Taiwan | ABOVE **Unknown**, Shanghai, China | NEXT SPREAD **Unknown**, Melaka, Malaysia

191

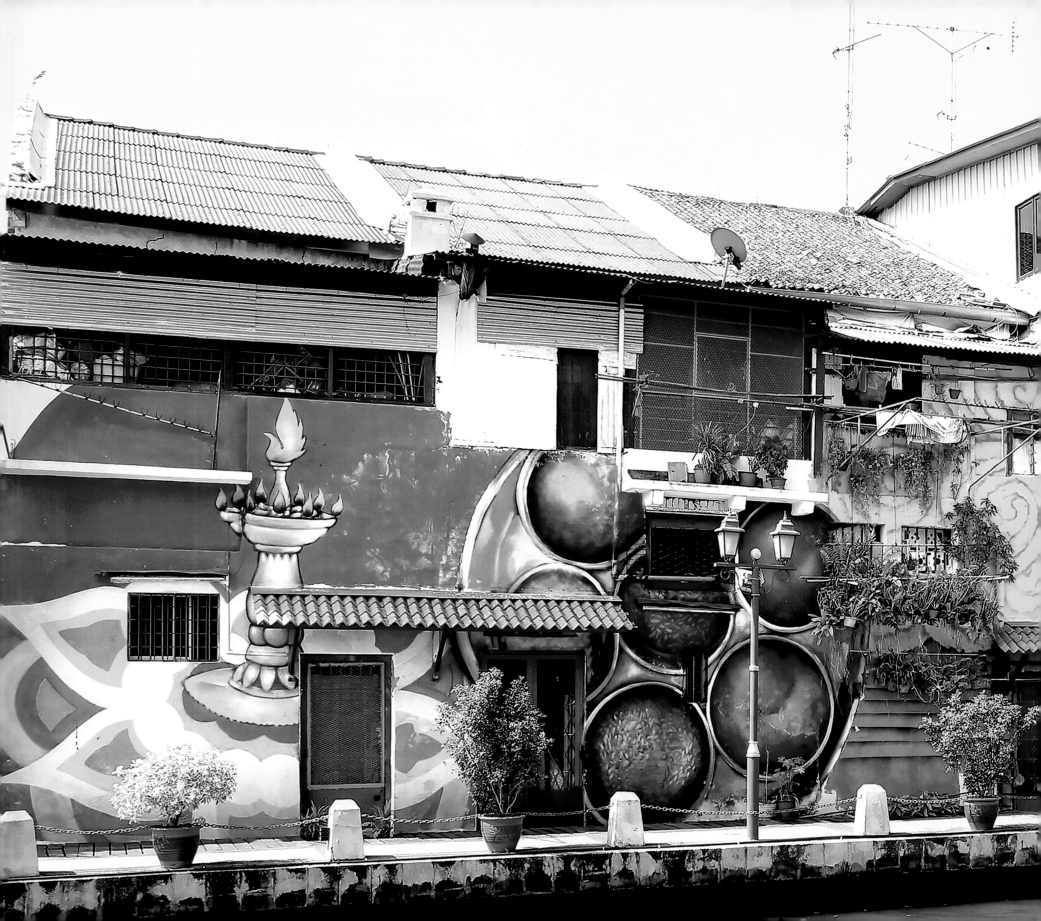

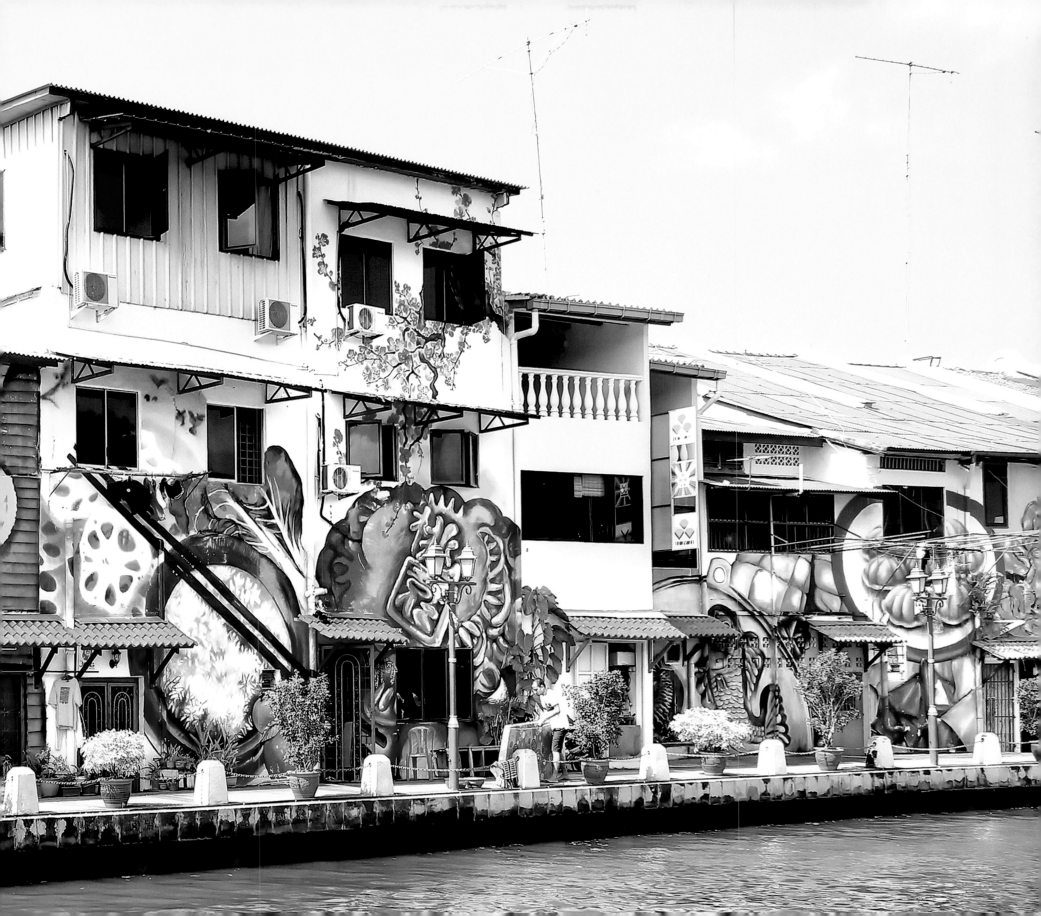

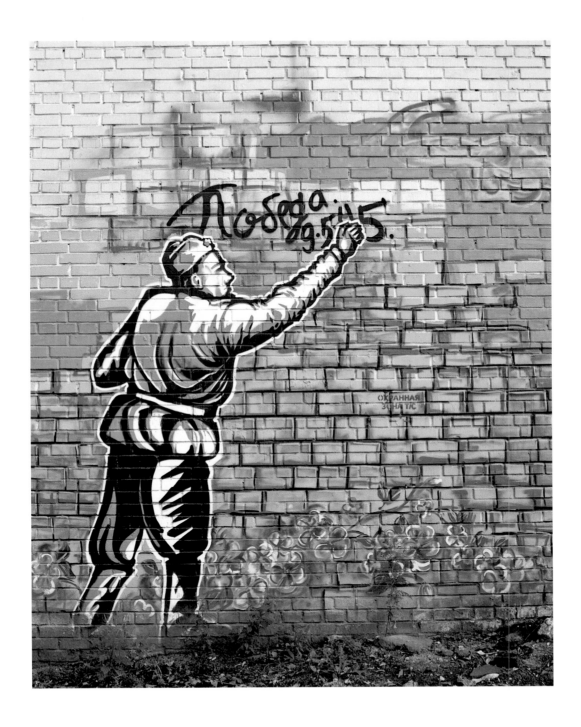

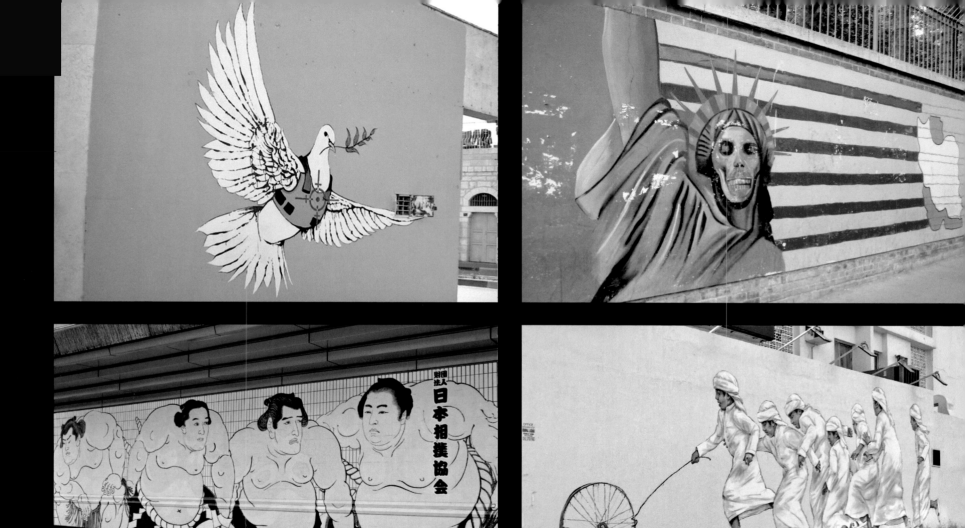

OPPOSITE **eL Seed**, Dubai, United Arab Emirates | ABOVE, CLOCKWISE FROM TOP LEFT **Banksy**, Israel | **Unknown**, Tehran, Iran | **Ernest Zacharevic**, Dubai, United Arab Emirates | **Ryogoku Kokugikan Mura**, Tokyo, Japan

CLOCKWISE FROM TOP LEFT **D*Face**, Tokyo, Japan | **Unknown**, Istanbul, Turkey | **Unknown**, Thailand |
OPPOSITE LEFT **Icy and Sot**, Dubai, United Arab Emirates | OPPOSITE RIGHT **Vhils**, Dubai, United Arab Emirates

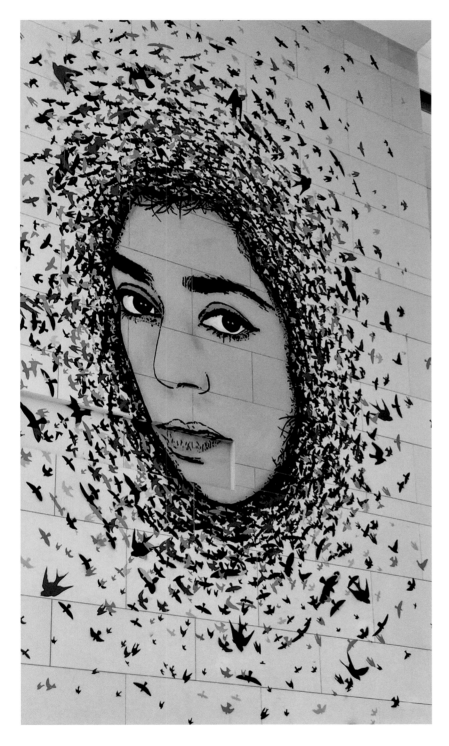
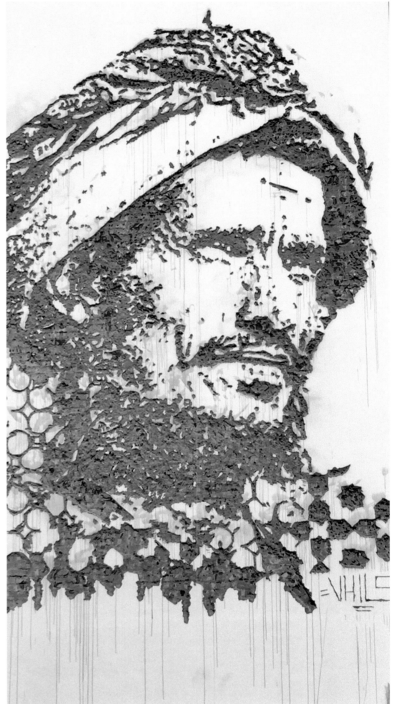

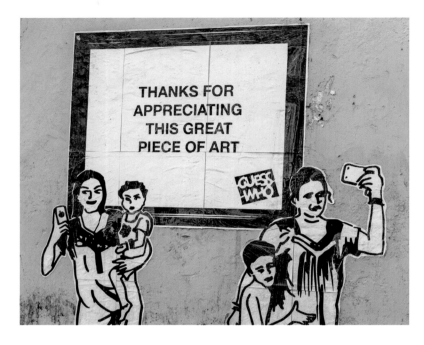

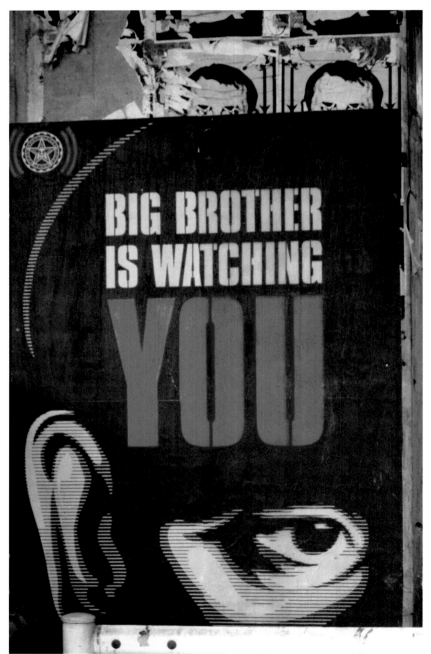

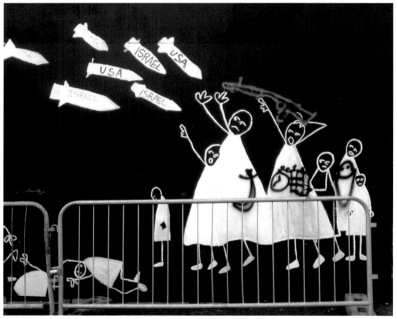

CLOCKWISE FROM TOP LEFT **Guesswho**, South India | **Shepard Fairey**, Tokyo, Japan | **Unknown**, Iraq | OPPOSITE **Case Maclaim**, Tokyo, Japan

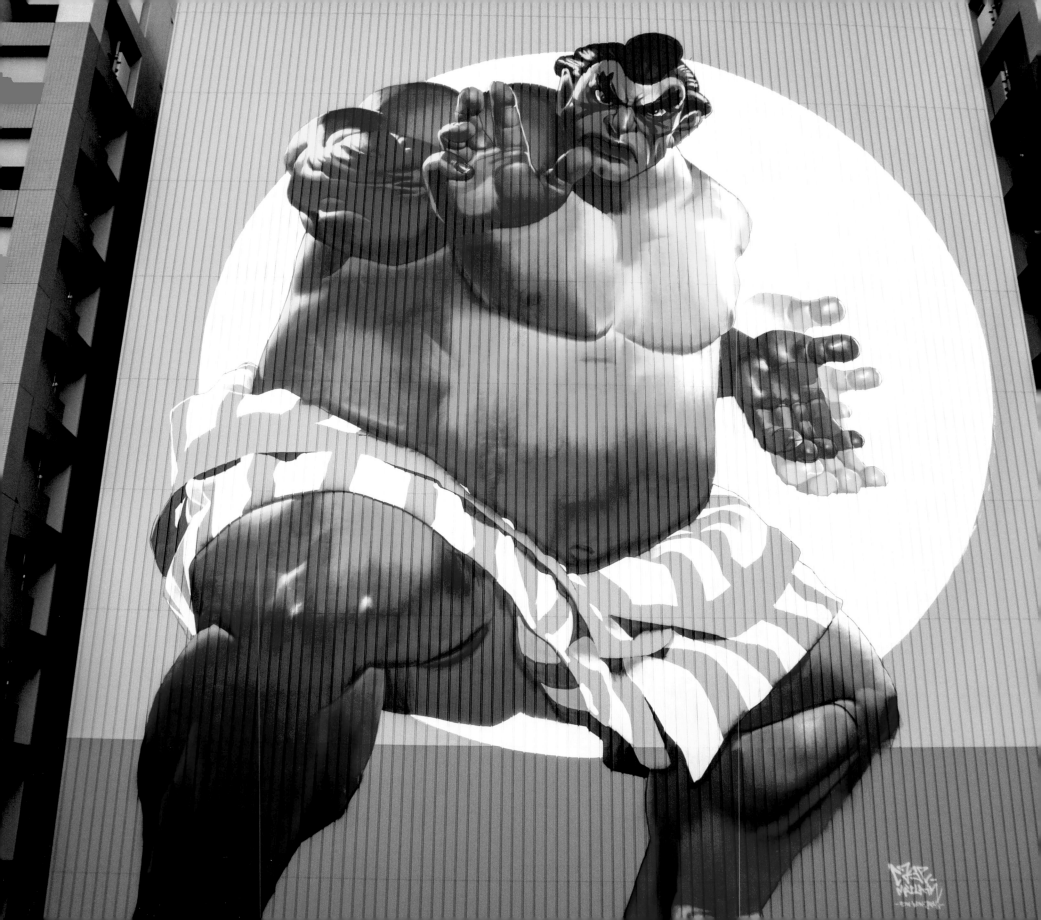

ABOVE **Unknown**, China | OPPOSITE **Unknown**, Penang, Malaysia

DEIH...XL

AFRICA

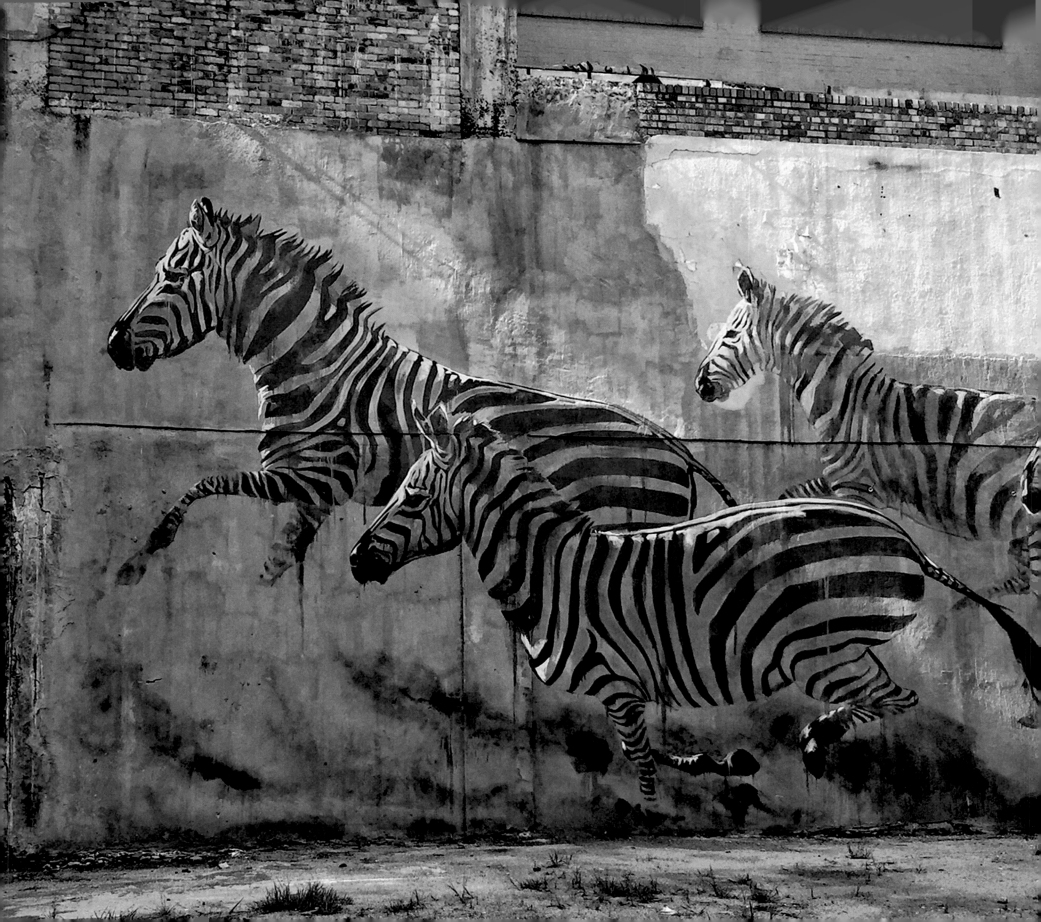

AFRICA

To say the African street art scene consists of vibrant and diverse works would be a gross understatement. How, then, can we understand the features that distinguish the expressive qualities of African street art? To begin, it is worth remembering that Africa is the second most populous continent in the world and one with a relatively large constituency of youth. Fifty-four countries notwithstanding, we should expect the many urban centers across the continent to bear works of incredible scope. Indeed, African street art does not have any single distinctive style in particular but consists of many. Hieroglyphics (more marginally) and Arabic graffiti style (more broadly), for example, can be seen across northern countries such as Egypt, Morocco, and Tunisia. The influence of music has significant bearing on the aesthetic of many African works and is especially apparent in places like Kenya and Nigeria, to name just two. Themes of early South African works by old-school street artists such as MakeOne1 and Falko pertain to the apartheid system and its repeal. South African representations now consist of many assorted themes. The broad range of tags, chrome lettering, throw-ups, and murals around the continent continue to challenge and inspire works around the world.

Art is not created in a vacuum, however. One would be remiss to presume that African street art appears in isolation from the context of Western graffiti. Urban cities such as Nairobi, Cape Town, Dakar, Rabat, Tunis, Cairo, and Johannesburg are representative of a dynamic intersection between local influences, American hip-hop culture, and globalization. During the 1990s, early African graffiti writers drew inspiration from the nascent publication of graffiti books and the increasing popularity of hip-hop music videos. This made the New York graffiti style a salient feature of early African street art, but this evolved with the advent of the new millennium. The Internet and visiting international street artists inspired Euro-style African street art, which was followed by the distinctive *pichação*, or wall-writing, style of Brazil. Today, these works amalgamate the above styles and, together with indigenous styles, colors, and motifs, represent a growing multicultural practice. It is within this sociohistorical space that we can regard these works more broadly, but this should not preclude us from regarding individual representations by virtue of their regional and cultural differences.

Bearing in mind the vastness of this continent, there is an obvious difficulty in pinpointing one encompassing feature of African street art. The disparate features that range across the continent should motivate us to question what, if any, the underpinnings of African street art are. Consequently, I hope that texts such as this one will continue to inspire the inclusion of underrepresented global works within the literature of graffiti and street art. In view of the above, the pages in this section serve as a sampling of an impressive multicultural collection of works.

— SHELBY MOSER, from the University of Kent, is a philosopher of art and aesthetics. Her research primarily concerns the aesthetic and evaluative features of street art and the ontology of video games.

Count frodo, Johannesburg, South Africa

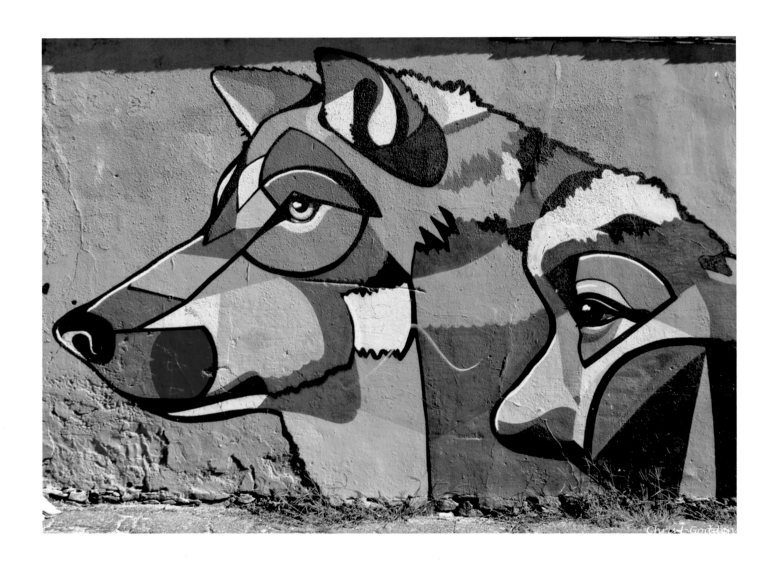

ABOVE **Nardstar***, South Africa | OPPOSITE **Faith47**, Johannesburg, South Africa

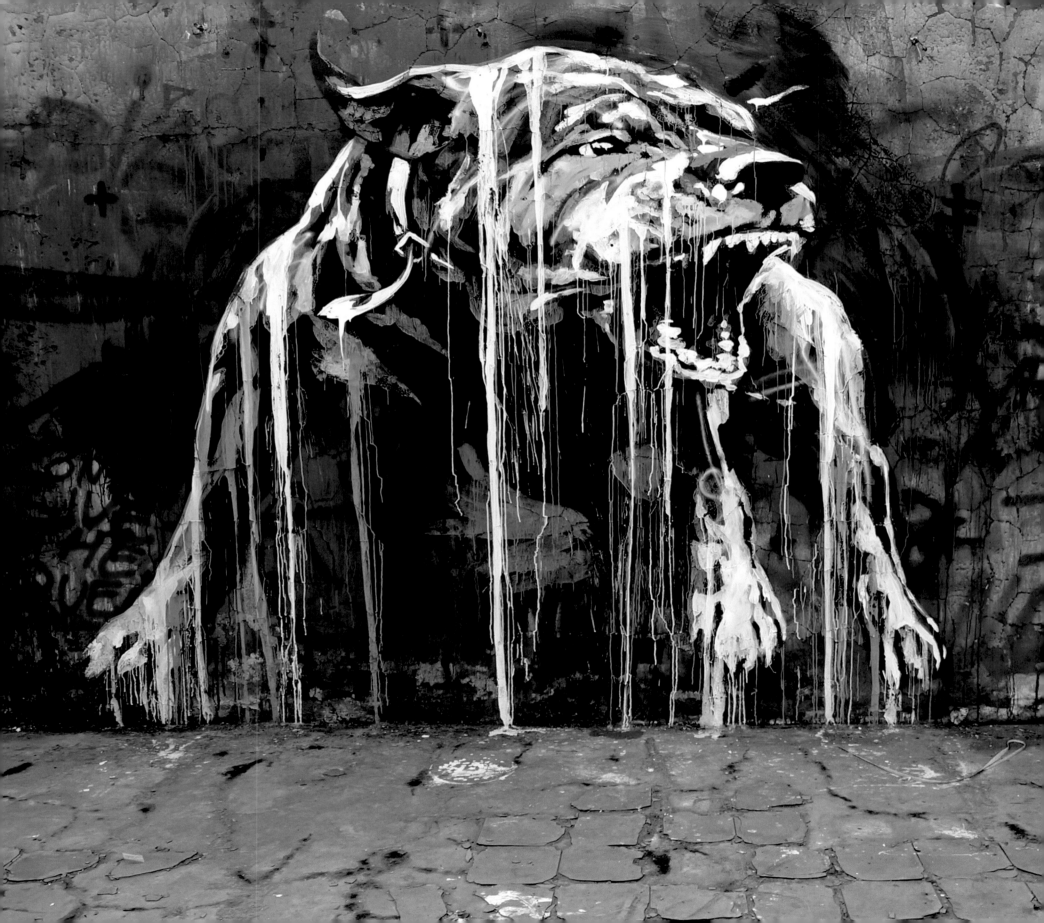

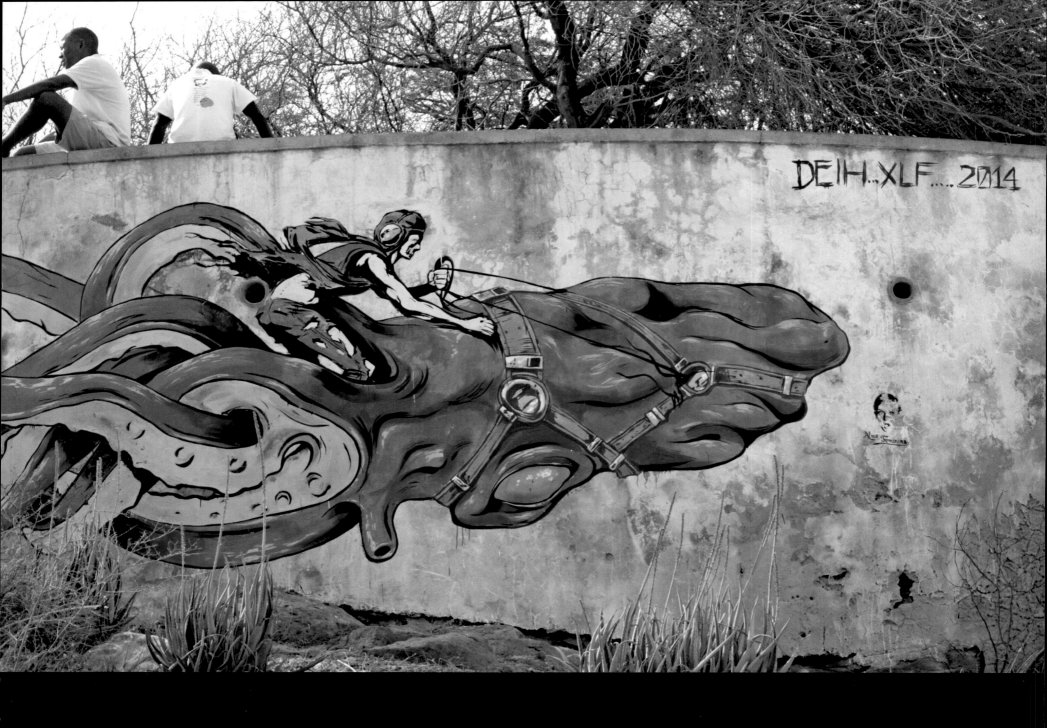

DEIH..XLF....2014

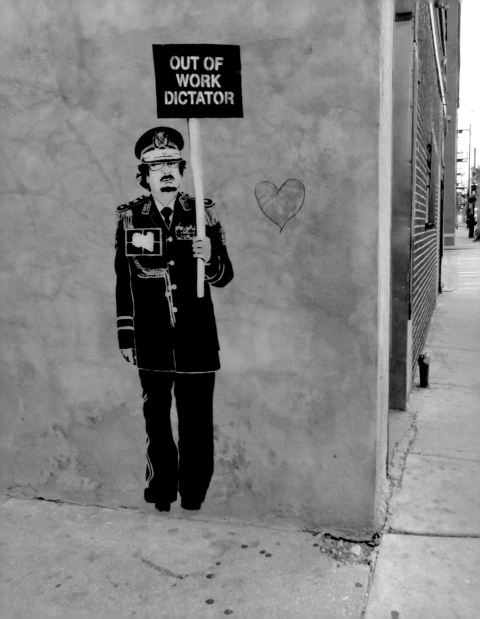

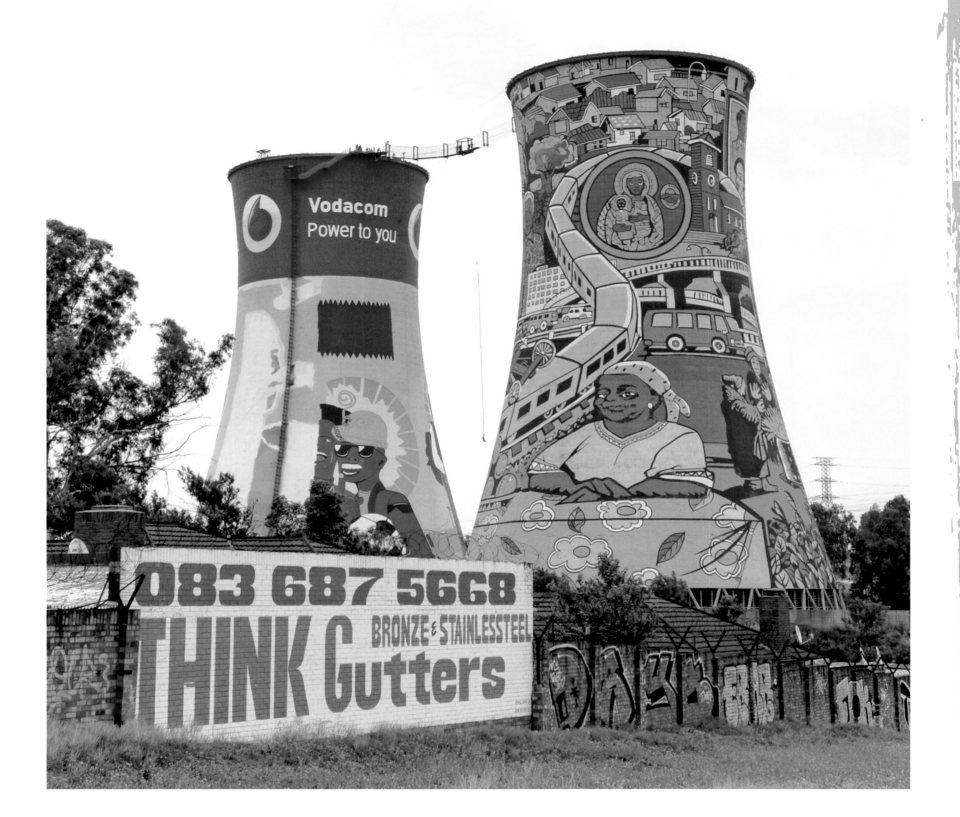

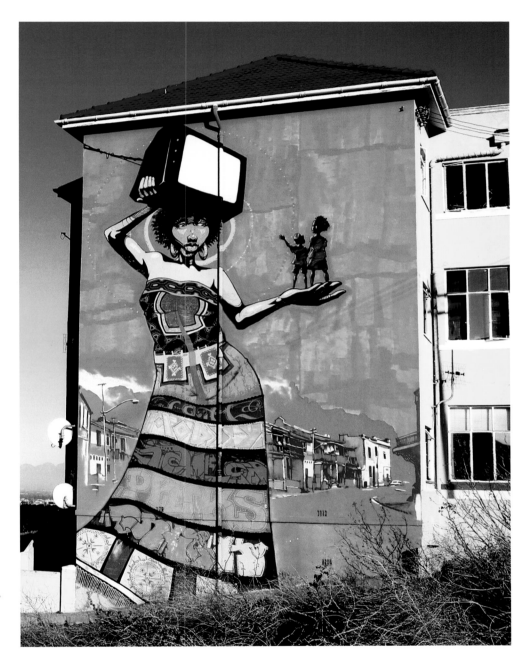

OPPOSITE **Unknown**, South Africa | CLOCKWISE FROM LEFT **Faith47**, Cape Town, South Africa | **zz**, Cape Verde, Africa | **Kazy**, Dakar, Senegal

213

OPPOSITE **Lady Aiko**, South Africa | ABOVE **Deih XLF**, Cabo Verde, Africa

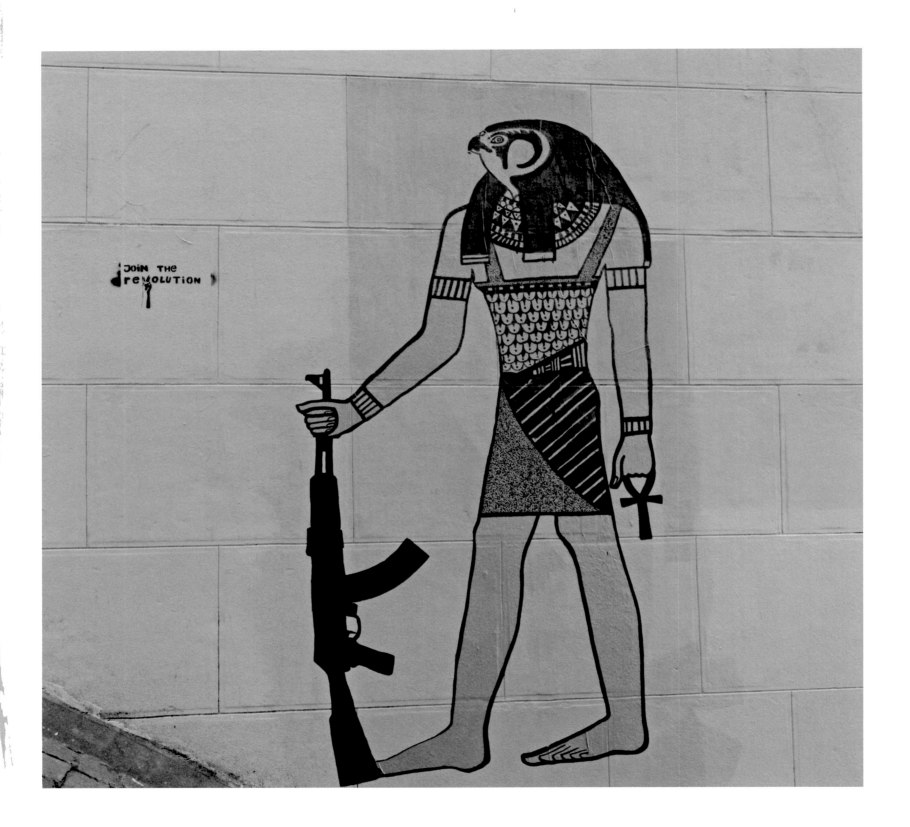

216

OPPOSITE **Unknown**, Egypt | ABOVE **Unknown**, Cape Town, South Africa

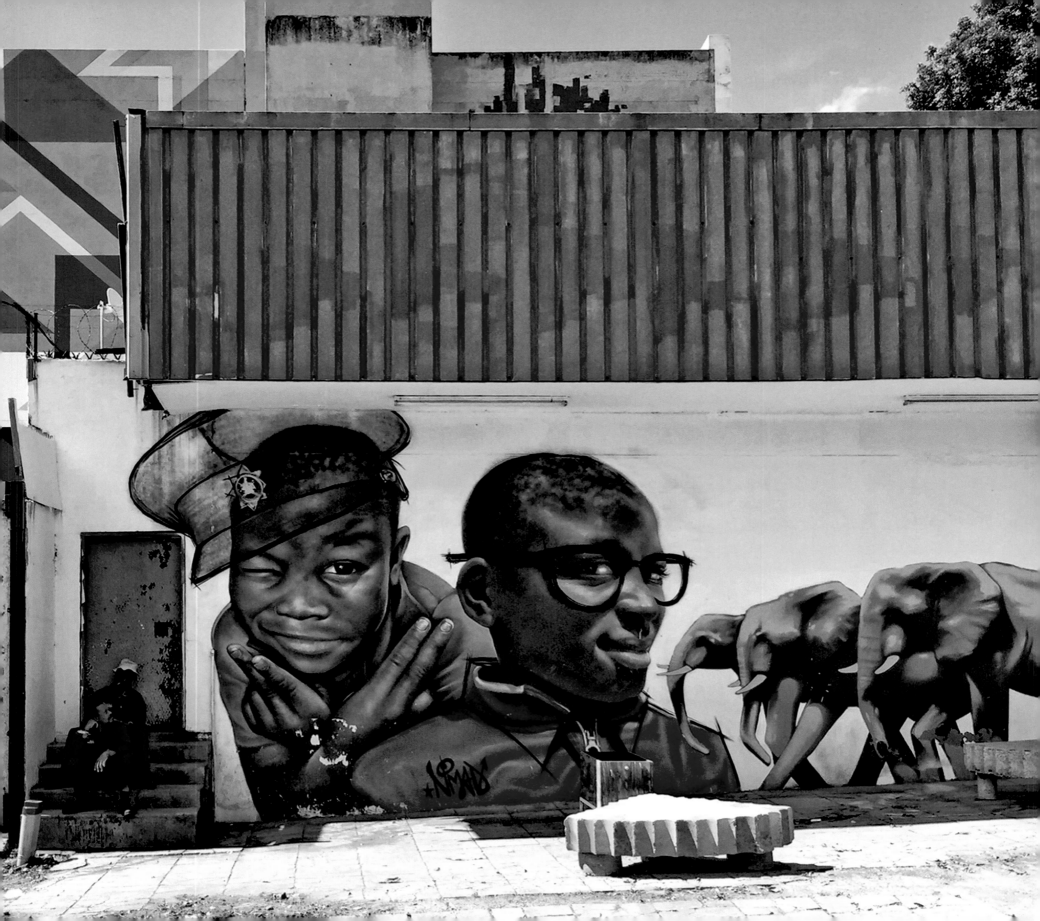

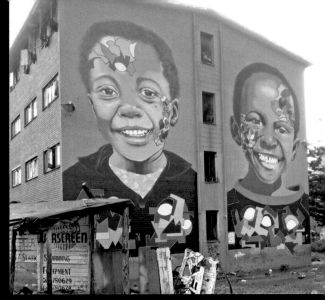

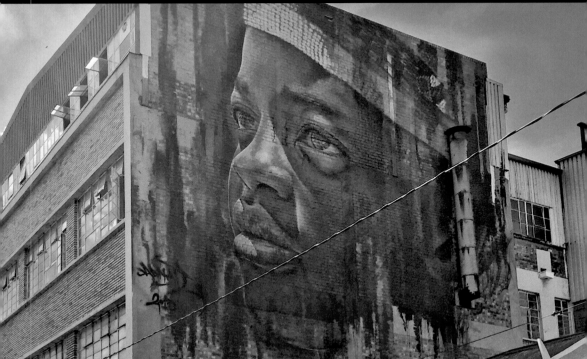

OSITE **Up, Justin Nomad, and Falko**, Johannesburg, South Africa | CLOCKWISE FROM TOP LEFT **Amsterdamage**, Zimbab

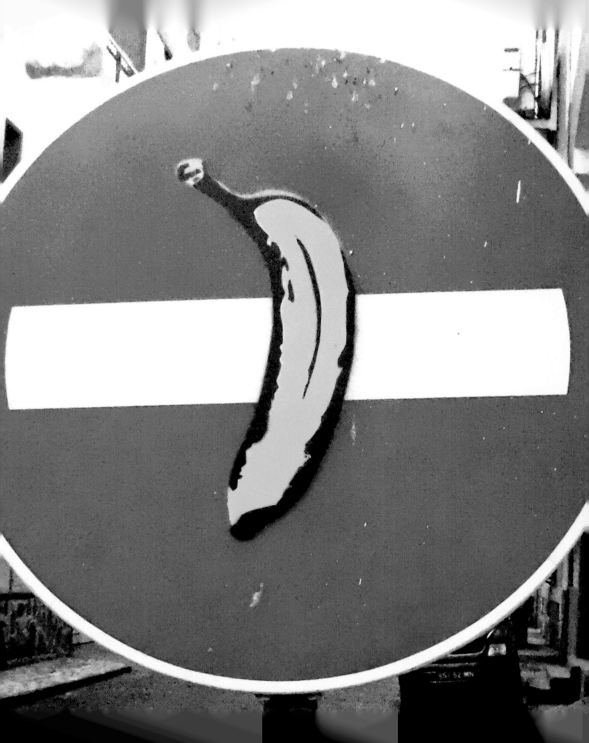

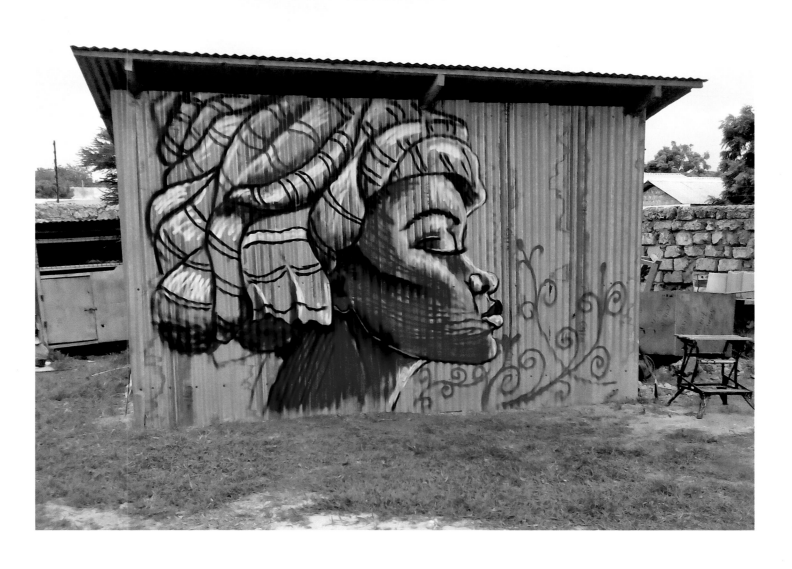

OPPOSITE **Alma Feminina**, Cape Verde, Africa | ABOVE **Bebeto Thufu**, Nairobi, Kenya | NEXT SPREAD **Boa Mistura**, Nairobi, Kenya

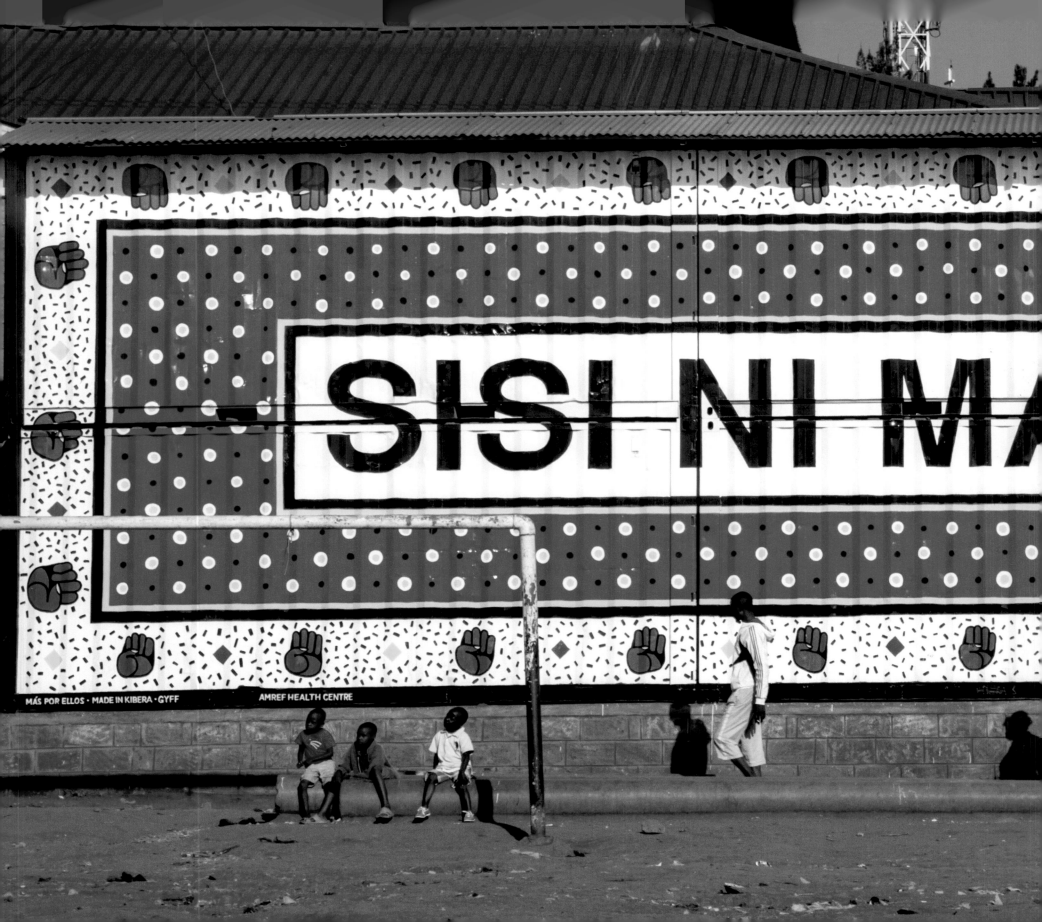

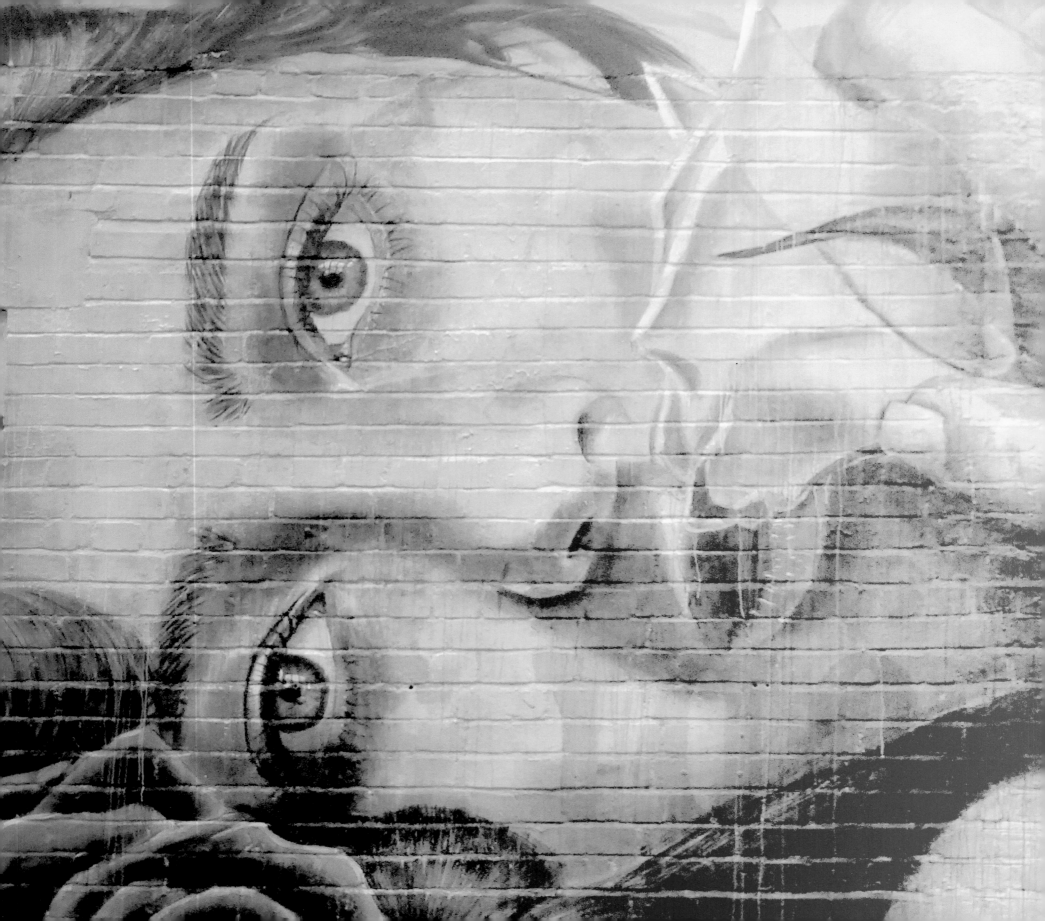

VISUAL GALLERY

Pages 2-3 | David Flores | Los Angeles, California | Photo by Lord Jim

Pages 4-5 | Tristan Eaton | Los Angeles, California | Photo by Lord Jim

Page 6 | Ron English | Miami, Florida | Photo by G. James Daichendt

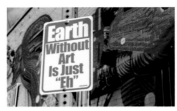

Page 9 | CamoLords | Los Angeles, California | Photo by Lord Jim

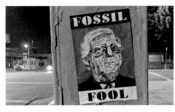

Page 11 | Robbie Conal | Los Angeles, California | Photo by G. James Daichendt

Page 11 | Banksy | Miami, Florida | Photo by Keny Anderson Butler

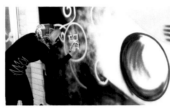

Page 11 | Shamsia Hassani | Kabul, Afghanistan | Photo from Canadian Embassy

Page 12 | Retna | Los Angeles, California | Photo by Lord Jim

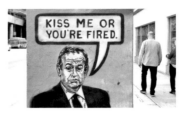

Page 12 | Teacher | Los Angeles, California | Photo courtesy of the artist

Page 15 | D*Face | Las Vegas, Nevada | Photo by Lord Jim

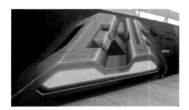

Page 15 | Lovepusher | Miami, Florida | Photo by G. James Daichendt

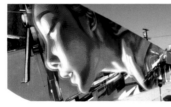

Page 15 | El Mac and Augustine Kofie | Los Angeles, California | Photo by Lord Jim

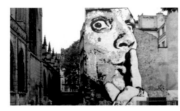

Page 17 | Jef Aerosol | Paris, France | Photo by G. James Daichendt

Page 17 | Sweet Toof | London, UK | Photo by G. James Daichendt

Page 17 | JR | Los Angeles, California | Photo by G. James Daichendt

Page 18 | Shepard Fairey | Los Angeles, California | Photo by Lord Jim

Page 20 | Yuree Kensaku | Bangkok, Thailand | Photo by Tim Jentsch

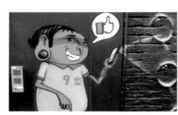

Page 21 | Cranio | London, UK | Photo by G. James Daichendt

Page 23 | Kenny Scharf | Miami, Florida | Photo by G. James Daichendt

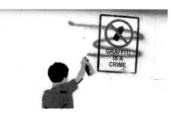

Page 24 | Plastic Jesus | Los Angeles, California | Photo courtesy of the artist

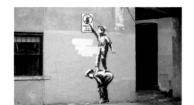

Page 24 | Banksy | New York, New York | Photo by Carnagenyc

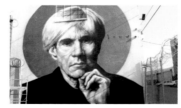

Page 28 | Drew Merritt | Los Angeles, California | Photo by Lord Jim

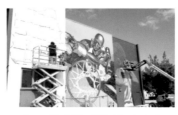

Page 28 | The RAW Project | Miami, Florida | Photo by G. James Daichendt

Page 29 | Sweet Toof | Bristol, UK | Photo by Lord Jim

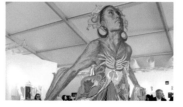

Page 31 | Swoon | Miami, Florida | Photo by G. James Daichendt

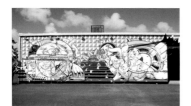

Page 32 | **How and Nosm** | Miami, Florida | Photo by G. James Daichendt

Page 35 | **Unknown** | London, UK | Photo by G. James Daichendt

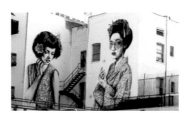

Page 38 | **Bik Ismo** | Miami, Florida | Photo by G. James Daichendt

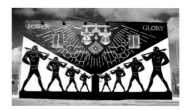

Page 40 | **Fin Dac** | Los Angeles, California | Photo by Lord Jim

Page 41 | **Shepard Fairey and Cleon Petersen** | Miami, Florida | Photo by G. James Daichendt

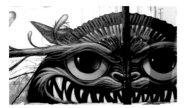

Page 43 | **Jeff Soto** | Los Angeles, California | Photo by Lord Jlm

Page 44 | **INo** | Miami, Florida | Photo by G. James Daichendt

Page 45 | **Hueman** | New York, New York | Photo by G. James Daichendt

Page 46 | **David Flores** | Azusa, California | Photo by G. James Daichendt

Page 47 | **Os Gêmeos** | Boston, Massachusetts | Photo by Yonolatengo

Page 48 | **Cryptik** | North Shore, Oahu | Photo by G. James Daichendt

Page 48 | **Swoon** | Honolulu, Hawaii | Photo by G. James Daichendt

Page 48 | **JR** | Los Angeles, California | Photo by Lord Jlm

Page 49 | **Vhils** | Honolulu, Hawaii | Photo by G. James Daichendt

Page 50 | **David Flores** | Los Angeles, California | Photo by Lord Jlm

Page 51 | **Morley** | Los Angeles, California | Photo by Lord Jim

Page 52 | **Bicicleta Sem Frieo** | Las Vegas, Nevada | Photo by Lord Jim

Page 53 | **Sever** | Miami, Florida | Photo by G. James Daichendt

Page 53 | **Madman** | Los Angeles, California | Photo by G. James Daichendt

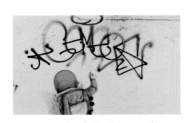

Page 54 | **Os Gêmeos** | New York, New York | Photo by G. James Daichendt

Page 54 | **Sirron Norris** | San Francisco, California | Photo by Jan Hughes

Page 55 | **Ron English** | Los Angeles, California | Photo by Lord Jim

Page 56 | **El Mac, Augustine Kofie, and Joseph Manuel Montalvo** | Los Angeles, California | Photo by Lord Jim

Page 57 | **Escif** | Montreal, Canada | Photo by Resis

Page 57 | **Case Maclaim** | Los Angeles, California | Photo by Lord Jim

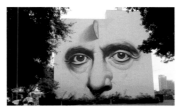

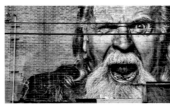

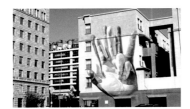

Page 57 | Case Maclaim |
Los Angeles, California | Photo
by Lord Jim

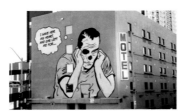

Page 58 | D*Face |
Las Vegas, Nevada | Photo
by Lord Jim

Page 59 | Unknown |
Miami, Forida | Photo by
G. James Daichendt

Page 59 | Barry McGee |
Detroit, Michigan | Photo by
Timothy Vollmer

Page 59 | Unknown |
New York, New York | Photo by
G. James Daichendt

Page 60 | Kenny Scharf |
Miami, Florida | Photo by
G. James Daichendt

Page 61 | Herakut |
Los Angeles, California | Photo
by Lord Jim

Page 62 | ASVP |
Chicago, Illinois | Photo by
G. James Daichendt

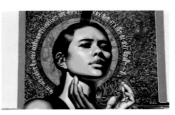

Page 62 | El Mac |
Costa Mesa, California | Photo by
G. James Daichendt

Page 62 | Kevin Ancell X Saber |
Honolulu, Hawaii | Photo by
G. James Daichendt

Page 63 | Earsnot and Nemel |
Miami, Florida | Photo by
G. James Daichendt

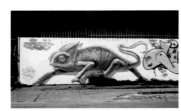

Page 64 | Floripa |
Miami, Florida | Photo by
G. James Daichendt

Page 64 | Opire and Bonar |
Miami, Florida | Photo by
G. James Daichendt

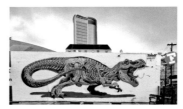

Page 65 | Nychos |
Oakland, California | Photo by
Tim Jentsch

Page 66 | Shepard Fairey |
Miami, Florida | Photo by
Tim Jentsch

Page 67 | RISK |
Honolulu, Hawaii | Photo by
G. James Daichendt

Page 67 | 1010 |
Honolulu, Hawaii | Photo by
G. James Daichendt

Page 68 | Gaia |
Washington, D.C. | Photo
by Lobo

Page 68 | Phlegm |
San Diego, California | Photo
by G. James Daichendt

Page 68 | Shepard Fairey |
Chicago, Illinois | Photo by
G. James Daichendt

Page 68 | CAMER1 |
San Francisco, California |
Photo by Ryan Musch

Page 69 | Martin Whatson |
Miami, Florida | Photo by
G. James Daichendt

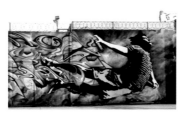

Pages 70-71 | Bumblebee |
Los Angeles, California | Photo
by Lord Jim

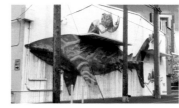

Page 72 | Kai'ili Kaulukukui |
Honolulu, Hawaii | Photo by
G. James Daichendt

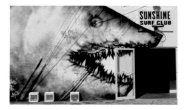

Page 73 | Shark Toof |
Miami, Florida | Photo by
G. James Daichendt

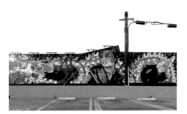
Page 74 | **David Flores** |
Los Angeles, California | Photo
by Lord Jim

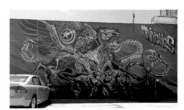
Page 74 | **Nychos** |
Los Angeles, California | Photo
by G. James Daichendt

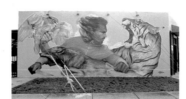
Page 74 | **Evoca1** |
Miami, Florida | Photo by
G. James Daichendt

Page 75 | **Madsteez** |
Maimi, Florida | Photo by
G. James Daichendt

Page 76 | **Paola Delfin** |
Miami, Florida | Photo by
G. James Daichendt

Page 77 | **Herakut** |
Miami, Florida | Photo by
G. James Daichendt

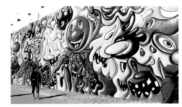
Page 78 | **Kenny Scharf** |
Las Vegas, Nevada | Photo
by Lord Jim

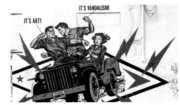
Page 79 and front cover |
Toxicómano | Miami, Florida |
Photo by G. James Daichendt

Page 79 | **Tristan Eaton** |
Los Angeles, California | Photo
by Lord Jim

Page 79 | **Jerkface** |
New York, New York | Photo
by G. James Daichendt

Page 82 | **Stinkfish** |
Colombia | Photo by
Anna Stolyarova

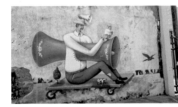
Page 84 | **Aec Interesni Kazki** |
Mexico | Photo by
Jay Galvin

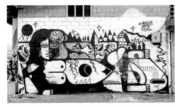
Page 85 and endpapers | **Negus
Arte Vida** | Costa Rica |
Photo by Scott Bennet

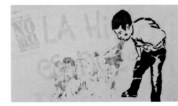
Page 85 | **Unknown** |
Colombia | Photo by
Bixentro

Page 66 | **Os Gêmeos** |
Brazil | Photo by
Davis Staedtler

Page 87 | **Hogar** |
Mexico City, Mexico | Photo
by Jay Galvin

Page 87 | **Unknown** |
Mexico | Photo by
Anna Stolyarova

Page 87 | **Cucusita** |
Buenos Aires, Argentina | Photo
by Anna Stolyarova

Page 87 | **Os Gêmeos** |
Brazil | Photo by
Anna Stolyarova

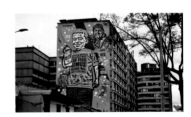
Page 88 | **Toxicómano** |
Bogotá, Colombia | Photo courtesy
of the artist

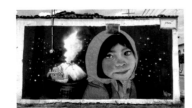
Page 88 | **Unknown** |
Cholula, Mexico | Photo by
Cordelia Persen

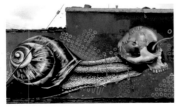
Page 89 | **Unknown** |
Mexico | Photo by
Jay Galvin

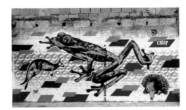
Page 90 | **CRISP** |
Bogotá, Colombia | Photo by
Danielle F. Manrique

Page 91 | **CRISP** |
Bogotá, Colombia | Photo
by Danielle F. Manrique

Pages 91–92 | **Unknown** |
São Paulo, Brazil | Photo
by Alf Ribeiro

Page 94 | **Unknown** | Santiago, Chile | Photo by Troita

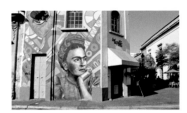

Page 95 | **Unknown** | Guadalajara, Mexico | Photo by Charlie Marchant

Page 96 | **Daniel Marceli** | Colombia | Photo by Kenzi Judge

Page 97 | **Unknown** | Mexico | Photo by Anna Stolyarova

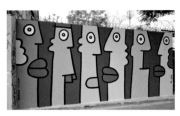

Page 98 | **Thierry Noir** | Chile | Photo by Rodrigo Marin Matamoros

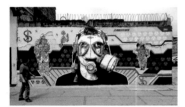

Page 99 | **DjLu** | Bogotá Colombia | Photo by Danielle F. Manrique

Page 99 | **DjLu** | Bogotá Colombia | Photo by Danielle F. Manrique

Pages 100–101 | **Jaz** | Buenos Aires, Argentina | Photo by Danielle F. Manrique

Page 102 | **Unknown** | Chile | Photo by Julian Cosson

Page 103 | **Unknown** | Chile | Photo by Troita

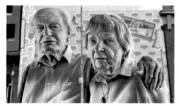

Page 106 | **Smug** | Melbourne, Australia | Photo by Tim Jentsch

Page 108 | **Mulga** | Australia | Photo by Tim Jentsch

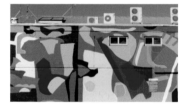

Page 109 | **Maya Hayuk** | New Zealand | Photo by Sheila Thomson

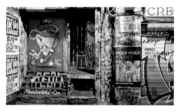

Page 110 | **Unknown** | Melbourne, Australia | Photo by The 3B's

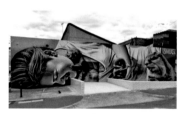

Page 112 | **Smug** | Melbourne, Australia | Photo by Tim Jentsch

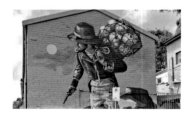

Page 113 | **Fintan Magee** | Sydney, Australia | Photo by Tim Jentsch

Page 114 | **Unknown** | Melbourne, Australia | Photo by Boyloso

Page 115| **Cam Scale** | Australia | Photo by Tim Jentsch

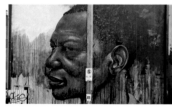

Page 116 | **Guido van Helten** | Melbourne, Australia | Photo by Tim Jentsch

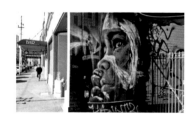

Page 117 | **Adnate** | Melbourne, Australia | Photo by Ross Schlemmer

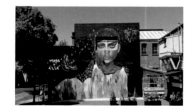

Page 117 | **Elle and Vexta** | Melbourne, Australia | Photo by Tim Jentsch

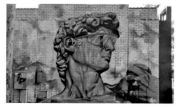

Page 117 | **Lingerid** | Melbourne, Australia | Photo by Tim Jentsch

Pages 118–119 | **Elk** | Melbourne, Australia | Photo by CTR Photos

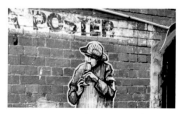

Page 120 | **Unknown** | New Zealand | Photo by Nick CP

Page 120 | **Fintan Magee** | Melbourne, Australia | Photo by Tim Jentsch

Page 121 | **Pleghm** |
Perth, Australia | Photo by
Tim Jentsch

Page 121 | **Fintan Magee** |
New Zealand | Photo by
Tony Hisgett

Page 122 | **Buzzard** |
Melbourne, Australia | Photo by
Ross Schlemmer

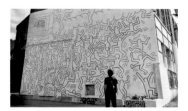

Page 122 | **Keith Haring** |
Collingwood, Melbourne, Australia |
Photo by Tim Jentsch

Page 123 | **Charles & Janine Williams** |
Christchurch, New Zealand |
Photo by Rob Paramo

Page 124 | **Scott Marsh** |
Sydney, Australia | Photo by
Tim Jentsch

Page 125 | **Peque** |
Sydney, Australia | Photo
by Tim Jentsch

Page 126 | **Unknown** |
Melbourne, Australia | Photo
by Ross Schlemmer

Page 127 | **Vhils** |
Sydney, Australia | Photo
by Benn Garrett

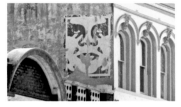

Page 127 | **Shepard Fairey** |
Sydney, Australia | Photo by
Erokism

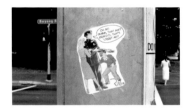

Page 127 | **Unknown** |
Sydney, Australia | Photo
by Erokism

Page 127 | **Unknown** |
New Zealand | Photo by
Mfcrowl

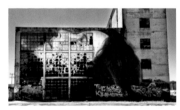

Page 128 | **Rone** |
Melbourne, Australia | Photo
by Tim Jentsch

Page 129 | **DALeast** |
Dunedin, New Zealand | Photo
by B4 Flight

Page 132 | **Os Gêmeos** |
Portugal | Photo by
Erdalito

Page 134 | **Blub** |
Florence, Italy | Photo by
G. James Daichendt

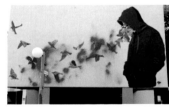

Page 135 | **Don John** |
Berlin, Germany | Photo by
Lord Jim

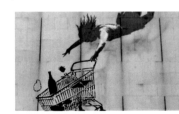

Page 135 | **Banksy** |
London, UK | Photo by
G. James Daichendt

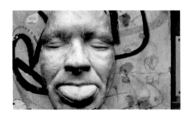

Page 135 | **Gregos** |
London, UK | Photo by
G. James Daichendt

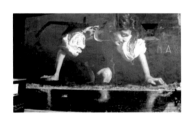

Page 136 | **Luis Gomez de Teran** |
London, UK | Photo by
G. James Daichendt

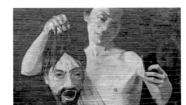

Page 137 | **Cosmo Sarsen** |
London, UK | Photo by
G. James Daichendt

Page 138 | **Fra** |
London, UK | Photo by
G. James Daichendt

Page 139 | **Hull Graffiti** |
London, UK | Photo by
G. James Daichendt

Page 139 | **Unknown** |
Amsterdam, the Netherlands |
G. James Daichendt

Page 140 | **Yipi Yipi Yeah** |
Madrid, Spain | Photo by
G. James Daichendt

Page 140 | **Clet** |
Florence, Italy | Photo by
G. James Daichendt

Page 140 | **Unknown** |
London, UK | Photo by
G. James Daichendt

Page 140 | **Yipi Yipi Yeah** |
Florence, Italy | Photo by
G. James Daichendt

Page 140 | **Clet** |
London, UK | Photo by
G. James Daichendt

Page 140 | **Clet** |
Paris, France | Photo by
G. James Daichendt

Page 140 | **Clet** |
Paris, France | Photo by
G. James Daichendt

Page 140 | **Yipi Yipi Yeah** |
Madrid, Spain | Photo by
G. James Daichendt

Page 140 | **Clet** |
Florence, Italy | Photo by
G. James Daichendt

Page 141 | **Unknown** |
Madrid, Spain | Photo by
G. James Daichendt

Page 142 | **Herr von Bias** |
Berlin, Germany | Photo by
Lord Jim

Page 143 | **K** |
Florence, Italy | Photo by
G. James Daichendt

Page 143 | **André** |
Venice, Italy | Photo by
G. James Daichendt

Page 143 | **Unknown** |
Paris, France | Photo by
G. James Daichendt

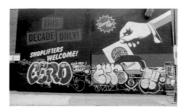

Page 144 | **Shepard Fairey** |
London, UK | Photo by
G. James Daichendt

Page 145 | **El Rey de la Ruina** |
Madrid, Spain | Photo by
G. James Daichendt

Page 146 | **Herr von Bias** |
Berlin, Germany | Photo by
Lord Jim

Page 147 | **Os Gêmeos** |
Berlin, Germany | Photo by
Lord Jim

Page 147 | **Pixel Pancho** |
Düsseldorf, Germany | Photo
by Lord Jim

Page 147 | **Herr von Bias** |
Berlin, Germany | Photo by
Lord Jim

Page 148 | **Cartrain** |
London, UK | Photo by
G. James Daichendt

Page 149 | **Pixel Pancho** |
London, UK | Photo by
G. James Daichendt

Page 149 | **Alex Diaz & Borondo** |
London, UK | Photo by
G. James Daichendt

Page 150 | **Invader** |
London, UK | Photo by
G. James Daichendt

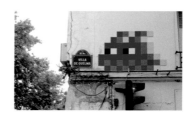

Page 150 | **invader** |
Paris, France | Photo by
G. James Daichendt

Page 150 | **Invader** |
London, UK | Photo by
G. James Daichendt

Page 150 | **Invader** |
London, UK | Photo by
G. James Daichendt

Page 150 | **Invader** |
London, UK | Photo by
G. James Daichendt

Page 150 | **Invader** |
Rome, Italy | Photo by
Photo by G. James Daichendt

Page 150 | **Invader** |
Paris, France | Photo by
Photo by G. James Daichendt

Page 150 | **Invader** |
London, UK | Photo by
Photo by G. James Daichendt

Page 150 | **Invader** |
Paris, France | Photo by
G. James Daichendt

Page 150 | **Invader** |
Amsterdam, the Netherlands |
Photo by G. James Daichendt

Page 150 | **Unknown** |
Berlin, Germany | Photo
by Lord JIm

Page 151 | **Minty** |
London, UK | Photo by
G. James Daichendt

Page 152 | **Blu** |
Rome, Italy | Photo by
G. James Daichendt

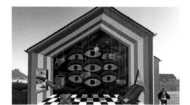

Page 153 | **Chase** |
Belgium | Photo by
Chase

Page 153 | **El Pez & Danny Recal** |
Amsterdam, the Netherlands |
Photo by G. James Daichendt

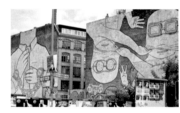

Page 154 | **Blu** |
Germany | Photo by
Timothy Vollmer

Page 155 | **Os Gêmeos,** |
Berlin, Germany | Photo by
Lord Jim

Page 155 | **Unknown** |
Berlin, Germany | Photo
by Lord Jim

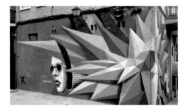

Page 156 | **Okudart** |
Madrid, Spain | Photo by
G. James Daichendt

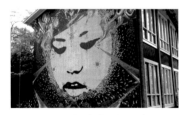

Page 157 | **Stinkfish** |
Amsterdam, the Netherlands |
Photo by G. James Daichendt

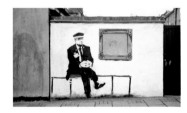

Page 157 | **Fin DAC** |
Madrid, Spain | Photo by
G. James Daichendt

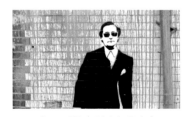

Page 158 | **Banksy** |
London, UK | Photo by
G. James Daichendt

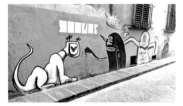

Page 158 | **Blek le Rat** |
London, UK | Photo by
Julian Tysoe

Page 159 | **Hyuro** |
Poland | Photo by
Kris Duda

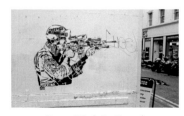

Page 159 | **Endless** |
London, UK | Photo by
G. James Daichendt

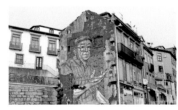

Page 159 | **Frederico Draw** |
Lisbon, Portugal | Photo by
Chris Thomas

Pages 160–161 | **Herr von Bias** |
Berlin, Germany | Photo by
Lord Jim

Page 162 | **Unknown** |
Florence, Italy | Photo by
G. James Daichendt

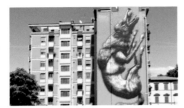
Page 163 | ROA |
Rome, Italy | Photo by
G. James Daichendt

Page 163 | Ericailcane |
Lisbon, Portugal | Photo
by Lord Jim

Page 163 | ROA |
London, UK | Photo by
G. James Daichendt

Page 163 | Aryz |
Bristol, UK | Photo
by Kyla Borg

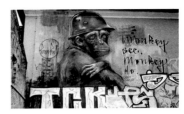
Page 164 | Herakut |
Berlin, Germany | Photo
by Lord Jim

Page 164 | Alexis Diaz |
London, UK | Photo by
Berit Watkin

Page 164 | ROA |
Madrid, Spain | Photo by
G. James Daichendt

Page 164 | Louis Masai |
London, UK | Photo by
G. James Daichendt

Page 165 | ROA |
Copenhagen, Denmark | Photo by
G. James Daichendt

Page 166 | Andrea Tarli |
Lisbon, Portugal | Photo by
Chris Thomas

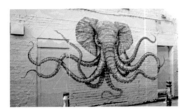
Page 167 | Nomad |
Berlin, Germany | Photo
by Lord Jim

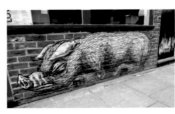
Page 167 | Fred le Chevalier |
Berlin, Germany | Photo by
Lord Jim

Page 168 | My Dog Sighs |
London, UK | Photo by
G. James Daichendt

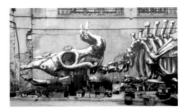
Page 168 | Unknown |
London, UK | Photo by
G. James Daichendt

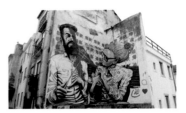
Page 168 | SYD |
London, UK | Photo by
G. James Daichendt

Page 169 | Shepard Fairey |
Berlin, Germany | Photo by
Lord Jim

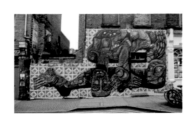
Page 170 | Zio Ziegler |
London, UK | Photo by
G. James Daichendt

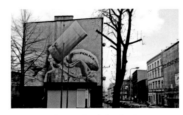
Page 171 | Blu |
Krakow, Poland | Photo by
Luxtowiec

Page 171 | Ludo |
Poland | Photo by
Kris Duda

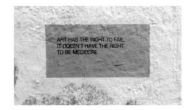
Page 171 | Liqen |
Spain | Photo by
Marta Nimeva Nimeviene

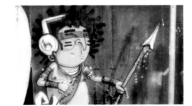
Page 172 | Cranio |
Berlin, Germany | Photo
by Lord Jim

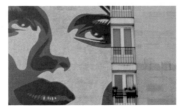
Page 173 | Shepard Fairey |
Paris, France | Photo by
G. James Daichendt

Page 174 | Francisco Bosoletti |
Salamanca, Spain | Photo by
Chris Thomas

Page 175 | Unknown |
Paris, France | Photo by
G. James Daichendt

Page 175 | Washfeet |
Madrid, Spain | Photo by
G. James Daichendt

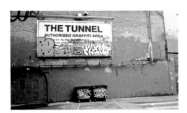

Page 175 | **Authorised Graffiti Tunnel** in London, UK | Photo by G. James Daichendt

Page 175 | **Ben Eine** | London, UK | Photo by G. James Daichendt

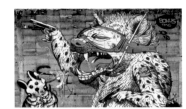

Page 175 | **Unknown** | London, UK | Photo by G. James Daichendt

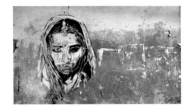

Page 178 | **Bukruk** | Thailand | Photo by Tim Jentsch

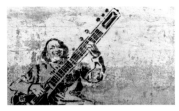

Page 180 | **Unknown** | Udaipur, India | Photo by Fabio Campp

Page 181 | **Rone** | Dubai, United Arab Emirates | Photo by Tim Jentsch

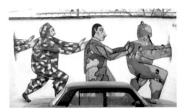

Pages 182–183 | **P183** | Moscow, Russia | Photo by Carlfbagge

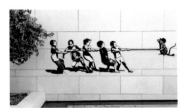

Page 184 | **Blek le Rat** | Dubai, United Arab Emirates | Photo by Tim Jentsch

Page 184 | **C215** | Delhi, India | Photo by Text

Page 184 | **Unknown** | India | Photo by Radek Rados

Page 184 | **Unknown** | Japan | Photo by Thierry Ehrmann

Page 185 | **ROA** | Bangkok, Thailand | Photo by Thanate Tan

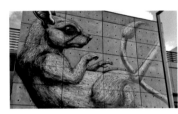

Page 185 | **ROA** | Dubai, United Arab Emirates | Photo by Tim Jentsch

Page 186 | **Eduardo Kobra** | Tokyo, Japan | Photo by Daniel Ramirez

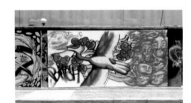

Page 188 | **Unknown** | Shanghai, China | Photo by Maria Ringgaard Møller

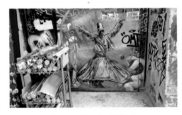

Page 188 | **C215** | Istanbul, Turkey | Photo by Istolethetv

Page 188 | **Tona** | India | Photo by Fafongen

Page 189 | **Eduardo Kobra** | Dubai, United Arab Emirates | Photo by Tim Jentsch

Page 190 | **Ciao** | Taipei, Taiwan | Photo by Sonse

Page 191 | **Unknown** | Shanghai, China | Photo by Maria Ringgaard Møller

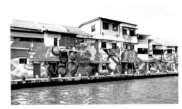

Pages 192–193 | **Unknown** | Melaka, Malaysia | Photo by Igor Plotnikov

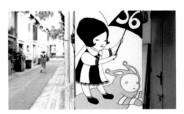

Page 194 | **56** | Singapore | Photo by Pawel Loj

Page 195 | **Unknown** | Moscow, Russia | Photo by Carlfbagge

Page 196 | **eL Seed** | Dubai, United Arab Emirates | Photo by Tim Jentsch

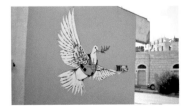

Page 197 | **Banksy** | Israel | Photo by Eddie Dangerous

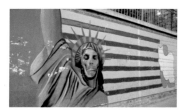

Page 197 | **Unknown** | Tehran, Iran | Photo by David Holt

Page 197 | **Ernest Zacarevic** | Dubai, United Arab Emirates | Photo by Tim Jentsch

Page 197 | **Ryogoku Kokugikan Mura** | Tokyo, Japan | Photo by Alex

Page 198 | **D*Face** | Tokyo, Japan | Photo by Lord Jim

Page 198 | **Unknown** | Istanbul, Turkey | Photo by FaceMePLS

Page 198 | **Unknown** | Thailand | Photo by Forbes Johnston

Page 199 | **Icy and Sot** | Dubai, United Arab Emirates | Photo by Tim Jentsch

Page 199 | **Vhils** | Dubai, United Arab Emirates | Photo by Tim Jentsch

Page 200 | **Guesswho** | South India | Photo by Fafongen

Page 200 | **Shepard Fairey** | Tokyo, Japan | Photo by xxspecialsherylxx

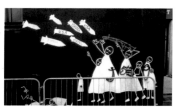

Page 200 | **Unknown** | Iraq | Photo by Jaqien

Page 201 | **Case Maclaim** | Tokyo, Japan | Photo by B4 Flight

Page 202 | **Unknown** | China | Photo by Caroline Lena Becker

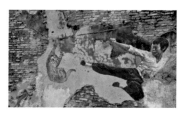

Page 203 | **Unknown** | Penang, Malaysia | Photo by Shankar S.

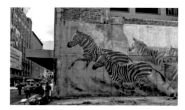

Page 206 | **Count frodo** | Johannesburg, South Africa | Photo by Tim Jentsch

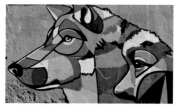

Page 208 | **Nardstar*** | South Africa | Photo by Chriss Godden

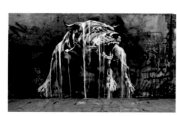

Page 209 | **Faith47** | Johannesburg, South Africa | Photo by Alma Feminina

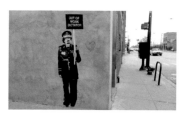

Page 210 | **Deih XLF** | Cape Verde | Photo by Alma Feminina

Page 211 | **Unknown** | Libya | Photo by Steven Vance

Page 212 | **Unknown** | South Africa | Photo by Francisco Anzola

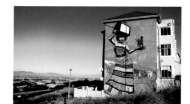

Page 213 | **Faith47** | Cape Town, South Africa | Photo by JX Stencil

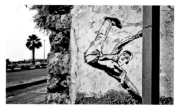

Page 213 | **Alma Feminina** | Verde, Africa | Photo by Alma Feminina

Page 213 | **Kazy** | Dakar, Senegal | Photo by Kazy

Page 214 | **Lady Aiko** | South Africa | Photo by Tim Jentsch

Page 21 5 | **Deih XLF** | Cabo Verde, Africa | Photo by Alma Feminina

Page 216 | **Unknown** | Egypt | Photo by Marko Kudjurski

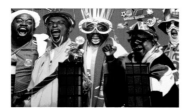

Page 217 | **Unknown** | Cape Town, South Africa | Photo by Gimas

Page 218 | **Up, Justin Nomad, and Falko** | Johannesburg, South Africa | Photo by Tim Jentsch

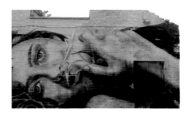

Page 219 | **Amsterdamage** | Zimbabwe | Photo by Tatenda Dimbi

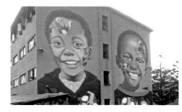

Page 219 | **Amsterdamage** | Zimbabwe | Photo by Tatenda Dimbi

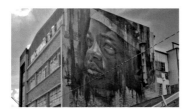

Page 219 | **Adnate** | Johannesburg, South Africa | Photo by Tim Jentsch

Page 220 | **Alma Feminina** | Cape Verde, Africa | Photo by Alma Feminina

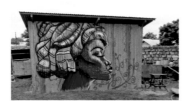

Page 221 | **Bebeto Thufu** | Nairobi, Kenya | Photo by Bebeto Thufu

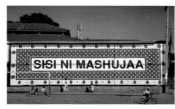

Pages 222–223 | **Boa Mistura** | Nairobi, Kenya | Photo courtesy of the artists

Page 224 | **Rone** | London, UK | Photo by G. James Daichendt

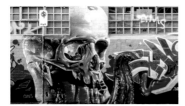

Page 238 | **SNUB** | Melbourne, Australia | Photo by B4 Flight

Page 240 | **Unknown** | London, UK | Photo by G. James Daichendt

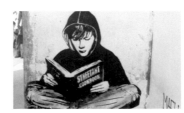

Page 240 | **Unknown** | Madrid, Spain | Photo by G. James Daichendt

Page 240 | **Cranio** | Liverpool, UK | Photo by Jonny Stanton

Page 240 | **Unknown** | London, UK | Photo by G. James Daichendt

Page 240 | **Stik** | London, UK | Photo by G. James Daichendt

Page 240 | **Pleghm** | London, UK | Photo by G. James Daichendt

Front and back single endpaper | **Unknown** | Miami, Florida | Photo by G. James Daichendt

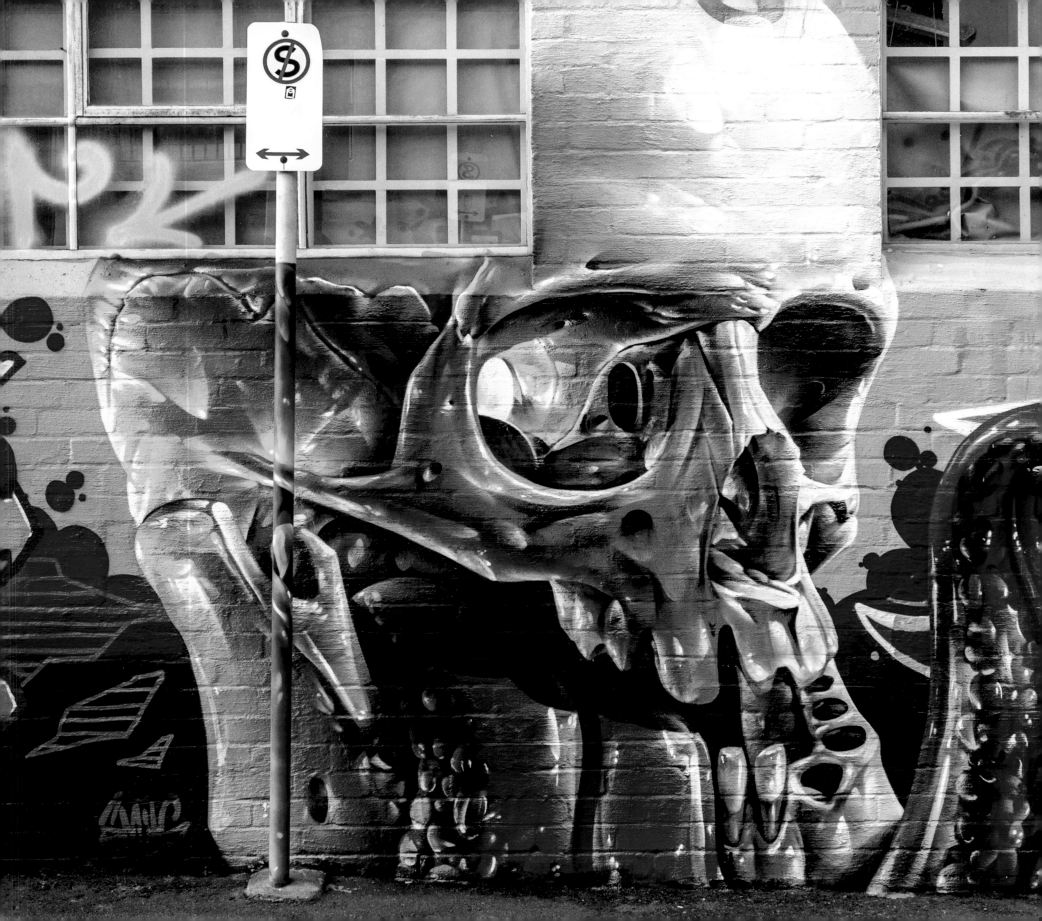

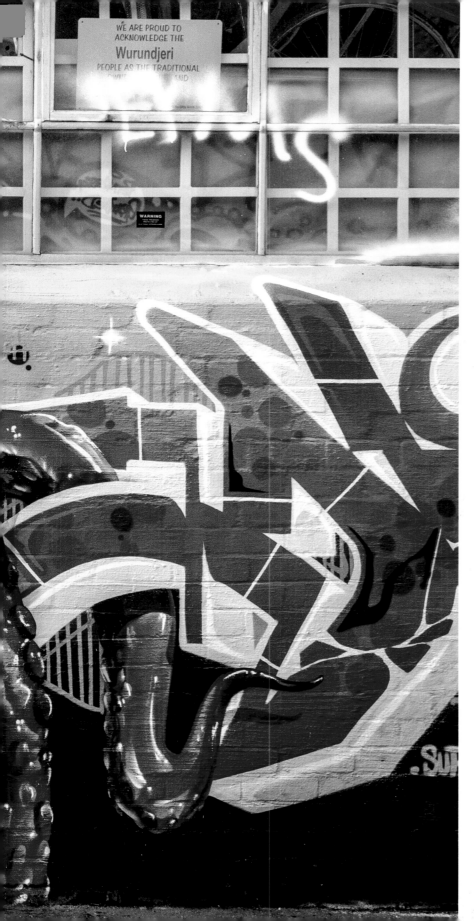

ACKNOWLEDGMENTS

Many thanks are due for this important book that has been in the works for several years. I am indebted to Weldon Owen for believing in the concept and the leadership of Roger Shaw, president and publisher of Weldon Owen, and Kevin Toyama, acquisitions editor, for their help in making it a reality. Special thanks to Chris Gruener, president and publisher at Cameron + Company, for his continued support of my work; Jan Hughes, managing editor, for shepherding the manuscript each step of the way; the copyediting of Judith Dunham; and the incredible design of Suzi Hutsell. The final product is a testament to your collective professionalism and keen aesthetic.

Ron English has been a significant contributor to the international street art scene for decades, and I am honored by his foreword and generous words. Many thanks to Tarssa for helping with the details and ensuring all was completed in a timely manner. Each chapter features remarkably smart and interesting introductions by Lord Jim, Shelby Moser, Ed Fuentes, Tim Jentsch, and Christina Hyesoo Valentine. Thank you all for your insight. Each of your individual voices contributed towards a text that celebrates and engages street art in a deep and meaningful way. I am also appreciative for key photos from Lord Jim, Tim Jentsch, B4 Flight, Rob Paramo, Danielle F. Manrique, Anna Stolyarova, Johnny Stanton, Teacher, Chase, Plastic Jesus, Maria Ringgaard Møller, Scott Bennett, Ross Schlemmer, Ed Fuentes, Almex, Mary Borges, Bebeto Thufu, Tatenda Dimbi, Alma Feminina, ST!CK UP K!D, and Chris Thomas. This book would not be possible without your help.

The street art of Toxicómano graces the cover, and I am thrilled to have their support in its use. This appreciation also extends to all the artists that I have had the pleasure to work with over the years (many who are represented in this text)—keep creating and making the world an exciting place to live. The most special of thanks is due to my wife, Rachel, and children, Samantha, Trey, and Logan, for sharing it all along the way.

weldonowen

Weldon Owen is a division of Bonnier Publishing USA
1045 Sansome Street, Suite 100, San Francisco, CA 94111
www.weldonowen.com

BONNIER

Library of Congress Cataloging
in Publication data is available.

ISBN: 978-1-68188-298-7

First Printed in 2017
10 9 8 7 6 5 4 3 2 1
2017 2018 2019 2020

Printed in China

President & Publisher Roger Shaw
SVP, Sales & Marketing Amy Kaneko
Associate Publisher Mariah Bear
Acquisitions Editor Kevin Toyama
Creative Director Kelly Booth
Art Director Allister Fein
Senior Production Designer Rachel Lopez Metzger
Associate Production Director Michelle Duggan
Imaging Manager Don Hill

Produced in conjunction with Cameron + Company
Publisher Chris Gruener
Creative Director Iain Morris
Designer Suzi Hutsell
Managing Editor Jan Hughes
Copy Editor Judith Dunham
Proofreader Mark Nichol

Cameron + Company would first and foremost like to thank Jim Daichendt for his
dedication to art and bringing his knowledge and insights to light in this book. We
would also like to thanks Roger Shaw, Mariah Bear, and Kevin Toyama of Weldon
Owen, for believing in this project and helping make it possible. Special thanks
to Suzi Hutsell for her inspried design; Iain Morris for his creative direction; Jan
Hughes for her editorial guidance; Judith Dunham for her copyediting prowess;
and to all the artists around the world who keep art alive and accessible. It is an
honor to feature these artists and play a role in promoting and exploring the
street art movement in the context of contemporary art history.

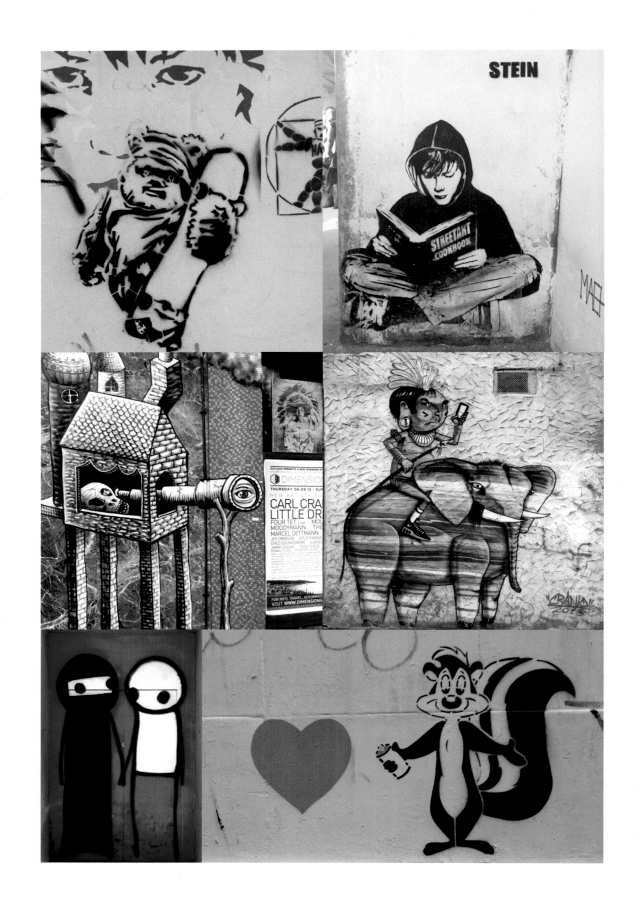

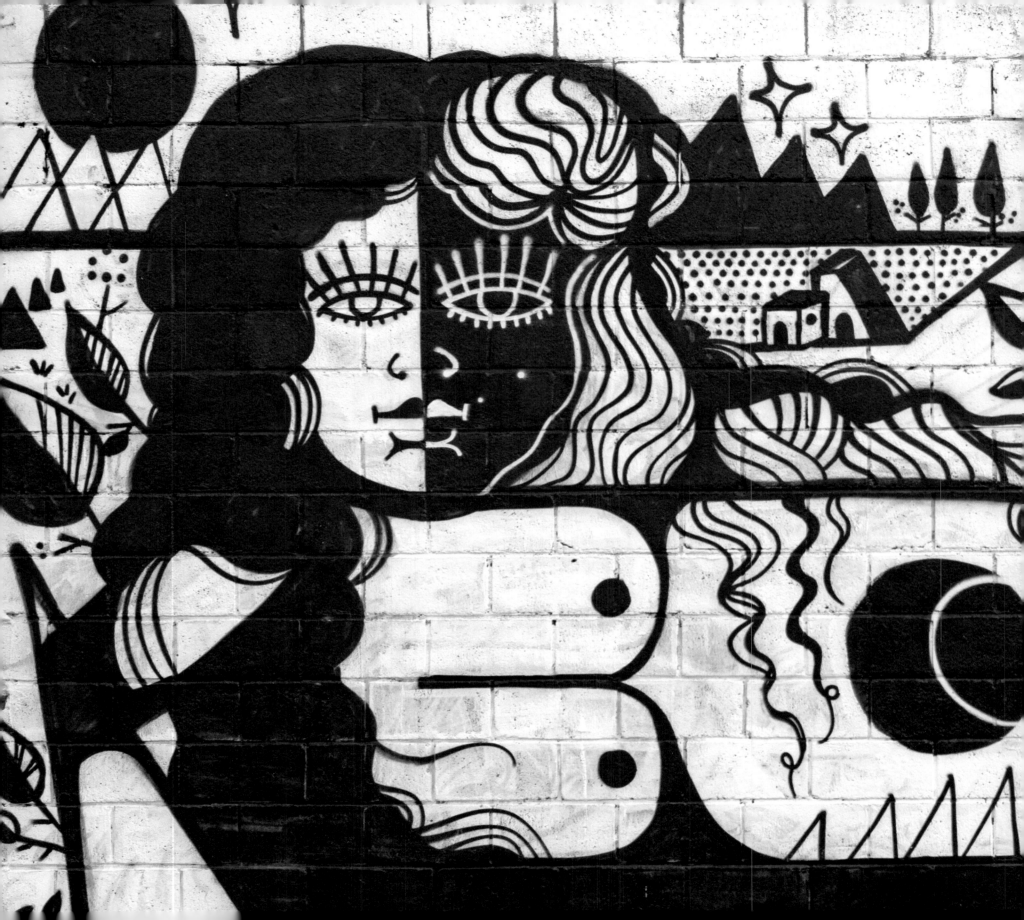